To Jill Watson!
Cotton is a joy!
Teresa Duryea
2017

COTTON & INDIGO
from Japan

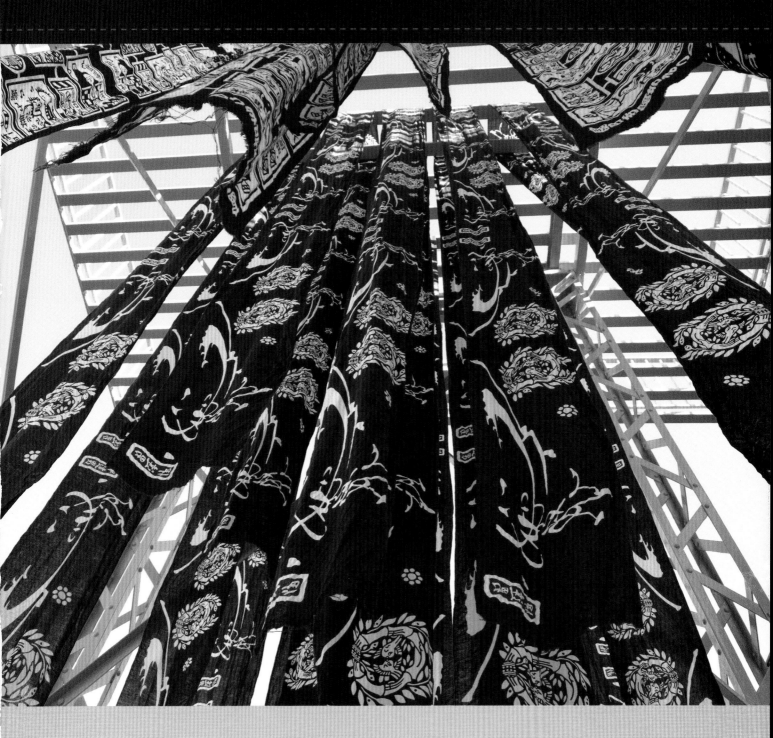

4880 Lower Valley Road · Atglen, PA 19310

Other Schiffer Books by the Author:

Japanese Contemporary Quilts and Quilters:
The Story of an American Import, ISBN 978-0-7643-4874-7

Other Schiffer Books on Related Subjects:

Threads of Gold: Chinese Textiles, Ming to Ching,
Paul Haig and Marla Shelton, ISBN 978-0-7643-2538-0

Southeast Asian Textiles, Claire and Steve Wilbur,
ISBN 978-0-7643-1810-8

Designed by Brenda McCallum
Cover design by Brenda McCallum
Front cover image of yukata: © oka - stock.adobe.com.
Type set in Americana/OpenSan

ISBN: 978-0-7643-5351-2
Printed in China

Published by Schiffer Publishing, Ltd.
4880 Lower Valley Road
Atglen, PA 19310
Phone: (610) 593-1777; Fax: (610) 593-2002
E-mail: Info@schifferbooks.com
Web: www.schifferbooks.com

For our complete selection of fine books on this and related
subjects, please visit our website at www.schifferbooks.com.
You may also write for a free catalog.

Schiffer Publishing's titles are available at special discounts
for bulk purchases for sales promotions or premiums.
Special editions, including personalized covers, corporate
imprints, and excerpts, can be created in large quantities for
special needs. For more information, contact the publisher.

We are always looking for people to write books on new
and related subjects. If you have an idea for a book, please
contact us at proposals@schifferbooks.com.

Dedicated to Akemi Narita.
A kind and generous person. A tireless supporter
of textile art and artists.

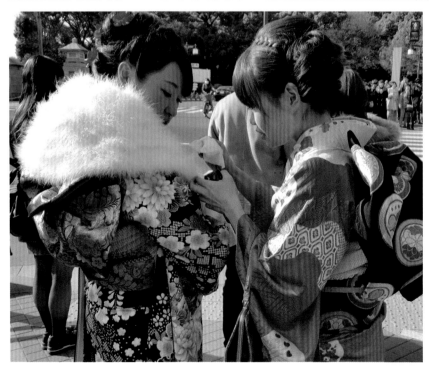

The beauty that is Japan
The sweeping majesty of Mt. Fuji and stunning streets of Tokyo
Shrines of deep orange and lush green forests of bamboo
Trains that transcend time and poignant memorials to peace
Crystal clear water and blue skies of an island nation
Japan awaits us

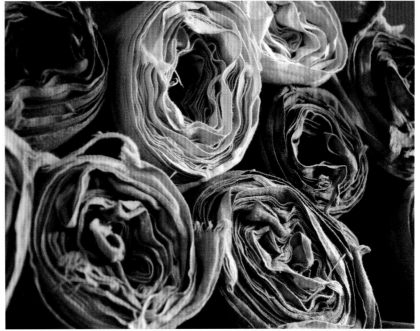

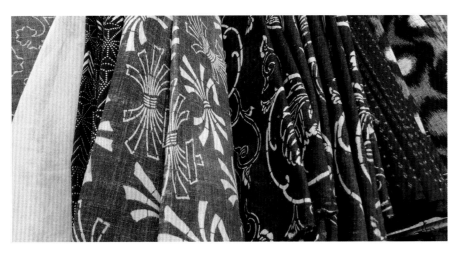

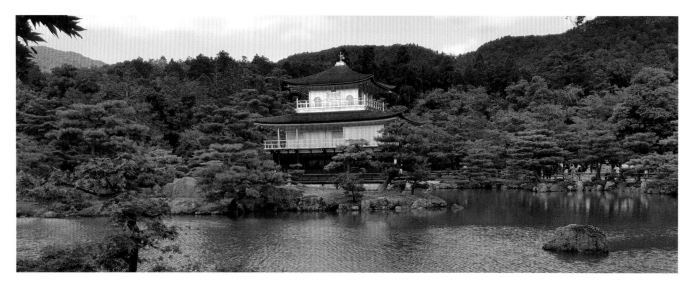

CONTENTS

QUILTS, COTTON & INDIGO

Cotton hasn't changed much over time. A seed lodges in the dirt and out comes an ugly little plant that could easily be mistaken for a weed except for one thing, eventually bolls of beautiful white fibers emerge. Once mankind figured out what those fibers could do, lives were forever changed.

When a foreign researcher visits Japan to talk to people about their history with cotton, the Japanese consistently describe cotton as a newcomer. After all, it's only been around for 600 years or so! For a country that's been awash in silk for thousands of years, after six centuries cotton is still novel.

But make no mistake, cotton has been enormously influential to Japan's culture. Several hundred years ago, Japan's working class, and the artisans, dyers, weavers, and seamstresses who lived among them, gave birth to the rich cotton textile traditions Japan celebrates today.

The beloved native indigo plant is closely connected and dependent on cotton. The fibers of cotton are uniquely well suited to absorbing indigo dye and the results of this extraordinary symbiotic partnership appear over and over in Japan's antique folk textiles. Indigo-dyed cotton warmed farmers and fishermen during the brutal winters, protected firemen from scorching hot flames and eventually offered breathable clothing for the masses during the hot, humid summer.

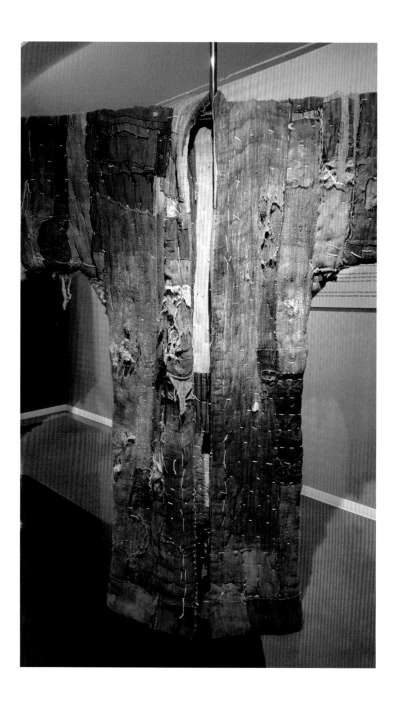

Donja, like the one pictured here, are extra-large, heavily padded textiles made in the shape of an oversized kimono and were used a century ago as bedding and blankets during cold winter nights.

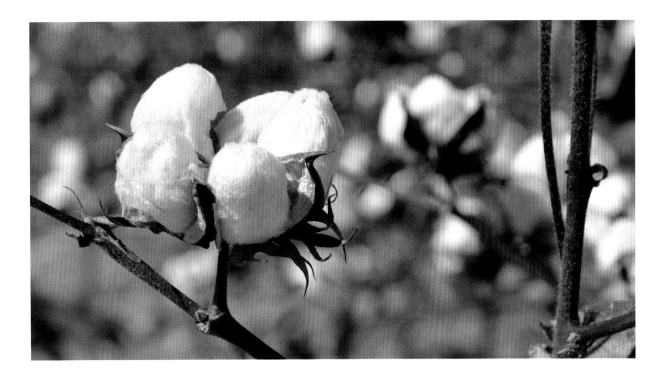

Today, the appreciation for cotton—old and new—is expanding. Japan has built 21st century museums to preserve and showcase their once neglected textiles, some of which have been reduced to mere rags, and other textiles that are carefully preserved are exceptional handmade works of woven, dyed, and stitched art made from cotton. Textile collectors, foreign and domestic, search high and low for exquisite Japanese cotton, seeking a piece of the past for themselves.

Indigo enthusiasts around the world look to Japan for the true Japan Blue. They find it in everything from domestically made, high-fashion cotton blue jeans to artisan made t-shirts, dresses, umbrellas and scarves sewn with cotton dyed exclusively by dyers using only natural indigo. Textile artists and quilters also embrace Japan's indigo. Shizuko Kuroha and her students are examples of quilters who are making extraordinarily new and beautiful quilts with old and faded indigo-dyed cotton and other antique cloth. Quilters around the world attend Kuroha's exhibitions, buy her books, and attempt to follow her example by making their own quilts with antique or vintage Japanese cotton, creating an even larger demand for these precious remnants.

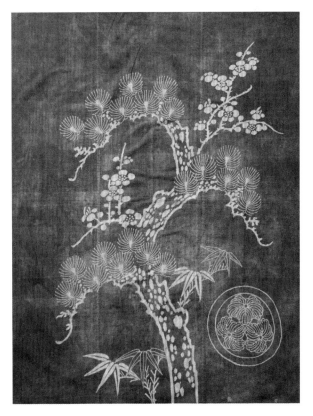

TOP Cotton growing near Lubbock, in West Texas. The state of Texas is the single largest cotton producing state in the US. Japan is typically among the top ten export destinations for American cotton.

BOTTOM Antique indigo-dyed, cotton *tsutsugaki*. *Tsutsugaki* is a traditional type of decoration that is created using a free-hand paste resist. This subtle blue indigo has perhaps faded over time, but indigo will never lose its color completely. Many people love the layered and complex color of indigo. *Collection of Carol Lane-Saber.*

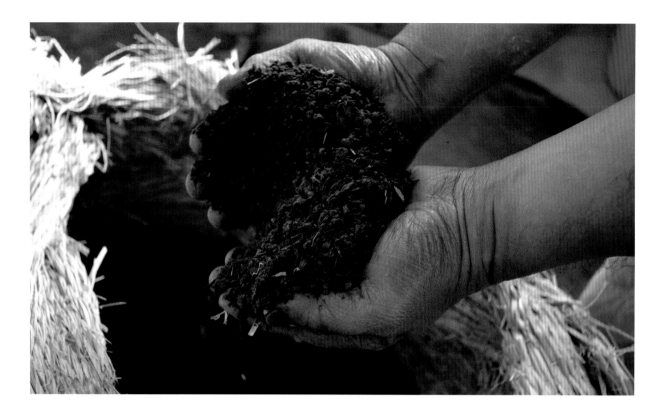

At the other end of the spectrum is the brand-new quilting cotton being designed and printed in Japan today. The artistic fabric designers featured here also happen to be quilters themselves, and this community includes some of the most innovative and talented fabric designers working today. Some of these designers, such as Keiko Goke and Yoshiko Jinzenji, are celebrities in the global quilt world, others are mostly known only within Japan.

Regardless of the fame of the designer, when "Made in Japan" appears on the fabric's selvedge, the customer has come to expect an extremely well-crafted textile because nowhere is the globalized commodity of printed quilting cotton produced with such exacting attention to detail, beauty, and quality than Japan. This industrious and highly creative island nation has taken the common cotton quilt fabric and honed it into a finely-tuned specialty whose excellence is unsurpassed by any other nation.

As a writer and researcher, this trifecta of quilts, cotton, and indigo reeled me in and demanded my attention. My childhood, my home, and my hobby all converged to pique my interest and provide me

an innate beginning for this story. First, I am a printer's daughter, and as such I spent my entire childhood surrounded by the transfer of color, line, and image to paper. I've also spent my entire career immersed in the communication of words and images. Second, cotton has attracted me for as long as I can remember and I have two decades of experience working with cotton as a quilter. My home also happens to be halfway between two of America's most celebrated cotton regions: the arid, windy prairies of West Texas and the fertile, moist land of South Texas. In Japan, I discovered bales of cotton imported right from the soil of my beloved state. And in West Texas, I brought a cotton quilt sampler constructed with fabrics made in Japan, parts of which can be traced to Texas cotton, completing the fiber to fabric circle.

Finally, indigo! While researching the history of quilting in Japan for my first book, I encountered indigo and Japan Blue and have been exploring this color, and this cloth, ever since.

Bringing quilts, cotton, and indigo together in this one book seems a natural homage to the breathtaking textiles made in Japan.

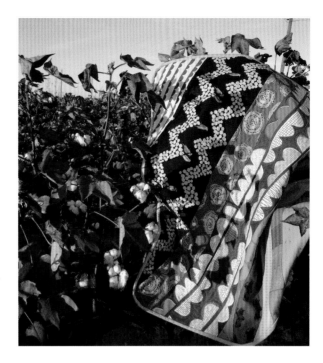

Note: All names in this manuscript are presented in the Western format with given name first, surname second.

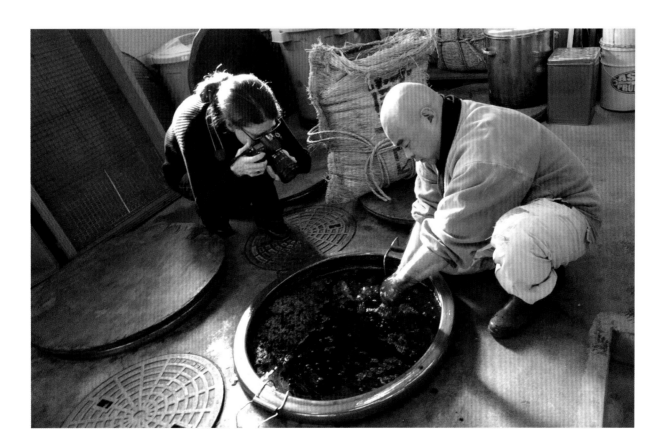

TOP A small quilt sampler featuring cotton fabric printed in Japan is draped over a cotton field in West Texas.

BOTTOM The author at work photographing Toru Shimomura, a natural indigo dyer. His studio sits in the picturesque mountain village of Ohara, near Kyoto.

ACKNOWLEDGMENTS

I am grateful for the endless encouragement of my husband, Jimmy W. Wong, and for the tremendous support from Akemi Narita and Nireko Ohira. This book would not have been possible without the incredible talent and generosity of these three people.

I would also like to acknowledge the assistance of the following individuals. Hirokazu Odajima & Tad Takeada, executives of Yamachu Mengyo; Hisako Fukui, executive of Yuwa; Kevin Bernet at Bernet International, a fascinating cotton trader, following the intercontinental footsteps of European traders 500 years ago; Pixie Onishi, an artist, founder of Pixie Studios, and half the force behind Moda Japan; Michiko Okunishi, an Osaka antique dealer with an impressive collection of antique cotton; Carol Lane Saber, former Japanese resident, avid quilter, and textile lover; Mariko Akizuki, a talented quilter and exceptional translator; Ichiro Takizawa, owner of Tokyo Wazarashi Co., Ltd., a *chusen* studio; Yonesuke Murai and Mitsutoshi Murai, father son duo, *chusen* masters, owners of Murai Senko Jo studio; Naruo Usui, the last weaver whose family business produces *Ise momen* woven cotton; Hiroshi Tachikawa, an energetic textile enthusiast who revived *Kameda jima* woven cotton; Kouji Takahashi, a quilt industry business owner; Trecia Terry Spencer, a quilter, business owner, and daughter of Texas cotton farmers; "Jackie" Yuriko Sakuraoka, a dentist/partner, Sakuraoka Dental Clinic in Otawara, Tochigi Prefecture; Keiko Goke, a longtime quilter, an extraordinary fabric designer, and a fellow blogger; Priscilla Knoble, a quilter and textile lover, owner of Stitch Publications and Willow Lane Quilting; Kate Adams, Quilt Curator, University of Texas Briscoe Center for American History (retired) and fellow Bybee Scholar (2015); Amy Gurghigian, retired teacher and school administrator, longtime friend, and my first quilt teacher; Polly Duryea, PhD, retired faculty from Peru State College, Peru, Nebraska and my aunt, my mentor, and my hero.

A stunning, hand-dyed *tenugui*, which is translated as a hand towel, is similar to a long, thin, cotton handkerchief. Many antique *tenugui*, like the one pictured here, are considered rare and special works of art and are sought by collectors all over the world. *Courtesy of Ichiro Takizawa, Tokyo Wazarashi Co., Ltd.*

TASTE, COLOR,
AND COOLNESS IN JAPAN

Color is odd. What attracts one eye, can repel another. The color we wear speaks volumes about who we are. Colors on the street tell us when to stop and when to go. The color of our skin can connect us or radically divide us. A colorful sunset exudes romance while the lack of color on an overcast day zaps us of warmth and happiness.

The color of the quilts of Yoko Saito, Shizuko Kuroha, and Yoshiko Jinzenji are as different from each other as night and day. Yet each of their sensibilities come from a profound sense of taste that is truly unique to Japan. This taste can best be described as *iki*.

Iki is a Japanese word for which there is no one-word English translation. The closest translation is the French term, *chic*, which means elegant taste. But *chic* does not fully express *iki*.

In 1926, the Japanese philosopher Shūzō Kuki was living in Paris, where he was inspired to write *The Structure of Iki [Iki nō Kōzō]* (1930) a seminal book considered by many to be a literary masterpiece. Shūzō's aim was to explain the essential Japanese concept of *iki* in terms a Western sensibility could understand.

He is widely considered to be Japan's first cultural anthropologist, and nearly a century later, his work still holds meaning. In the twenty-first century, his theories are relevant for helping quilters and art lovers around the world understand the allure of the white, off white quilts of Yoshiko Jinzenji, the deep indigo quilts of Shizuko Kuroha, and the taupe, brown, and gray quilts of Yoko Saito.

> *"Iki embraces the past and lives in the future.
> It permeates the minutest details of everyday life in Japan."*
>
> —Shūzō Kuki

Iki is a matter of taste. The word taste literally comes from tasting, so taste is something we learn over time. We make value judgments based on our own personal taste. And interestingly, just as taste for certain foods can change, our taste for color and style can also morph over time. As children, our color values have no limits. As adults, color choices can be incredibly specific for some and wildly uninhibited for others. And for some, a color that was abhorred as a young adult can become accepted, or even beloved, as a person ages. When it comes to *iki*, the profoundness of this sensibility requires that the colors must whisper. The whisper of white, the whisper of taupe, and the whisper of deep, dark blue black. These palettes do not shout. They do not exhaust your sensibilities. Rather, their power comes softly and as such, just like a precious whisper from the past, their magnetism is unforgettable. Learning to appreciate *iki* requires time.

> *"Coloring for the expression of iki must be something
> that asserts the relational in a whisper."*
>
> —Shūzō Kuki

There are three primary color schemes associated with *iki*: gray or ash white; brown and lemon brown; and dark blue azure.

Shūzō explains that there is no coloring more fitting as *iki* than gray, a colorless sensation that shifts from white to black. It is the very lightness of color. Gray and the variances of ash white were beloved during the Edo period. Yoshiko Jinzenji embodies the very core of this color. Her uber-modern studio quilts fully embody the spirit of *iki* as they whisper their white and off-white hues and the shades of nature.

The second beloved color scheme is tea brown. This particular hue is assigned many different names such as smoky brown, chestnut, or sea pine. Today the worldwide quilt community knows this palette as taupe or taupe-ism. To the Japanese sense, tea brown, or taupe, is actually a flashy tone ranging from red orange to yellow, tinged with black. The

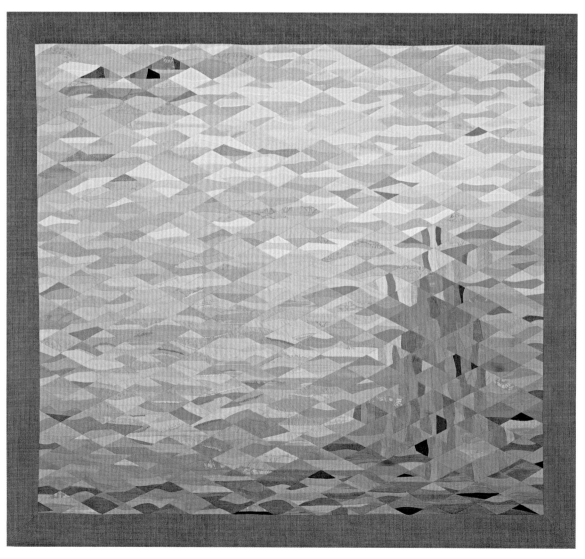

TOP Iki is a matter of taste. It is an aesthetic that whispers its intent with cool colors.

BOTTOM Kyoko Yoshida. *En brise Juin.* 2006. Antique cotton: 75" × 85" (190 × 215 cm). Pieced, hand quilted. The "lightness of color," as Shuzo Kuki explains in *The Structure of Iki,* is what attracts the viewer's eye to this gorgeous quilt. It is flawlessly pieced, which gives it a painterly effect, and every detail is carefully planned so the viewer finds peacefulness in these beautiful, cool colors.

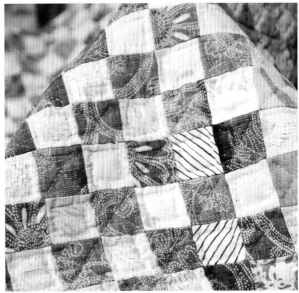

beauty of taupe lies in the gorgeous tonal quality on the one hand, and the reduced levels of saturation on the other—a combination that is tricky to achieve. Japan's Yoko Saito is a master of the taupe palette and she has helped introduce the taupe-ism movement to quilters around the world through her quilts, books, patterns, and fabric collections.

The third color, azure, is more vivid and highly saturated. In fact, it is so saturated it can even venture toward midnight black. This is the palette so lovingly adopted by Shizuko Kuroha. The elegant quietness of the indigo azure employed by this artist compels the eye to linger on her stunning quilts leaving the viewer soothed, yet wanting more.

These colors are cool colors, the opposite of warm tones. And Shūzō says, that when the soul has tasted the full stimulant of warm colors, it inhales the tranquility of the cool ones.

TOP LEFT The whisper of soft copper and tiny traces of green, in this exquisite, hand-woven textile made by Yoshiko Jinzenji, is the epitome of serenity, an expression of *iki*.

TOP RIGHT Shizuko Kuroha. *Spring Breeze* (detail). 2002. This gorgeous quilt is made with antique indigo and other soft and faded cotton. The light, breezy design, the gentle hand quilting, and soft, subtle palette is the perfect expression of *iki*.

BOTTOM Akiko Shibusawa. *Transparent Work II.* 2015. Polyester, aluminum-coated nylon and plain nylon, velvet, felt, and printed cotton: 85" × 85" (215 × 215 cm). Appliquéd, reverse appliquéd, pieced, machine quilted. This imaginative, abstract studio quilt with its sparse and splendid use of color, exudes *iki*. The artist has created a quilt with unusual textiles and a subtle placement of quirky and colorful objects and shapes. Many of the small objects and shapes are created with Yoshiko Jinzenji's printed cotton fabric collections.

Coolness stands alone. It comes from a particular sense of urbane stylishness and a certain level of detachment. The opposite of *iki* is conventional.

Yoko Saito, Yoshiko Jinzenji, and Shizuko Kuroha are certainly unconventional quilt artists. Shizuko stitches her art with worn and faded antique textiles. Yoshiko, on the other hand, is at the very forefront of modern weaving, dyeing, stitching, and printing methods to create an entirely new era of cotton textiles. And Yoko Saito has an impressive collection of commercially printed quilting cottons. The dichotomy of these artists is a striking example of Japan's old and new. While some are making quilts that respect and honor the past, others are pushing boundaries to create new ways of working with textiles. Yet, for these three artists, their color schemes clearly speak in a whisper. They are cool and detached, yet their very refinement is alluring, commanding the viewer's eye closer. Their *iki* is uniquely Japanese. They embrace the past and reflect the future.

ABOVE This *tenugui* (hand towel) is a hand-crafted work of art created by a process known as *chusen*, a type of paste resist and pour dyeing. The colorful and funky illustrated images literally pop against the gorgeous *iki* background colors. *Courtesy of Ichiro Takizawa, Tokyo Wazarashi Co., Ltd.*

TOP LEFT These antique cotton textiles, with their soft palette of indigo and other natural colors, exude *iki*.

BOTTOM The rose-gold/copper-colored quilt in the foreground is made from a single piece of fabric that is representative of the complete and total one-woman industry of Yoshiko Jinzenji. She dyed the thread for this cloth in Indonesia, she wove the cloth herself into this very delicate color scheme, she planned out how to use the cloth to make a quilt so that no piece would be wasted, and she stitched the quilt herself on a longarm machine. This total control of an idea and a product, from start to finish, is a process she calls "engineering" quilts. The end result is an exquisite blend of color, pattern, and taste that personifies the very idea of *iki*.

PART ONE

QUILTS

It's highly plausible that there are as many quilters in the world as there are golfers.* The two hobbies, and careers for some, share a lot of similarities, the primary one being passion. Both endeavors are also extremely time consuming, which is actually part of the attraction for those who partake.

Many people are cognizant of the fact that there are thousands of golf courses around the world for golfers to play, yet these same people might be surprised to learn that there are also seemingly thousands of venues for quilters to play as well, the primary ones being retail shops. These specialty outlets, both brick and mortar and of course, online, can be found in nearly every corner of the world and most of the merchandise is dedicated wholly to quilters. These entities sell quilt fabric, thread, notions, books, patterns, machines, and a plethora of accessories. Interestingly, quilt shops rarely sell finished quilts. Instead, they cater to the makers.

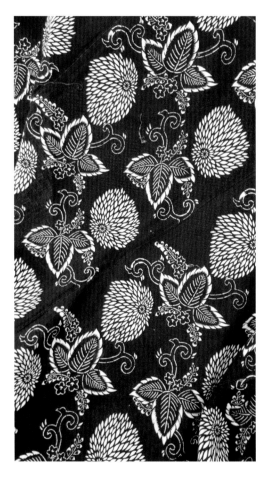

*According to *Quilters Newsletter* and Quilts, Inc.'s 2014 survey there are approximately 16 million active quilters in the United States, which is the largest concentration of quilters in the world. There are an estimated two to three million active quilters in Japan. Other large quilting markets are the U.K., France, Northern Europe, Australia, Canada, and Taiwan.

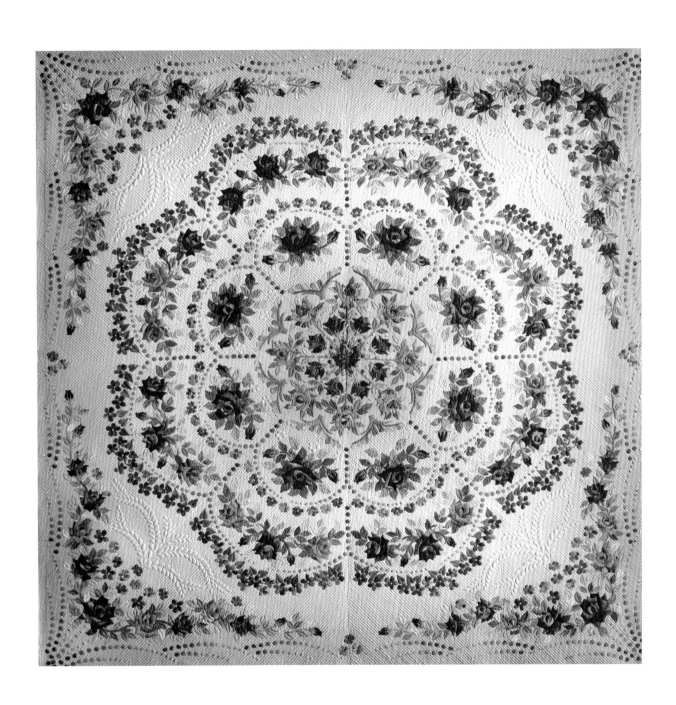

Junko Fujiwara. *Brilliant Rose.* 2014. Cotton: 84" × 84" (213 × 213 cm). Hand embroidery, hand appliquéd, hand quilted. This masterful cotton quilt exemplifies the exquisite hand-work and soft taupe palette often seen in Japanese quilts, and is a vivid expression of *iki.* Junko Fujiwara lives in Narashino, Chiba. *Brilliant Rose* was awarded the International Quilt Association Founder's Award in 2015. *Courtesy International Quilt Association. Photo by Mike McCormick.*

Akiko Shibusawa. *Hexagons Patch Quilt*. 2007. Cotton commercial fabrics designed by Yoshiko Jinzenji: 67" × 59" (169 × 150 cm). Pieced, machine quilted. This fresh, contemporary quilt draws inspiration from traditional block patterns and features Yoshiko Jinzenji's commercially printed quilting cotton.

OPPOSITE Kokka produces the Echino brand of fabrics, popular with quilters, home decorators, and garment sewers all over the world. In Europe, Daphné Parthoens makes small purses from her home-based business in Belgium and many of her designs feature Echino fabric, as well as fabric by other Japanese designers. Her simple, cute designs combined with the funky Japanese aesthetic have enabled Daphné (through her company Octopurse) to sell thousands of bags online to customers all over the world.

Fabric Made in Japan

Successful fabric designers who specialize in quilting textiles can be found all over the world. Standing alone though, among all those choices, is the distinct Japanese aesthetic. The source of this distinction is linked to several elements, such as the beautiful hand of the Japanese cotton, the fine printing, and of course the stunning and unusual designs and palette.

There is a growing community of extremely accomplished and talented Japanese quilters who also design contemporary and traditional fabric collections. These artists have taken their exquisite technical expertise, honed after decades of working with needle and thread, and turned their hand to the paint brush and other tools of the conventional artist to create unique fabric art.

To illustrate this story, the author selected an exceptional sample of Japanese quilters who work double duty as fabric designers. Each artist has a unique voice, an aesthetic that stands out among the rows and rows of fabric bolts. Some of their designs are funky and fun, some are gorgeous romantic florals, and some are pure modern art. All of them are grounded in the brilliant and cool Japanese vibe.

One serious consideration that benefits the Japanese designers is the superior printing quality of cotton fabric printed in Japan. The country remains the premier destination for the finest printed textiles in the quilt world and the author has gone inside these printing mills in order to explain how and why Japan maintains this quality and reputation.

This story also explains something that often remains a complete mystery: where all this cotton is grown, as well as the locations where that cotton was woven to become the base textile that eventually is printed into the beautiful fabric that quilters lovingly sew into their quilts. Interviews with many of Japan's top quilt fabric manufacturers reveal this critical information. Their answers are surprising.

When these factors are combined—the unique Japanese aesthetic and palette, and the superior textile printing—the fabrics made in Japan exude exceptional quality and beauty.

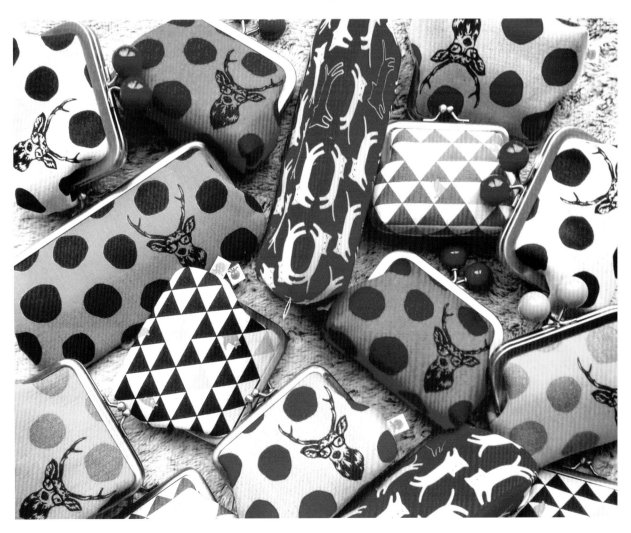

DESIGNER QUILTERS

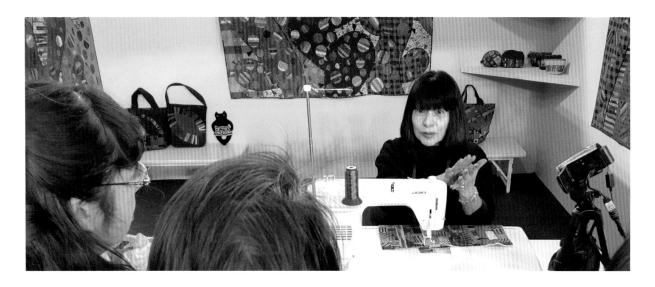

Keiko Goke // An Artist's Eye for Color

Keiko Goke is an artist who first began making quilts in the early 1970s. She is a self-taught quiltmaker and has paved her own path from day one. Her artistic quilts are filled with color and a sense of whimsy and they often tell a powerful story or capture a happy moment. Many of her quilts are infused with hand embroidery or embellishments, but they are quilted on a machine, a fact which has been part of her construction method since her first quilt. Her machine quilting, especially in the early days, clearly set her apart from her contemporaries and she has been influential in attracting a new generation of quilters who are inspired by modern sewing and quilting techniques.

She actively teaches a dedicated group of students from her studio in Sendai, and she also travels and teaches internationally. Her quilts have been exhibited in many prominent international exhibitions, including the International Quilt Festival in Houston, the Quilt National competition in Ohio, and of course, the Tokyo International Great Quilt Festival. In fact, each year she hosts a booth at this massive quilting event and many quilters make a direct

LEFT Keiko Goke offers a live demonstration to quilters gathered at the 2016 Tokyo International Great Quilt Festival, which is held each January at the Tokyo Dome (a baseball stadium). Many quilters in Japan and elsewhere are eager to learn her techniques and discover how she achieves her creative use of color and design.

RIGHT Many fabric designers in Japan create their art first on paper, rather than on the computer.

line to her booth to quickly purchase collections of her commercially printed cotton quilting fabrics. The popularity of these fabrics have helped spread Keiko's reputation among quilters worldwide.

Keiko designs her fabric the old fashioned way, on paper, not on a computer. Her commercial fabrics are executed exactly as she imagines them, with an acute replication of the original texture. By manipulating her Japanese-oil pastel sticks, pencils, paints, and other mediums, she can completely control her image by blending colors and creating soft edges.

Her designs are so complex that in order to replicate these on fabric, the process sometimes requires printing one color on top of another, known as over-printing. In addition, some designs can also require removing color,

a complicated tactic known as discharge. When layers of color are over-printed, some traces of color can be discharged in order to create an entirely new and unusual hue. Furthermore, an additional requirement for some of her fabric collections is the need for far more than the standard 15 colors that can be printed in one production run, so this means a few fabrics go through a second round of automated screen printing.

These soft edges, vibrant color blends, and discharge effects are not easy to print, and are certainly not inexpensive to replicate. But Keiko is an artist who does not compromise. Fortunately, she found a production partner that understands and appreciates her aesthetic and is willing to undergo these extra steps to produce her stunning fabrics. That partner is Yuwa Shoten.

This image captures two original fabric designs on paper (left) by Keiko Goke and two samples of the finished, printed fabrics. The artwork for these patterns is created the old-fashioned way, with Japanese oil pastel sticks, pencils, paints, and other mediums, and not on a computer. In order to replicate these intricate, original designs, the printer sometimes must print one color on top of another, known as over-printing. In addition, some designs can also require removing color, a complicated tactic known as discharge. When layers of color are over-printed, some traces of color can be discharged in order to create an entirely new and unusual hue. Furthermore, a few prints included in some of Keiko Goke's fabric collections require far more than the standard fifteen colors that can be printed in one production run. So this means a few fabrics go through a second round of automated screen printing. All of these extra steps contribute to the unique aesthetic of these particular collections.

Keiko Goke has an extraordinary sense of color. She is often asked to explain her use of color and in fact, this is the one question she gets most often from students or new people she meets, and she is loath to answer. This is because her color sense comes naturally. Just like a musician who can improvise her own music, Keiko Goke can create her own world of color. She does not over think it and she cannot explain it.

Her innovative sense of color and design is evident in both her large body of distinctive quilts, as well as her commercial fabric collections. A conversation years ago with Kaffe Fassett, an internationally known fabric designer, inspired Keiko to begin designing commercial fabrics. He assured her that her point of view was original and that quilters would find her aesthetic interesting.

Originally she intended to produce her collections with Rowan, the same fabric company that produces Kaffe's collections. However, a series of events led her to look inside Japan and she approached Yuwa Shoten about producing her designs. The choice has been a good one for both of them. At the time, though, Keiko assumed that Yuwa would find her designs too contemporary and unusual when compared to the rest of the fabrics they produce. But after several Yuwa representatives spent time in her Sendai studio, they recognized that her aesthetic had appeal and would help diversify Yuwa's portfolio.

Occasionally, Keiko will use her commercial fabrics in her own studio quilts. One such quilt, *To Tomorrow,* incorporates her prints into the background. Her quilting lines are thoughtfully placed and the hand embroidery adds texture and color. *To Tomorrow* is a bright work that is filled with movement and conveys a sense of joy, which are hallmarks of her work.

Keiko Goke. *To Tomorrow.* 2014. Cotton: 34" × 22" (86 × 55 cm). Hand embroidery, pieced, machined quilted. Part of the fabrics featured in this quilt are from Keiko Goke's commercial quilting cotton collections.

Noriko Fujisawa // Keiko Goke's Master Student

Noriko Fujisawa is a student of Keiko Goke's and her quilt, *Summer Garden* (2015), won first place in the Original Design category at the 2016 Tokyo International Great Quilt Festival. This particular quilt features improvisational, pieced vertical strips, filled with color, and among the strips there are leaves formed to resemble flowers. Amidst these unique fabric choices are bits and pieces of Keiko Goke's printed commercial fabric, along with solids and other fabrics as well. It is an interesting and contemporary assembly of cotton fabrics.

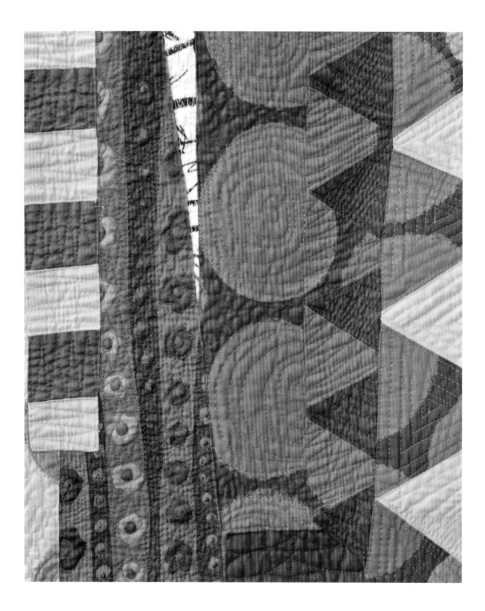

ABOVE Noriko Fujisawa. *Summer Garden* (detail).

RIGHT Noriko Fujisawa. *Summer Garden*. 2015. Cotton: 187 × 196 cm. Pieced, machine quilted. *Summer Garden* won first place in the Original Design category at the 2016 Tokyo International Great Quilt Festival. Amidst these unique fabric choices are sections of Keiko Goke's printed commercial fabric, along with solids and other fabrics. It is an interesting and contemporary assembly of cotton fabrics.

31

Yoko Ueda // Florals, Romance, and Nature

Yoko Ueda, who studied fine arts in college, is a seasoned artist who turned to quiltmaking in 1987 as her primary creative outlet. She lives in Kamakura, Japan, a resort town that sits on the Sagami Bay and is ringed by mountains. Being surrounded by the fresh sea breeze and the cool mountain air is partly what inspired her to begin designing her own fabric collections in 2010. Her popular cotton fabrics use imagery that is both natural and romantic.

Yoko is a dedicated quilt teacher who currently teaches about 100 students in her studio, known as Ueda Art School. She also travels often to teach in

Yoko Ueda. *Rain Flowers*. 2015. Cotton commercial fabrics designed by the artist, embellished with paint (by hand and stencils): 71" × 71" (180 × 180 cm). Pieced, appliquéd, machine quilted.

Osaka, Nagoya, and Tokyo, as well as internationally. She enjoys the process of sharing her perspective on color and design with her students. Besides teaching, Yoko has been awarded numerous creative awards for quilting and knitting and her work has been shown in many countries, including Japan, the US, Australia, France, Denmark, Spain, and China. Her warm personality and her collection of beautiful, inviting quilts also make her a popular guest for Japan's morning television talk shows.

She creates her fabric designs by hand first with paint, stencils, collage, or drawing. Then she turns these layered designs over to Yuwa Shoten to be produced into the stunning collections of quilting and garment fabric for which Yuwa is known. Yoko's design aesthetic is a perfect match for the quality products produced by Yuwa and her fabric is sold in quilt stores around the world.

Yoko Ueda. *Butterflies.* 2016. Cotton commercial fabrics designed by the artist, other prints, metallic thread: 71" × 71" (180 × 180 cm). Pieced, appliquéd, machine quilted.

A protractor. A ruler. Paint. And *sumi* ink. These are some of the conventional tools that the talented contemporary quilter Yasuko Saito uses to create fabric collections that are full of bright colors, vivid designs, and most of all, movement. No computers are needed.

Capturing and reflecting movement are hallmarks of Yasuko's contemporary art quilts. The concept fits her perfectly because she herself is full of energy. She is an enthusiastic promoter of Japan's art quilt community and she encourages her fellow quilters to embrace contemporary designs, to learn machine quilting, and most importantly to exhibit their work. When she is out promoting quilts or just visiting with friends, she often dresses in traditional kimonos—some of which she has sewn herself. She feels this is an important public reminder of Japan's traditional culture.

When it comes to her quilts and fabric art, however, she is in constant pursuit of new ideas and innovative designs. Many of her quilts convey strong waves of motion—accomplished with swirling sections of fabric or quilted stitches that swerve with energy. She has been creating quilts for several decades and many of her most recent studio quilts aptly feature the word movement and a number in the title.

When she opted to turn her artistic hand toward fabric design, this constant focus on movement carried over. As of 2016, she has completed some sixty-five variations of fabric designs. Some of her fabric designs look like freshly painted round swirls, as if the artist just lifted her brush. Her quilt titled *Movement #80*, which was created on request specifically for this book, features that very same swirled fabric in various colorways cut up and pieced back together. The colorful montage with its twelve large, improvisational blocks, is an astute homage to a traditional block quilt, yet it is uniquely original, primarily because of the painterly aspect and the pieced assemblage of the artist's original fabric design.

The fabric collections of Yasuko Saito are printed in Japan by Kei Fabrics. Kei is a small, boutique fabric manufacturer that produces several lines for quilting, garment sewing, and also home decorating. Yasuko Saito's fabrics are primarily distributed within the Asian market.

LEFT Yasuko Saito is a well-known quilter, teacher, and fabric designer. Her contemporary style is innovative and fresh and she is an expert in adapting free-motion quilting to add depth and motion to her art quilts. She often wears beautiful, traditional kimonos when she is out in public.

RIGHT Yasuko Saito.
Movement #80 (detail).
2016.

Yasuko Saito. *Movement #80*. 2016. Cotton fabric designed by the artist: 78" × 64" (198 × 164 cm). Pieced, machine quilted. This vibrant art quilt is composed of twelve improvisational, pieced blocks in the center, surrounded by a smaller border of pieced blocks. The expert piecing here with similar fabric that has been printed in different colorways produces an unexpected sense of motion, as if the circles could twirl in place. This quilt is made exclusively with fabric from the artist's designs, which are manufactured by Kei Fabrics, and was created on request for this book.

Yoshiko Jinzenji grew up in a home that cherished Japan's traditional cultural arts. Like her mother and grandmother, as a child, Yoshiko dressed most days in a kimono. Beginning at age nine, she began serious study of *ikebana* (flower arranging) and traditional tea ceremony.

Hers was a life lived with incredible focus and clarity. She seemed destined to follow in the footsteps of the masters before her in both of these art forms. But in 1970, Yoshiko found herself living in Canada, and a chance encounter with handmade quilts changed everything.

By the 1980s, Yoshiko had moved back to Japan and began traveling extensively to Bali, Indonesia. Eventually she made a home there and split her time between Bali and Kyoto. Bali provided a base for exploration for hand weaving bamboo and cotton fibers. It also turned out to be a perfectly natural setting to explore dyeing techniques.

Some forty-five years later, her pure vision and keen sense of innovation have given the quilt world a legacy of quiet, powerful, and impeccably executed abstract expression.

Her interest in quiltmaking stems in part from a fascination with textiles, a love that she says dates back to wearing a beautiful kimono every day and having the feel of those exquisite silks next to her skin. This love has led her on a lifelong quest to explore textiles from every angle including transforming unexpected synthetics into quilts, hand weaving unusual fibers, and an intense study of dyeing with natural ingredients such as bamboo.

Yoshiko's hand-dyed textiles, mostly silk, but occasionally cotton, exude an earthy, natural off-white color. Years ago, she began a quest to search for a powerful white with the quiet sheen of *iki*. After experimenting for many years, she devised a method to "cook" the textiles in fresh bamboo. Her hand-dyed textiles are allowed to dry in the sun as a way to absorb fresh air and natural bleaching into this special cloth.

In 2014, Yoshiko returned to live full-time in her gorgeous, custom-built home up in the mountains outside Kyoto. Her unusual two-story home, with its natural setting and impeccable decorating, has been featured in numerous architectural and lifestyle magazines. The home includes a special sparse, quiet room reserved

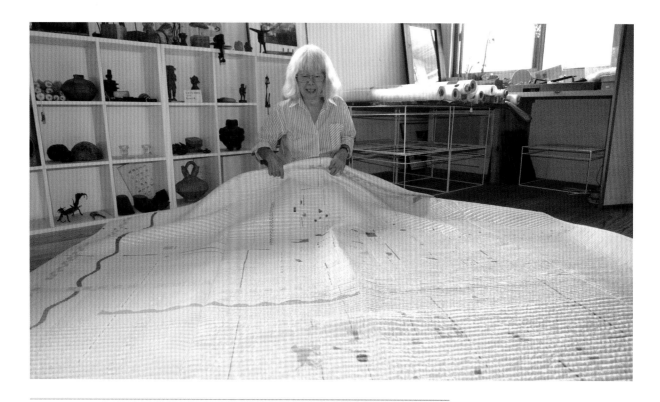

Yoshiko Jinzenji, pictured in her home in the mountains of Kyoto, inspects one of the very large quilts she has made over a 40-year career as an innovative quilt artist. This one is titled *Hieroglyphic Quilt II* and was made in 2007. In 2015, she retired from quiltmaking but continues to mentor a group of her longtime students.

LEFT Detail of *Hieroglyphic Quilt II,* made by Yoshiko Jinzenji in 2007. It is constructed with layers and layers of translucent, synthetic fabrics placed over cotton fabric featuring designs from her commercial collections.

for tea ceremonies, and a huge kitchen. In fact, it is the kitchen where she expends her creative energy now. In 2015, she essentially retired from quiltmaking, but continues to mentor a small group of her longtime students and design new fabric collections for Yuwa.

Her Kyoto home is where her body of work is housed, at least what's left of the collection minus the quilts that have been snapped up by collectors or acquired by museums, including the Victoria and Albert Museum in London, International Quilt Study Center and Museum in Nebraska, the Spencer Museum in Kansas, and others around the world.

The opportunity to see these finely tuned, minimalist masterpieces up close is an unforgettable experience. Her quilts are infused with a plethora of tiny details that create rich hues and astonishing texture. In a world saturated with color, these mostly white, off white, and other natural-color quilts are incredibly tranquil and beautiful.

To fulfill her vision, Yoshiko Jinzenji completely plans out every single detail of her quiltmaking before she begins working—everything from the inspiration, to the construction, to the installation of the final piece—each task is carefully planned. This includes spinning thread, dyeing it, weaving the cloth, piecing the quilt, or forming one "whole cloth" quilt top, stitching the final quilt, and even the placement of where the quilt will lie or hang when it's finished. She refers to this all-encompassing process as "engineering quilts" and her incredible dedication and focus is an aspect that distinguishes her as an elite artist.

Yoshiko Jinzenji. *Watermark,* 1990s. Nylon, polyester, rayon: 72" × 99" (183 × 253 cm). Layers of transparent fabric are pieced, machine quilted. *Collection of International Quilt Study Center and Museum, Lincoln, Nebraska.*

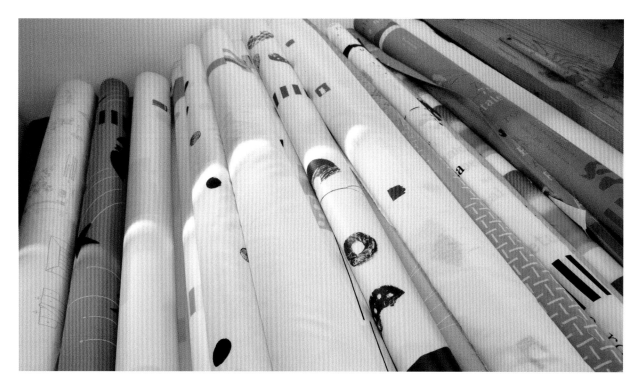

One example of the end-to-end engineering process she often pursues came about when she participated in a unique partnership with a Japanese textile producer and an American organic cotton farmer. Around 2008, she used organic, extra-long staple cotton thread provided by Taishobouseki Company. The thread was made from organically-grown cotton from a farm near La Union, New Mexico. Over a two-year process, she wove the thread into a "whole cloth," dyed it using natural bamboo and mahogany dyes, stitched it herself, and created yet another fully-engineered quilt.

These quilts are constructed in new and innovative ways. Some of her very large quilts are created and quilted (or stitched) in pieces before each section is assembled to form the whole. This technique, which is sometimes known as "quilt as you go" is not new in quilting, but what is innovative is her particular method for assembly. Typically, the edges where two or more blocks meet will have rough, unfinished edges. Yoshiko has invented multiple ways to solve this problem and her unusual solutions add texture, originality, even a bit of technical mystery, to her finished quilts.

Rolls of cotton fabric printed in Japan by Yuwa Shoten and designed by Yoshiko Jinzenji.

BOTTOM RIGHT This gorgeous roll of uncut, cotton fabric was hand-woven by Yoshiko Jinzenji.

LEFT Yoshiko Jinzenji's sophisticated two-story home, with its natural setting, mountain views, and impeccable decorating, has been featured in numerous architectural and lifestyle magazines. Her Kyoto home houses her body of work, at least what's left of her collection minus the pioneering studio quilts that have been snapped up by collectors or acquired by museums around the world.

Antique cotton and new cotton have both played a big part in her quiltmaking. She has designed several collections of commercial quilting cotton for Yuwa Shoten and she views this process as another creative outlet, and one she enjoys immensely. She is not a prolific commercial fabric designer and her printed collections are produced in limited quantities, primarily because her aesthetic does not appeal to the mass market. But those quilters and garment sewers who appreciate her minimalism which is infused with subtle shades of yellow, orange, dusty blue, green, and turquoise, and of course white and off-white, as well as other soft colors, treasure these fabrics and even seek them out relentlessly. These fabrics are particularly popular among Western contemporary quilters.

The unusual methods she uses to design her collection of commercially printed cotton speaks to the way her innovative mind works. For example, Yuwa Shoten (the company that has produced all of her fabric) explains that Yoshiko originally approached fabric design as an exercise in creating a finished "whole cloth," one that might have a similar look to one of her finished quilts. This is the antithesis of most cotton intended for the quilt industry where repetitive patterns and designs are preferred so they can be cut into patches and mixed with other fabrics to create a quilt. But Yoshiko would lay fabric on the floor and balance the aesthetic as if it were a whole work of art that might be several yards/meters long. Over time, her design methods have evolved to become slightly more conventional, but her commercial fabrics remain distinctively original.

BOTTOM These tightly quilted lines, along with the coolness of *iki*, are hallmarks of the extraordinary quilts of Yoshiko Jinzenji.

Yoshiko Jinzenji's Yuwa fabric collection is also popular with her own students.

One student in particular, Akiko Shibusawa, has created a body of work that emulates the style of her master teacher. The student-teacher relationship has a different connotation in Japan than in other parts of the Western world. The case of Yoshiko Jinzenji and Akiko Shibusawa in particular helps explain this dynamic. The "student" is a highly accomplished artist and she has chosen to study with one master. She chooses to make art that closely references the work of her master teacher, but her skill and dedication set her apart as an accomplished artist in her own right.

In almost all of Akiko's large and stunning quilts, small patches of Yoshiko's commercial cotton fabrics can be discovered tucked away in some small area, or peeking out from reverse appliqué, or as the material that covers the back of the quilt. Akiko Shibusawa's *Ribbon Tape Quilt* (2006) is a classic example. Within this mostly white, abstract studio quilt, there are sparse ribbons of color that pop up unexpectedly. These very much emulate actual ribbons fluttering across a sea of white.

Another studio quilt, titled *Dimension Quilt* (2003), is created with unusual synthetics and tiny bits of Yoshiko Jinzenji's commercial cottons which are crafted into masterful abstract pieces. Some of these pieces resemble stairs to nowhere, others resemble long steel beams or rail-thin strips, and others are simply random splatters of tiny dots. The balance of these items, which are cast on a vivid bronze background, are perfectly balanced and offer wonderful elements of intrigue.

These minimalist quilts require patience and personal experience to truly appreciate. The artist has removed extraneous color and cleared the design of clutter, techniques that Akiko honed after three decades of working and studying with her mentor.

These incredibly refined quilts draw the viewer's eye to the fine detail and exquisite technical achievement. The machine quilting stitches are impeccable, made

LEFT Akiko Shibusawa is a tangible example of the student-teacher relationship in Japan. She is a serious artist of her own accomplishment who chooses to make art that references the style of her master teacher, Yoshiko Jinzenji. In this photo, Akiko is wearing a darling, quilted coat she made herself using some of Yoshiko's modern, abstract commercially printed cotton.

RIGHT This photo shows the back of a quilt made by Akiko Shibusawa using commercially printed cotton designed by Yoshiko Jinzenji. The design for this particular fabric is envisioned as a "whole cloth," versus fabric designed for patchwork.

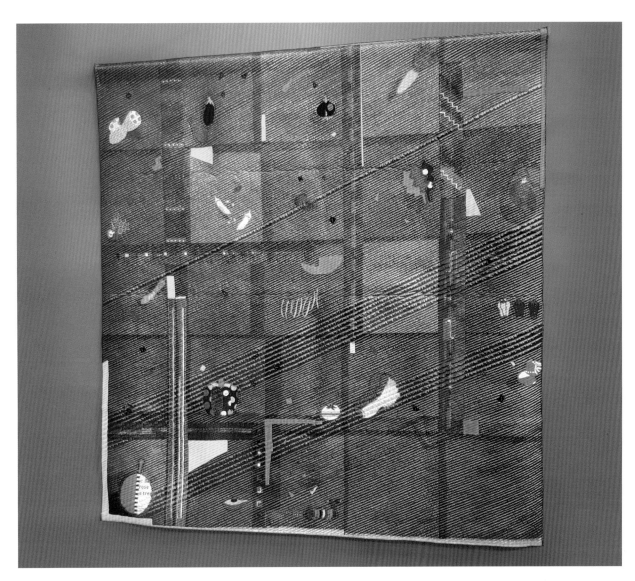

with parallel diagonal lines running across the entire quilt, with each line sitting only a quarter-inch or so apart. Given the very large dimensions of these quilts, one would assume she executes the quilting on a large long-arm quilting machine, but that is not the case. She quilts on a domestic machine and one can scarcely imagine the tremendous patience and time it must take to move this huge quilt through the machine's narrow opening to quilt one entire line from side to side.

When the viewer steps back and considers these pieces in their entirety, the quilts of Akiko Shibusawa are both striking and very special works of art and serve as gorgeous tributes to her teacher, Yoshiko Jinzenji.

TOP Akiko Shibusawa. *Transparent Work II*. 2015. Synthetics, nylon-coated synthetics, velvet, felt, and cotton designed by Yoshiko Jinzenji: 85" × 85" (215 × 215 cm). Appliquéd, reverse appliquéd, machine quilted.

BOTTOM This detailed view shows the small pieces where the printed cotton designs of Yoshiko Jinzenji were incorporated using appliqué and reverse appliqué.

TOP Akiko Shibusawa. *Dimension Quilt.*
2003. Polyester, aluminum-coated nylon
and plain nylon, velvet, felt, and printed
cotton designed by Yoshiko Jinzenji:
98" × 92" (250 × 235 cm). Appliquéd,
reverse appliquéd, pieced, machine
quilted.

RIGHT Akiko Shibusawa. *Bricks in Bars
Quilt.* 2012. Bamboo-dyed cotton,
Sumi ink, printed cotton designed by
Yoshiko Jinzenji: 75" × 90" (192 × 230 cm).
Pieced, machine quilted. The artist
created an original abstract design using
a combination of hand-drawings in Sumi
ink and printed cotton.

MELODY MILLER / COTTON + STEEL

Melody Miller is the founder of Cotton + Steel, an American company which began in 2013 and has since become one of the most successful collections of quilting cotton to ever hit the industry. The unusual hues and vintage aesthetic of the Cotton + Steel fabrics come from a collaboration between five American designers, many of whom have strong connections to Japan, and a narrative for their company that is widely promoted as made in Japan.

Long before this new start-up was launched, Melody spent about 3 years working as a designer for Kokka Ltd., a prominent Japanese fabric manufacturer. Kokka is known for their vivid, yet simultaneously restrained, sense of color, and their very modern designs. Kokka is also the producer of the celebrated Echino line of fabrics that are marketed to quilters, garment sewers, and home decorators. In fact, it was the Echino aesthetic that first attracted Melody to Kokka.

While she was delighted with the quality of the cotton fabric that Kokka produced, Melody and her colleagues at Kokka experienced language and logistical challenges that made the process a bit more difficult, especially since she was based in the US. The day to dayness of working alone, while her colleagues were in Japan, is in part what inspired her to form her new company as a design collaborative.

RJR Fabrics is the parent company of Cotton + Steel, yet Melody and the four other designers maintain control of the C+S lines. Melody had done her homework: she found the cotton textiles produced by RJR to be of exceptional quality, and so she sought RJR out to shepherd this new business.

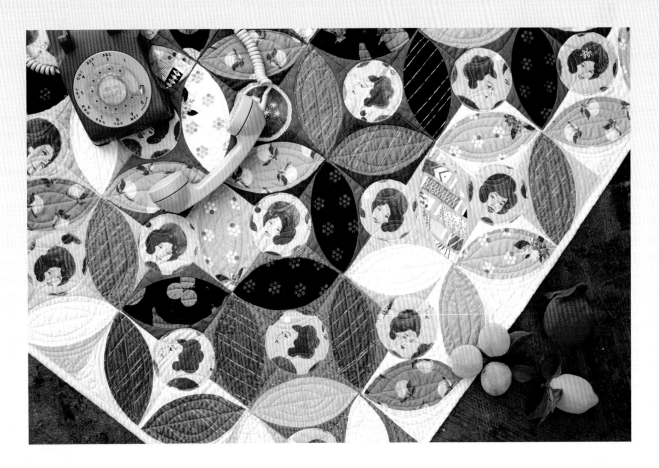

The colorful telephone and bits of fake fruit are part of the inspiration behind this quilt titled *Fruit Dots* designed by Melody Miller, the founder of the fabric line Cotton + Steel.

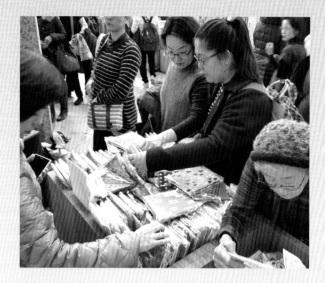

Melody lives in the Southern United States, in Atlanta, Georgia, and as such, cotton has played an important part in her family's history. Her father worked in a cotton mill as a young man, and her grandfather was employed in a cotton mill as a child. Her grandmother even worked at a Singer sewing machine factory for a time.

When Melody made her first visit to Japan to see the cotton warehouse and printing facilities where her new fabrics were being produced, she saw raw cotton that had been gathered from all over the world. She could not help but remember the connection her father and grandfather had with cotton, and now she, one and two generations later, was helping produce beautiful cotton textiles for consumers all over the world.

As of 2016, all Cotton + Steel fabric has been printed at Kurokawa-Daido, one of Japan's most esteemed printing facilities. Kurokawa is renowned for their fine line printing techniques. Melody and her colleagues, Rashida Coleman-Hale, Alexia Abegg, Kim Kight, and Sarah Watts, strongly believe that by producing their textiles in Japan, and specifically Kurokawa, they are getting the best quality available in the market today.

Melody and the other designers often hear quilters' feedback that they love the extraordinary hand of Cotton + Steel fabric, and Melody believes this is directly attributable to the extra care and expertise of the staff at Kurokawa.

The "made in Japan" element of their business model is promoted on their website, on their videos, and through social media and it is widely understood by the Western quilters who purchase their fabrics. This narrative is perhaps one partial explanation for their success, especially for quilters who have an awareness of the quality of textiles emanating from Japan.

But another explanation might also be the fact that Cotton + Steel has taken this message directly to the consumer, primarily through savvy use of social media, an advertising model that had not been used to a large extent by the fabric manufacturers prior to Cotton + Steel's success.

The commitment to this direct-to-consumer strategy, coupled with the "made in Japan" production narrative, is something the Cotton + Steel designers feel strongly about and plan to continue. All of the designers admit they have a love affair with Japan and hints of Japan can be found in many of their designs. One of the designers, Rashida, lived in Japan and her mother had a modeling career there. Alexia's mother also spent much of her childhood in Japan.

So far, the designers have been thrilled with the reception of their fabrics around the world. Of course, they hope the momentum will continue. Based on the multitude of mentions in the quilt blogosphere, the exhibits and competitions, and the numerous trade media reports, it seems that modern quilters, traditional quilters, and all those in between, recognize the unique point of view these interesting collections exude and are using them to make creative and astonishing new quilts with an ever so subtle made in Japan impression.

TOP Shoppers in Tokyo sift through a selection of precut Cotton + Steel fabrics. The five American women who design for Cotton + Steel all have strong connections to Japan and all Cotton + Steel fabric is made in Japan.

BOTTOM As of 2016, all Cotton + Steel fabric has been printed at Kurokawa, one of Japan's most esteemed textile printing facilities. Kurokawa is renowned for their fine line printing techniques.

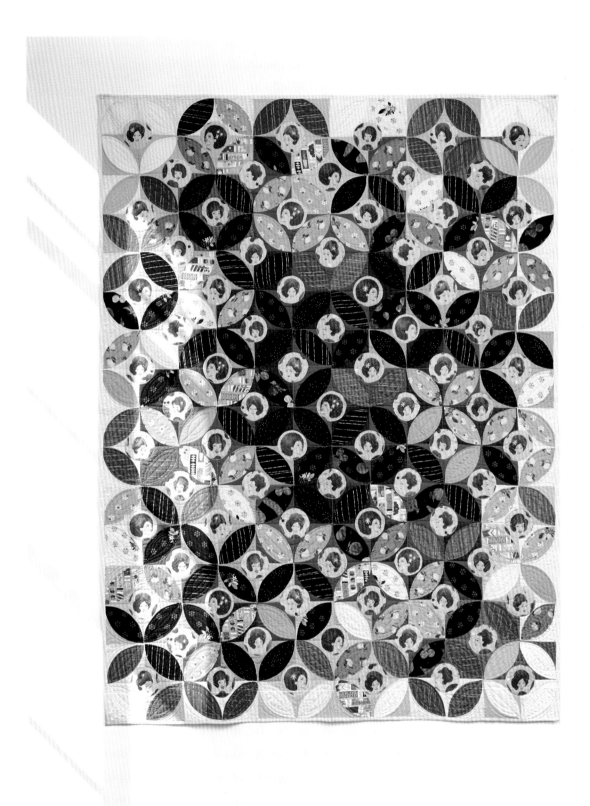

Melody Miller. *Fruit Dots*. Cotton prints designed by the artist and printed in Japan. Pieced, machine quilted.

PRINTING QUILTING COTTON IN JAPAN

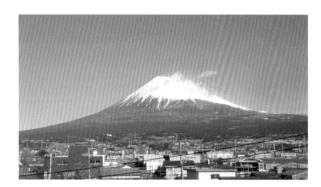

When it comes to printing textiles, it's a very fine line that sets Japan apart. Other countries endeavor to emulate Japan's quality, most notably Korea which runs a very close second to Japan. But at least for the multi-billion-dollar quilt industry, when "Made in Japan" appears on the selvedge, it carries with it the expectation that each bolt of cotton will be produced with the finest lines, the finest finish, and the finest color reproduction.

Capturing exactly why and how Japan has earned this reputation requires an understanding of an impressive series of particular nuances which, when considered in their entirety, add up to a hefty achievement unique to Japan.

Some of these nuances are human and stem from the country's deep cultural roots and an enormous respect for tradition and for each other, as well as an appreciation for fine detail. Other nuances are natural, such as water, in particular for one printer located near the foot of the bountiful Mt. Fuji, and for another who draws the soft ground water of historic Kyoto. Yet still, other nuances are technical, the consequence of centuries of history in textile arts and epitomize the very best of the modern world.

In order to explore the nuances and renowned status of Japan's textile printing industry, the author was granted extensive private tours and interviews at two of Japan's most formidable textile printing facilities: Kurokawa-Daido Co., Ltd., on the outskirts of Kyoto and Nihon Keisen Kaisha, Ltd., in Hamamatsu.

LEFT The majestic Mount Fuji is a beautiful and dominating icon. It is also an incredible source of crystal clear water, and for the nearby city of Hamamatsu, which is home to one of Japan's major textile printing mills, this water is an important competitive advantage.

RIGHT Akiko Shibusawa. *Hexagons Patch Quilt* (detail). 2007. This contemporary studio quilt features fabric designed by Yoshiko Jinzenji. It is produced by Yuwa Shoten and printed in Kyoto at Kurokawa-Daido Co., Ltd.

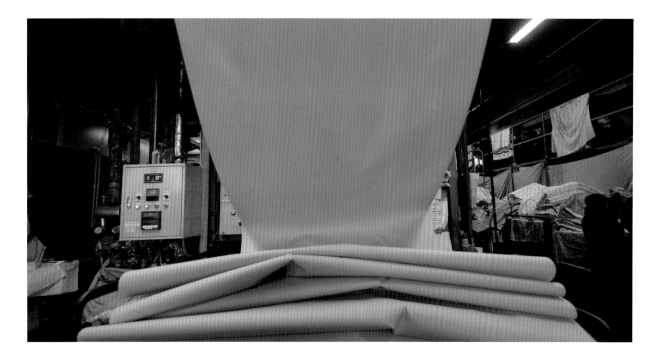

The Stencil and Screen Evolution

Remnants of some of Japan's oldest known textiles available today date back to the seventh and eighth centuries, and these bits of clothing and other items, when considered along with textile arts from the more recent past, give an indication that the people of Japan have lavished true artistry on even the most common of textiles for eons.

One thing is certain, many of the complex pattern-dyeing techniques employed throughout this prolific history were created with variations of the ever-present stencil, or cut wood blocks. These stencils (or silk screens) have been enormously influential in allowing the artist to effectively transfer a wide variety of designs to cloth, usually one color at a time. From the oldest handmade *katazome* prints to the modern cotton *yukata* and *tenugui* handicrafts being produced today, Japan exudes a deep respect for screen printing. This profound admiration for screen printing carries over to the technicians and executives of the modern-day printing mills and hints at an enormous differentiator for Japan.

TOP Gray goods, the name for milled but unfinished textiles, are being prepared for printing.
Photographed at Kurokawa's printing mill in Kyoto.

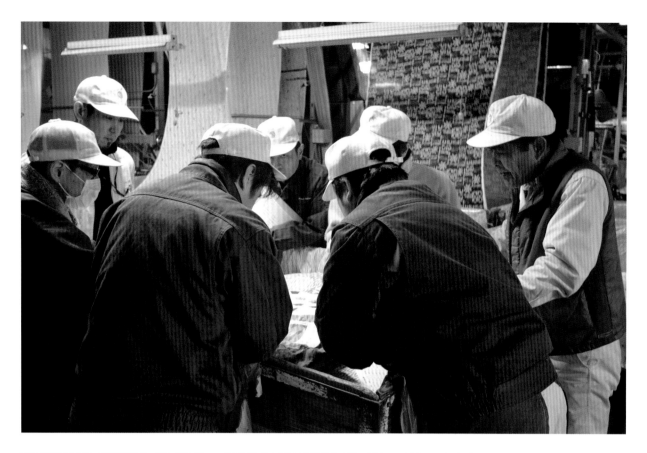

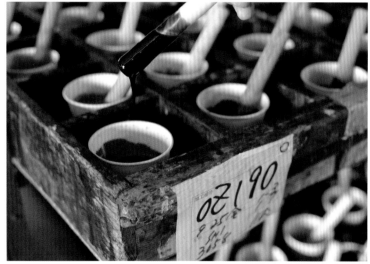

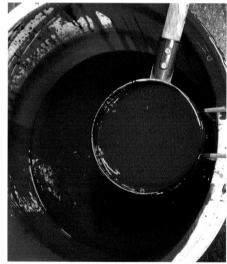

TOP The conscientiousness of the Japanese worker is a critical differentiator. Many workers at these large companies work their entire career at one place, and many senior people will continue working long past the retirement age of sixty-five. This team is reviewing their work at Nihon Keisen. The pride by which this team approaches their job stems from a deep respect and honor that is seemingly innate throughout Japan. *Photographed at Nihon Keisen in Hamamatsu.*

LEFT These small containers of printing paste (a variation of ink) are part of the "color kitchen," a highly specialized process that mixes paste to exacting color standards.

RIGHT This bucket is filled with printing paste. Once the exact color from the printer's "color kitchen" has been finalized, the paste will be mixed in larger quantities to print the textiles.

For example, the fastest and most efficient way to print large runs of quilting cotton is to use rotary printing, which is essentially an offset technique similar to paper printing. Giant cylinders hold templates that enable printing paste (a variation of ink) to be applied to fabric as it quickly moves through this system. Rotary printing is innovative, highly efficient, and three-times faster than most other methods.

But this is not how the vast majority of quilting cotton is printed at Japan's major printing mills that specialize in quilting cotton. Rather, these printers prefer a slightly slower method, that allows for meticulous control of every step in the process. Japan's finest quilting cotton is produced by a process known as automated flat screen printing. The screen used in this method is essentially an extremely high-tech version of the handmade silk screen that has been employed in Japan for centuries.

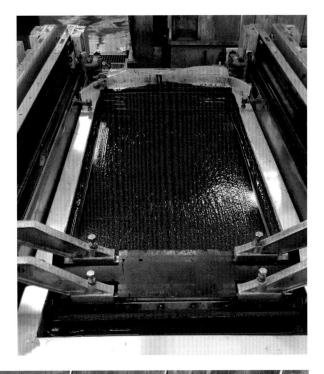

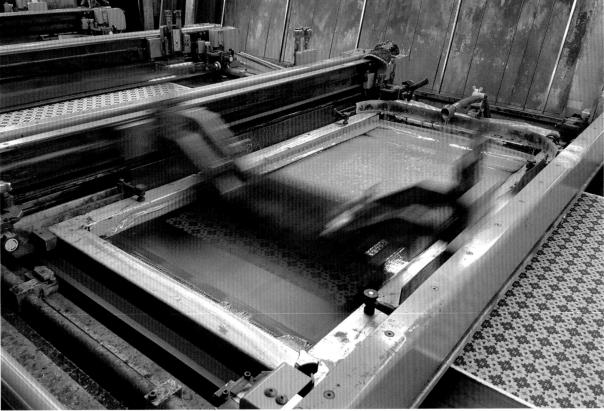

These vivid colors of printing paste are pulled across the screen by the fast and powerful squeegee at Nihon Keisen. There is one screen in the automated screen printing process for each color. As the fabric moves along the conveyor belt, a series of flat screens hover above, then lower, and the paste is transferred through the screen to the fabric. Automated flat screen printing can accommodate fifteen colors in one run. It is interesting to note that one dot for each color used is typically printed on the selvedge.

The Equipment and the Human

Nihon Keisen and Kurokawa-Daido have each been printing textiles for more than 100 years and today they are considered among the elite producers in the world of quilting cotton. The primary production route of automated flat screen printing chosen by these two printers is not necessarily the fastest, nor is it the latest technological innovation.

It is reasonable to assume that printing facilities around the world all have access to the same equipment and technology. Essentially all of the latest and most up to date printing presses and intellectual innovations are available for sale on the open market. So assuming the same equipment and know-how is available to all, it is fascinating to investigate how one company is able to rise above a competitor, or how one country can earn a reputation that separates it from another. Interestingly, in the case of Japan's top quilting cotton manufacturers and printers, the answer to this question is complex. It has little to do with equipment or technology, actually, and more to do with an artistic philosophy, dedication, and determination.

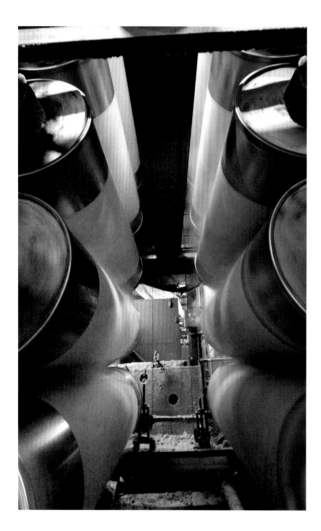

LEFT The giant, glowing rollers are part of the finishing stage at Nihon Keisen. Most fabric manufacturers and printing mills in Japan expend incredible time, money, and effort towards finishing their fabrics to make them soft, shiny, textured, lustrous, matte, or any number of desired effects. The techniques used to create the finish are proprietary and highly coveted.

RIGHT The printing process requires large quantities of water. One of the many screens required to print just one color on one fabric is being washed in an automatic washer.

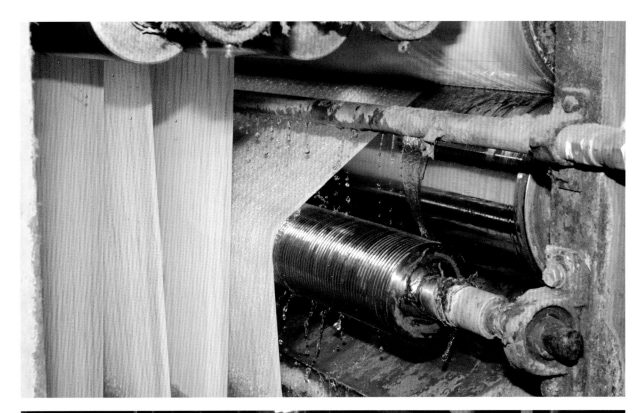

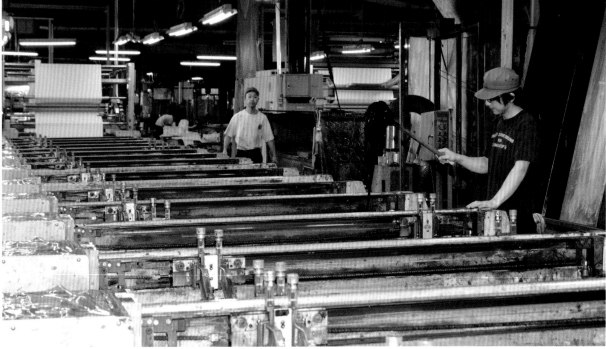

TOP Ample amounts of clear, clean water is a vital element of the entire printing process. Some colors are impossible to print without clean water and this can be a challenge for printing in less-developed counties. In this photo, water is used during the finishing process. Commercial fabrics are washed repeatedly to remove excess printing paste, etc.

BOTTOM This photo, from the large Kurokawa printing facility, shows how fabric is constantly monitored by highly-skilled technicians. These individuals add printing paste to the process by hand. Their incredibly swift movements pour exactly the right amount of paste onto the screen at just the right millisecond.

The word automated in reference to automated flat screen printing is appropriate, but this automation is also accompanied by a large component of human ingenuity. The squeegee, for example is fully automated and incredibly precise, as is the method by which the fabric moves down the production line. There is one screen for each color required and every single screen is constantly monitored by highly-skilled technicians. The automated techniques that align the registration of the various colors are incredibly precise and sophisticated, thus allowing for extreme accuracy of fine-lines, referred to as "fine-line printing.'

But the human element is hefty too, and must be carried out with precision, specifically when these individuals add printing paste to the process by hand. Their incredibly swift movements pour exactly the right amount of paste onto the screen at just the right millisecond. Too much paste and the design can be ruined, not enough paste and the color will not be properly saturated. Their efforts, when considered against the backdrop of so much twenty-first century automation, are impressive. Each company has specialties that define their reputations, with credentials they have earned over time.

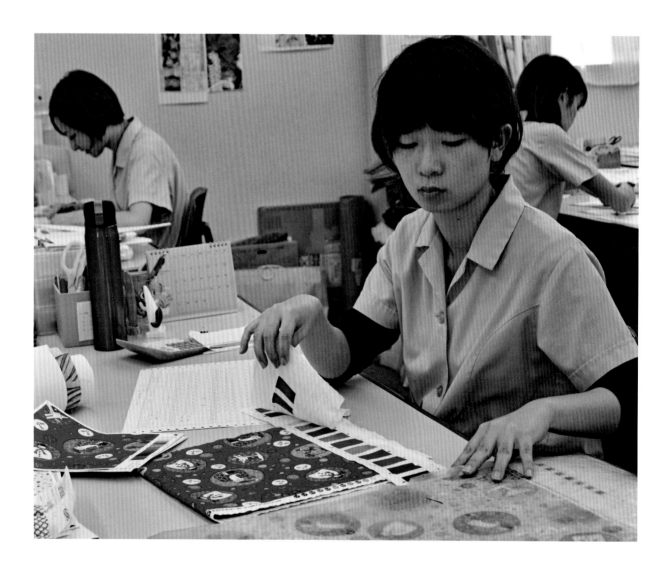

These technicians at the Kurokawa printing mill are making critical decisions to identify and match the desired colors for each design. The first step in color matching relies on a small swatch of fabric from previously printed textiles and the human eye. Next, the colors are calculated using a sophisticated, and proprietary, computer software matching system.

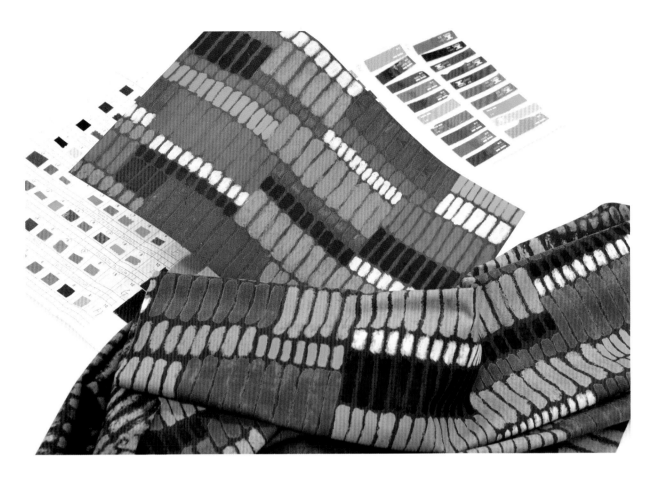

Nihon Keisen was founded in 1900. Its reputation centers on the ability to produce very sophisticated, and repeatable, color. Again, the difference comes down to nuance, but their customers have come to expect excellence in color for their finished fabrics printed at Nihon Keisen. In addition, Nihon Keisen places a considerable emphasis on communication with their customers and every step of the process is discussed and highly planned before each job begins. They also have the distinction of being the nearly exclusive printer for all of the Moda fabric that is made in Japan. Moda is one of the largest quilting fabric manufacturers and many quilters have a strong preference for Moda's cotton textiles. The company produces thousands of new collections each year and as of 2016, approximately 45 percent of all Moda fabrics are printed in Japan at Nihon Keisen.

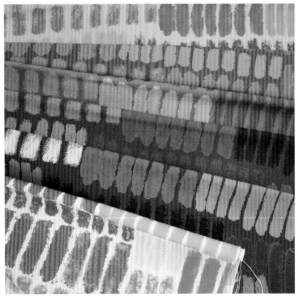

TOP Pictured here is an original drawing for a fabric design by Keiko Goke and a manufacturing work order behind it indicating a swatch of each color that will be required for printing. A sample of the final fabric showing the meticulous match is pictured here as well. Drawings and swatches like these are a critical part of the production process for designers, fabric manufacturers, and printers. *Photographed at the office of Yuwa Shoten, in Osaka.*

BOTTOM Once a pattern or design has been chosen, that same pattern or design is often printed in many different color schemes, known as colorways. This allows the quilter a wide variety of ways to use each fabric in a collection.

Kurokawa-Daido was founded in 1920 and they are credited with pioneering many of the techniques employed in the industry today. In addition, Kurokawa has perfected a proprietary technique for dealing with the join line in fabric printing. The join line happens when one screen butts up against the next; there can be an unintended line where the two meet. Kurokawa's technique essentially eliminates this line. Kurokawa also specializes in metallic printing. Metallic printing is a process that prints a particular color that looks like metal has been applied to the fabric (such as gold or silver leaf, or copper).

TOP Yoko Ueda. *Butterflies* (detail). 2016. Features commercial fabrics designed by the artist.

BOTTOM Yoko Ueda. *Rain Flowers* (detail). 2015. Cotton commercial fabrics designed by the artist, embellished.

Thus, the conscientiousness of the Japanese worker is a critical differentiator. One technique these companies employ centers on training new leadership. They have designed programs where young employees are put in positions of great responsibility, even supervising older, more experienced workers. In this way, the older people will support the young managers and their learning curve is accelerated over what one might learn in a classroom. Worker camaraderie is important and when one succeeds, all succeed. This model is altogether different than some conventional Western corporations where a young worker who is placed in a position of authority without experience or qualifications might potentially be mocked, ignored, or even compromised, an outcome that would be rare in Japan.

It is common for staff at these large Japanese printing mills to work their entire career at one place. Many senior people will continue working long past the retirement age of 65 and the pride by which they approach their job is distinctly different than what can be found in similar industries in other countries.

This pride stems from a deep respect and honor that is seemingly innate throughout Japan. Consider these examples. Taxi drivers voluntarily wear a suit and white gloves every day out of respect for their customers. Train employees respectfully bow as they enter and exit each individual car—even when no one is looking! Technicians and staff at the large printing mills have a similar philosophy, a similar code of respect, and they are constantly striving to bring honor to their job.

These small swatches of cut cloth are used to select and match colors for new printing orders. Matching colors by eye is the first step; afterwards sophisticated color matches are mixed using computer software.

Printing and Water

The printing process requires large quantities of water, and Japan's climate, geography, mature infrastructure, and extreme care for the environment are a distinctive advantage for the textile industry.

Both printers explain that access to water is critical, but it must be the right type of water. This is a primary reason why their facilities are located where they are. Nihon Keisen's plant sits near the foot of Mt. Fuji and as such, they have ample clean water that flows from this mostly snow-capped volcano. Kurokawa, located in Kyoto, is also in the vicinity of snow-capped mountains and has access to clear, soft ground water. Crystal clear, soft water is required to produce vibrant colors, and in fact, it is impossible to print some colors at all without extremely clean water.

Not all countries where textiles are printed have access to the same quality of clean water as Japan, so this is a clear advantage.

The Mysterious Finish

Yet another astonishing differentiator is the amount of time, effort, and cost that is expended on "finishing" printed fabrics for the quilt industry.

When bolts of cotton are aligned on the shelves of quilt shops, one can feel subtle differences between one fabric and another. For example, one fabric might feel luxuriously textured and dense, while another might feel incredibly soft and paper thin. These differences are known as the hand of the fabric. The most obvious assumption is to surmise that a fabric's hand comes primarily from the quality of the cotton and the thread count. In the case of Japanese cotton, the thread count can in fact be a partial indicator of higher quality, as many textiles produced for the Japanese market, (but certainly not all), are produced with a higher thread count than textiles for consumption in other countries.

But while cotton quality and thread count of the base textile is important, this is not the most relevant factor in distinguishing one fabric from another. It is actually the finish, or the final treatment, that gives quilting cotton its hand.

Most fabric manufacturers and printing mills in Japan expend incredible time, money, and effort towards giving their fabrics the most beautiful hand achievable. It is a constantly evolving process of experimentation and innovation to find the best solutions and there are a wide variety of techniques employed to create many categories of "finishes." These techniques are proprietary and coveted as powerful competitive advantages. In fact, each company's specialized finishing techniques are as closely guarded as the technology in a new Apple iPhone.

Masahiko Sotowa, the president of Yuwa Shoten, explains the finishing process this way. Yuwa could just print the fabric and leave it, but that would never work. When a quilter buys fabric, they will ultimately use it to make something precious, something they will cherish. So Yuwa believes that since quilters will typically put their heart and soul into making a quilt, they deserve the very best fabric with the best hand that is worthy of their efforts.

This line of thought, and the constant pursuit of quality, permeates the "made in Japan" industry.

Basic finishes can be permanent, durable, semi-durable, or temporary and these are accomplished by the printer using either mechanical processes or chemicals. The type of finish will determine how the fabric feels when it is new and also how it performs over time when it is laundered, ironed, sewed, or otherwise used by the consumer. For example, some finishes can enhance the textile's ability to hold a crease, an appealing benefit for quilt construction. In order to accomplish this ability to hold the crease made by an iron or even finger pressing, the special finish adds a type of memory to the fibers of the cloth. In some textiles, this memory will be eliminated when the cloth is laundered, but in other examples this memory, or finish, will withstand multiple washings. This is part of the reason that millions of quilters are divided into the "pre-wash everything" camp or the "never pre-wash" camp. Some quilters prefer to wash first in order to know how their fabric will perform after multiple washings before they begin constructing a quilt; others prefer to work with new cloth that has not been washed in order to preserve the benefits of these many special finishes.

Another typical finishing effect is a special luster that is added to the cloth that can be retained, even after the cloth is ironed. Other finishes can completely transform the material. Flannel, for example, starts out as a somewhat ordinary fabric, and the soft, thick "flannel" effect is achieved by specific finishing techniques.

Ultimately, there are hundreds of variations of finishes that can be applied to cotton textiles, and it's common for more than one finish to be applied to quilting fabric.

LEFT Hand-dyed works of art, such as this antique *tenugui*, were created by artisans using the all-important screen process. Japan has been creating screens for centuries. Today's modern, flat-screen textile printing stems from this long and illustrious history of carefully crafted textiles created from hand-made screens. The iconic image is a *daruma* face. The *daruma* is a good luck symbol and *daruma* dolls are a popular talisman to help Japanese stay focused on their goals. *Image courtesy of Ichiro Takizawa, Tokyo Wazarashi Co., Ltd.*

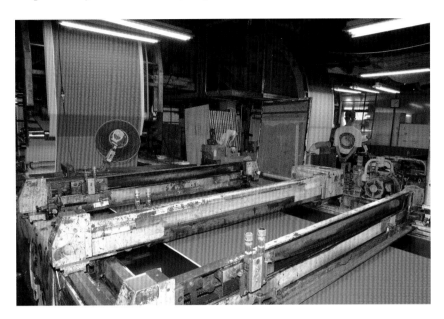

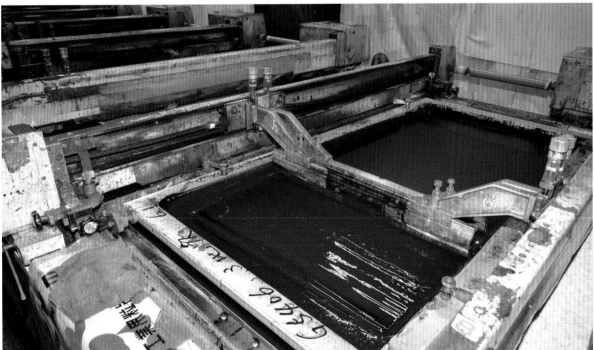

TOP LEFT This intense and vivid orange is seen here just moments after progressing through the sophisticated automated flat screen printing process at Kurokawa-Daido Co., Ltd.

TOP RIGHT & ABOVE This rich red color is being applied by a process known as automated flat screen printing, and Kurokawa believes that this method of screen printing allows for meticulous control of every step in the process.

Most quilters are in it for the fabric. They love the colors, the patterns, the designs, the possibilities. Some quilters love their fabric so intensely that they could not possibly cut it. Instead they make purchases, lovingly fold it up, and there it sits on a shelf, coveted like a fine collector's item. Other quilters use all their fabric and even treasure and use every single scrap. Most quilters fall somewhere in between.

Regardless of where an individual quilter falls in this spectrum of adoration and utility, there is a long and complicated process that quilting cotton undergoes before it reaches the consumer. Understanding how this cloth is made can further reinforce one's appreciation for fine fabrics.

The automated flat screen printing system is a popular process for quilting cotton printed in Japan.

Other printing methods are also used. These include roller printing, duplex printing, rotary screen printing, and digital printing.

The automated flat screen process, while slightly slower than other methods, has the advantage of producing precise, intricate designs with complicated registration, known as fine-line printing. Automated flat screen printing also allows for sophisticated and superior applications of shading and other special effects.

Here's how the beautiful cotton fabrics made in Japan for the quilt industry are printed and finished using the automated flat screen method.

STEP 1 / Gray Goods
Newly manufactured textiles, called gray goods (sometimes referred to as greige goods), are purchased. Gray goods are textiles that have just come off the weaving loom, essentially virgin cloth that has not been mechanically or chemically treated. Cotton gray goods are off-white, sometimes beige or gray, and look natural and imperfect. Depending on the quality, the weave can be uneven and the surface has texture.

Automated flat screen printing is achieved essentially through the same motion used with a handmade silk screen. The screens are typically made of silk, nylon, polyester, vinyl, or metal.

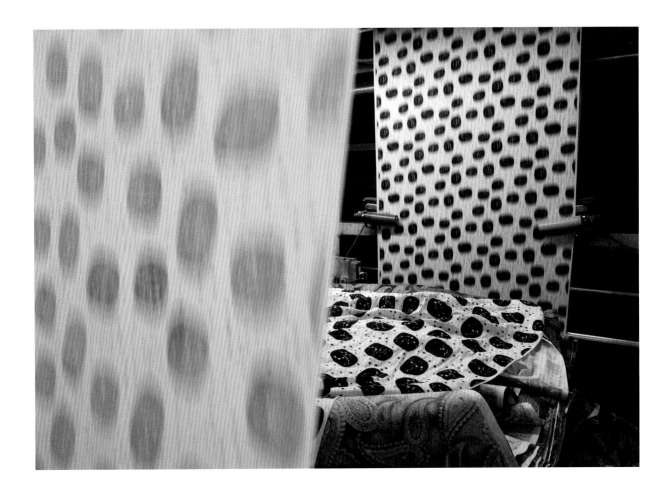

Once gray goods arrive at the printing mill, they are inspected, sorted, and sewn together to form extremely long trains of continuous fabric.

Gray goods used in Japan's textile printing industry in the twenty-first century are primarily milled in other countries and imported by the fabric companies or the printing mills. Some gray goods are milled in Japan. A small number of fabric manufacturers purchase domestic gray goods for special collections because of their higher quality.

STEP 2 / Singeing
Gray goods go through a singeing process. Singeing is a process that uses either flame or heated plates to remove any roughness on the surface of the cloth, such as protruding or excess threads. Singeing ensures the surface of cotton cloth will be completely smooth to prepare it for printing.

STEP 3 / Scouring
The cloth goes through a scouring process to remove any impurities, such as natural wax, seed fragments, dirt, or sizing (sizing is similar to a thick starch). As the yarn (or thread) is prepared for weaving, sizing (or size) is added to the yarn to provide strength. Before printing, the sizing must be removed.

STEP 4 / Bleaching
Fabric is bleached pure white to prepare it for printing. Bleaching involves a series of bleach baths, then the fabric is dried and smoothed as it goes through a series of heated rollers.

STEP 5 / Mercerizing
Newly bleached fabric is mercerized, which involves stretching the fabric and then immersing in a special solution. This process causes the individual threads in

When "Made in Japan" appears on the selvedge of cotton fabric, it carries with it the expectation that each bolt of cotton will be produced with the finest lines, the finest finish, and the finest color reproduction. Here at Kurokawa-Daido, newly printed fabric flies through the finishing process and eventually will undergo an extensive inspection before being shipped to customers.

the textile to be permanently reshaped, or swollen, in order to fill in any miniscule gaps in the weave and give the fibers a more lustrous, or silky, sheen. Mercerization also improves the ability of the textile to absorb the printing paste (a variation of ink).

STEP 6 / Tentering

Tentering stabilizes the fabric and sets the final permanent width. The fabric passes through a series of extremely hot chambers and the cloth is held taut at the edges. As it moves through this high heat, the tension adjusts the warp and weft threads and realigns the cloth to its permanent width. Tentering also removes wrinkles.

STEP 7 / Screen Printing

The fabric designer's artwork is separated into colors and one screen for each color is created. The screens are made from silk, nylon, polyester, vinyl, or metal. The screen is stretched on a frame.

The printing pastes are mixed and prepared for printing in the "color kitchen." Prior to the actual production, the printing mill and the fabric manufacturer/designer would view and approve "strike offs," which are test swatches prepared in small batches. Any color corrections or changes are made during this pre-production stage.

When the full-scale production begins, extremely long trains of continuous fabric are placed on a conveyor belt. A series of flat screens float above the fabric. As the fabric stops, the screen is lowered. A squeegee passes over the fabric and pushes printing paste through the screen onto the textile. Only certain parts of the screen (or design) are open to allow the color to transfer to the cloth. The parts where no color is desired are blocked. As the fabric progresses, the next screen will apply the second color, and so on. One dot for each color used is typically printed on the selvedge.

Automated flat screen printing can accommodate fifteen colors in one run. On rare occasions, some fabric designs will require more than fifteen colors and these would go through a second production run.

STEP 8 / Drying

After printing, the fabric moves through a drying process, then it is steamed to set the colors.

STEP 9 / Finishing

Fabric moves to the finishing stage. The first step involves a series of steam and wash treatments to remove any excess printing paste and ensure the fabric is colorfast. Afterwards, the fabric goes through a series of proprietary finishing processes that enhance the hand by making it either soft or textured, shiny or matte, lustrous or glossy, stiff or relaxed, or any number of desired effects. There are hundreds of variations of special finishing techniques.

STEP 10 / Calendaring

Most quilting cotton goes through a calendaring process as the final step. A calendar is a machine with a series of very heavy rollers that can be used to create a variety of finishes. In simple terms, the calendaring process is a bit like a giant, high-speed iron, although calendaring methods can be either hot or cold. Calendaring produces a perfectly smooth cotton textile. Most quilting cotton is treated by cold calendaring which produces a smooth surface with a light luster, but no shine. Heat calendaring can produce a high-gloss finish. In many cases, the effects of calendaring will be removed after the fabric is washed. However, some fabrics are pre-treated with a resin chemical that can extend the life of the calendaring treatment significantly.

JAPAN'S
QUILT FABRIC MANUFACTURERS

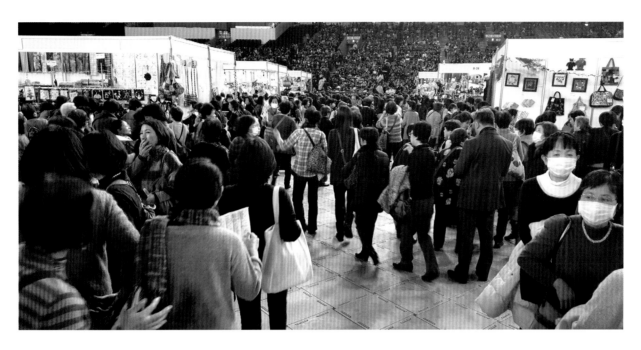

For the most part, the fate of the fabric designer is uniquely tied to the fabric manufacturer. It is the manufacturer who takes these treasured designs and brings them to life in a large scale, commercial setting.* The manufacturer invests the funds to acquire the cotton and decides what level of quality that cotton will be. The manufacturer also pays for the printing, shipping, etc. and finally, distributes the fabric to consumers. In some cases, the designers will participate in these decisions, but not always.

The following section introduces a subset of Japan's top fabric manufacturers chosen by the author. Each company specializes in quilt textiles and their products are exquisite. The fundamental consumer market for these manufacturers is Japan, and in fact, some of their most precious fabrics can only be found within Japan.

However, each company has established a global presence and they work diligently to expand their international sales. Partnering with well-known quilters to design quilt fabric collections is part of the answer to introducing global quilt consumers to the remarkable textiles these companies work so diligently to produce.

*Technology is rapidly evolving and there are multiple options for fabric designers to produce their designs directly, specifically using digital printing. This option is primarily geared toward smaller-scale production models and access to affordable, high-tech digital printers through the Internet can enable a designer to print fabric, and sell it, without the representation or support of a fabric manufacturer.

The popular Tokyo International Great Quilt Festival is a massive opportunity for Japan's fabric manufacturers and designers. More than 200,000 people attend the week-long event, held annually in the Tokyo Dome. Shoppers come from all over Japan, and the world, searching for the newest fabric collections, as well as antique textiles, sewing and quilting machines, notions, and many other items.

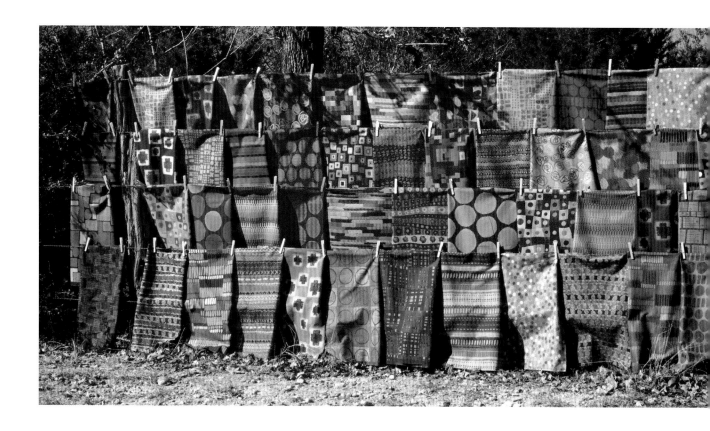

Yuwa Shoten Co., Ltd.

Headquarters: Osaka
Raw Cotton: China, other countries
Gray Goods: Some shirting and sheeting
is milled in China. Some cottons and high-end
lines are milled in Japan.

Yuwa is perhaps one of the most interesting fabric companies in Japan. Interesting because of their approach to the business, interesting because of their somewhat eclectic product mix, and interesting because of their passionate dedication to the quilting customer.

Yuwa is known as the producer of lovely, pastel florals and romantic prints. This palette is soft, conservative, and appealing to a large population of Japanese quilters. Yoko Ueda is one of the quilt artist and designers whose dreamy floral prints are part of the Yuwa portfolio. But these designs are by no means ordinary. In fact, Yuwa is constantly thinking outside the box. For example, Yuwa partnered with a museum in Mulhouse, in the Alsace region of France, to reproduce a series of gorgeous eighteenth century French florals based on a fabric swatch book from 1902. The inspiration for this unique collaboration came not only from the antique textiles, but also from European flowers,

drawings, greeting cards, and clothing. A beautifully produced book documents this special collaboration between a museum and a fabric manufacturer, and it is further evidence of the ways in which Yuwa is constantly seeking to keep their collections fresh.

Their business approach is perhaps quite different than their competitors. Yuwa starts with the finished design, and then works backwards to determine how the fabric will be produced. The first question is: how will the customer use it? Once Yuwa settles on a direction, they choose whether the fabric will be cotton, linen, etc. Then a supplier and printing process is chosen. And the decisions continue from there, always keeping the customer and end use at the forefront. In addition, Yuwa sources a portion of their unfinished textiles (gray goods) from mills in Japan which rely on higher quality raw cotton, another factor which contributes to the astounding quality of their printed quilting cotton. Yuwa also imports gray goods from China.

As for portfolio, Yuwa is the producer of fabric lines from two of Japan's most innovative fabric designers: Yoshiko Jinzenji and Keiko Goke. Their quirky and abstract designs are a world away from the lovely and conservative florals and prints that Yuwa is known for. Keiko Goke designs extremely vivid, colorful contemporary fabrics. Yoshiko Jinzenji is at the

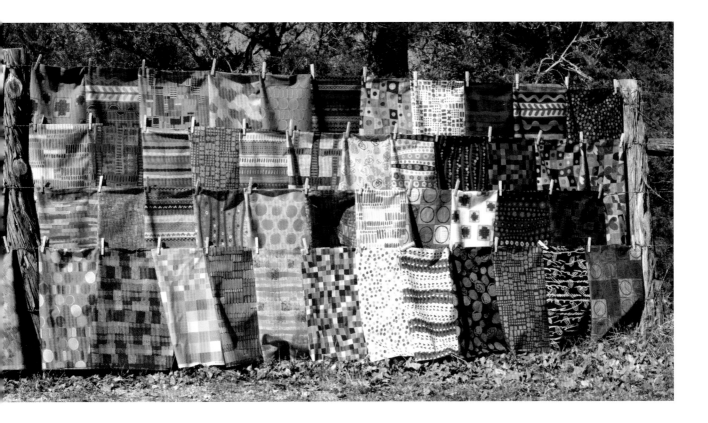

forefront of avant-garde and her fabrics are very minimalist designs, light on color and big on abstractness.

Yuwa's philosophy is that the customer expects, even deserves, good quality and Yuwa cannot let them down. Price and quality are a constant balance for every company, but Yuwa admits that there are many instances where they print extra colors, and add even more steps to the finishing process, sometimes at additional cost, in order to make the fabric just a slightly better color, or softer, or more luxurious, whatever they feel the customer will treasure most.

Keiko Goke typically designs one new fabric collection per year and as of 2016, she has approximately fourteen collections. This photo (taken in 2016) includes most every print in her entire collection and highlights her artsy and meticulous palette, as well as her quirky design aesthetic. Quilt shop owners from all over the world including Australia, Europe, the US, the UK, Taiwan, even Indonesia, often contact her about the opportunity to sell her fabrics, and she is thrilled at this positive international response. This fabric is manufactured by Yuwa Shoten and printed at one of Japan's most historic and renowned textile printers, Kurokawa-Daido Co., Ltd., on the outskirts of Kyoto.

Kokka Ltd.

Headquarters: Osaka
Raw Cotton: China, Pakistan
Gray Goods: Majority are milled in Japan. Some are sourced from China, Pakistan.

Kokka Ltd. focuses most of their attention on the garment industry and home decorating. Quilting is considered a secondary market. That said, Kokka is known and loved among a small collection of Western quilters who are aware of the very popular Echino brand, which is a collection of cotton prints with a modern, funky aesthetic. This mix of modern and funk is somewhat typical of the whole Kokka portfolio. Kokka also manufactures Nano Iri. Many designs in their popular collections are uber contemporary and also somehow quite unique. Kokka describes them as very Japanese. One differentiating factor of Kokka fabrics is the hand and the quality of the cotton. The vast majority of Kokka's gray goods are sourced from Japanese textile mills. This dedication to using high-quality cotton goods that are milled in Japan certainly contributes to the distinctive hand and astonishing quality of Kokka fabrics.

Lecien

Headquarters: Osaka
Raw Cotton: China
Gray Goods: China, Pakistan
Woven: Made in Japan

Lecien is owned by Wacoal Holdings Corporation. Lecien is perhaps best known to quilters as the company that produces fabrics designed by Yoko Saito. The company produces fabrics by other designers as well. Most of Lecien's quilting cotton portfolio is in the taupe palette and they make woven fabrics and printed cotton.

Lecien is also supportive of Japan's domestic handicraft weaving industry. In partnership with Yoko Saito, Lecien has commissioned two woven collections (2009 and 2016) from *Kameda jima* weavers in Niigata Prefecture which have been popular with quilters worldwide.

Daiwabo Text Co.

Headquarters: Osaka
Raw Cotton: Mixed sources
Gray Goods: Mixed sources
Woven: Made in Japan

Daiwabo is a well-established textile company whose fabrics are sold internationally. Their signature product is yarn-dyed woven fabrics, and they produce beautiful cotton printed textiles as well. Daiwabo is meticulous about the yarn that is chosen for their woven fabrics. The yarn is made with imported cotton. All of Daiwabo's woven textiles are produced in Japan. They rely on weaving companies located in some of the same regions where traditional weaving skills have been handed down through the generations.

Daiwabo's patterns are based on traditional Japanese and European designs. Each color in the company's popular taupe palette is enhanced by multiple layers of color under-neath it in order to add depth and intensity. This is true for both woven and printed fabric. The company feels this layering of color, coupled with extra effort on the hand of the fabric, produces the finest fabrics for the quilt industry.

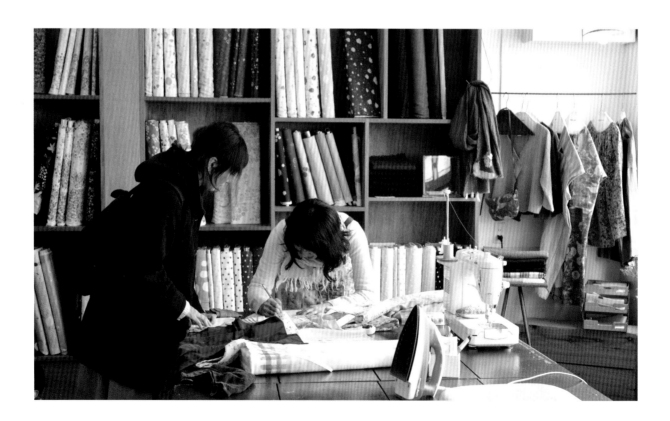

Japan's specialty retail model is dominated by very small stores who cater to specific markets. This particular garment and sewing boutique sells soft cotton florals designed by Nano Iri, a brand manufactured by Kokka. Its small size and knowledgeable staff allow for ample interaction with customers.

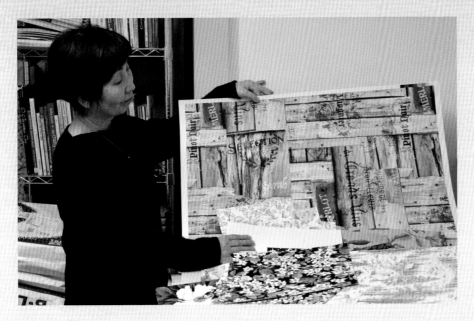

Moda & Moda Japan

Headquarters: Dallas, Texas
Raw Cotton: United States, China, Pakistan
Gray Goods: Pakistan

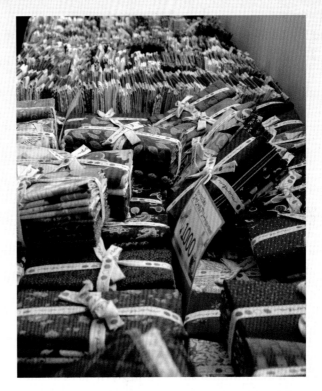

Moda is one of the largest fabric companies in the world. Their primary focus is the quilt industry. Moda is headquartered in Dallas, Texas, yet Moda conducts a significant portion of their business in Japan. Approximately 45 percent of all Moda fabrics are printed in Japan. Moda produces around 100 groups of fabric each year and contracts with roughly forty-five fabric designers working in several countries. Moda fabrics are sold in thirty-three countries. Moda Japan is the branch of the company that distributes Moda fabric domestically.

Moda's "made in Japan" fabrics are printed almost exclusively at Nihon Keisen, a relationship that began in the early 1990s. Moda explains that the decision to print fabrics in Japan is based purely on quality. They consider the specific requirement of each line, and make decisions on where to print based on requirements for color, finish, and other related needs.

To facilitate their Japanese business activities, Moda has a unique arrangement with two related entities, K TEX Co., Ltd and Pixie Studios, headed by Kimikazu Nishimura and Pixie Onishi. Both work exclusively with Moda. Pixie Studios, which is based in Osaka, has a team of designers who create quilting designs that are imaginative and endearing. Many Pixie Studio collections end up becoming popular choices for Moda customers.

BOTTOM Hundreds of patterns and colors are lined up for quilters to choose from at one of Moda's retail stores in Osaka. This innovative neighborhood boutique features a warm and inviting coffee shop downstairs and a small retail and sewing space upstairs.

COTTON

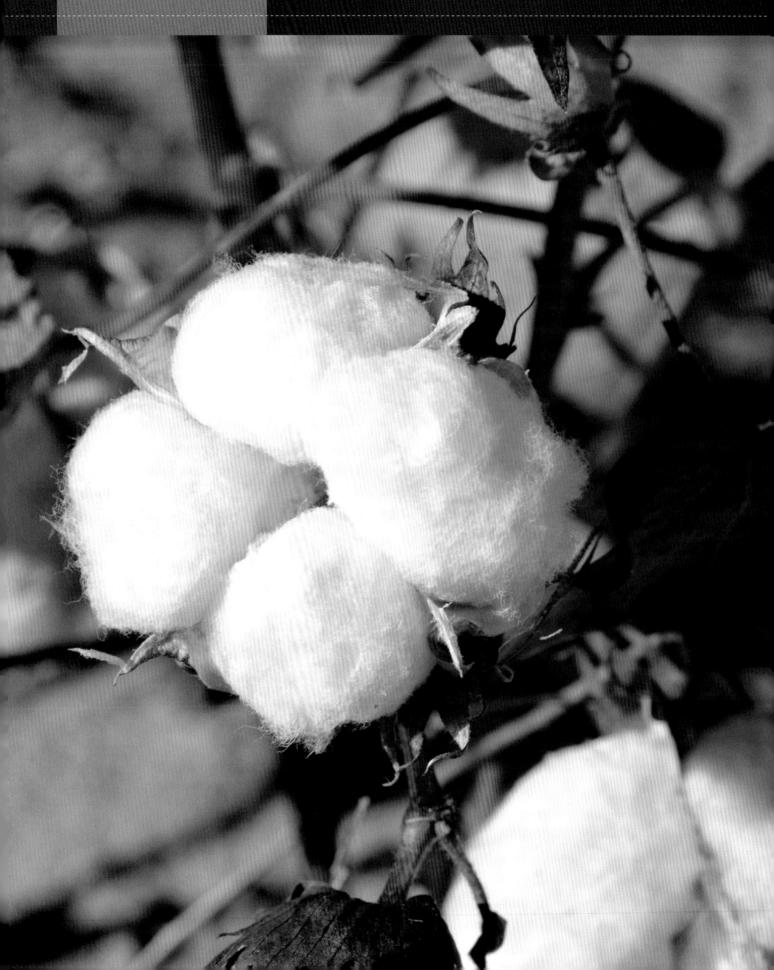

Cotton has been prevalent in Japan for around 600 years and has played an enormous role in the country's culture and traditions. Exotic cotton textiles were first ferried to Japan from China in the fourteenth century, creating a high demand for these exquisite fabrics. Before long, Japan went into full-scale import mode. The rich and powerful treasured these decorated and celebrated Chinese fabrics and they commissioned extraordinary clothing, costumes, and vestments made of cotton. Once cotton fibers became readily available, common folk were also captivated by the possibilities of this new and unusual fiber and eventually learned to lavish incredible talent and taste on everyday cotton work clothes and other useful items.

Farming too was forever changed. Recognizing the value and opportunity of this fresh new fiber, family farms began experimenting with growing cotton and by the mid-1600s, a brand new cottage industry was born. Peasant families, who could not afford fancy imported textiles, could now make their own cloth from cotton grown on their own land.

The feudal lords of Japan's Edo period (1603–1868) held all the power, and they ruthlessly regulated commerce and daily life. These rulers saw to it that farmers only farmed, dyers only dyed, weavers only weaved, and merchants were the only ones authorized to transact sales. Small-scale cotton farming changed some of this rigidity. For the first time, a farm family could grow its own cotton and then spin it, weave it, wear it, sell it, or trade it. That meant that farmers, spinners, weavers, and in some cases even merchants, could all be found living under the same roof. A new social structure was born and this societal reshuffling benefited families by allowing them to earn extra money from their home business. It also changed commerce by creating new paying jobs for peasants who did not own land.

Yet, the cities' elite and powerful lords still exerted enormous influence. In 1660, they banded together and formed the very first cotton trade group to regulate the new cotton economy. Cotton remained heavily regulated for the next 300 years.

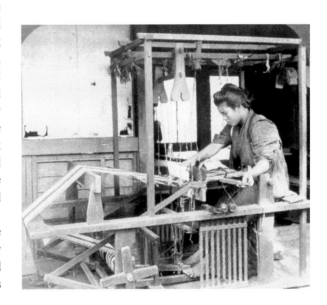

TOP A woman dressed in a cotton kimono featuring a traditional checkered pattern in a cloth known as *Ise momen*. The kimono is made from a hand-crafted, yarn-dyed woven cotton from the Mie Prefecture region of Japan using 100-year-old mechanized looms. The thread is spun in Japan from imported American cotton.

BOTTOM This woman is weaving cotton on a farm in 1904, during a time when many farmers would grow small amounts of cotton and weave it for their own use or for sale. In this photo, the weaver is barefoot and her kimono sleeves are rolled up so she can work. The loom's shuttle is in her hand and she is about to pass it through the warp threads. *Courtesy Nagasaki University Library.*

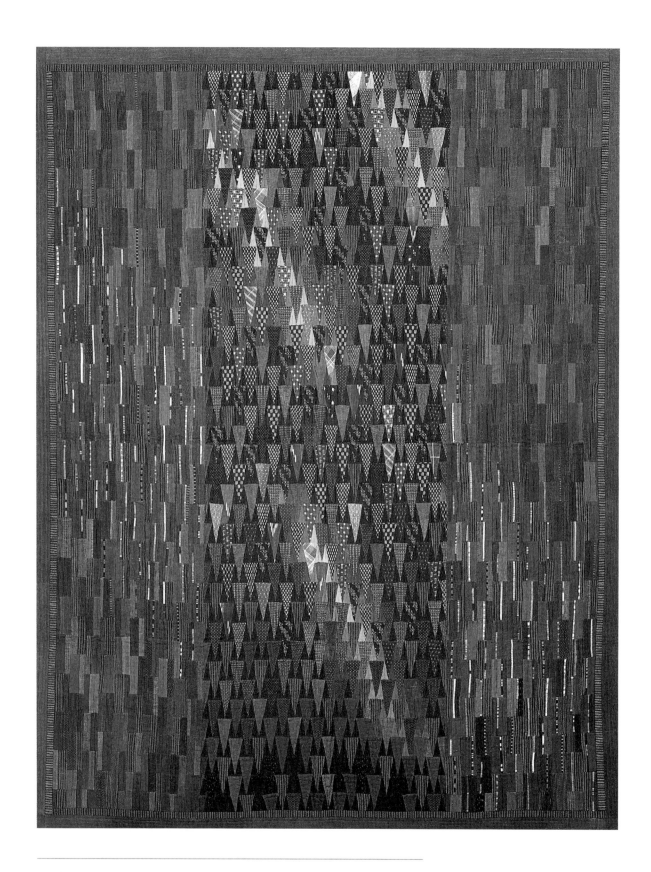

Tamiko Mawatari. *Encore*. 2008. Antique cotton: 89" × 69" (227 × 176 cm).
Pieced, hand quilted. This stunning, richly-colored quilt, with its unusual geometric
pattern, is made with several types of antique cotton, including woven fabric, *kasuri*,
and indigo-dyed pieces. The artist has been working with traditional folk textiles
for many decades and she is well versed in how to find the best selection of
cotton from Japan's many antique dealers and markets.

While the domestic farming and weaving industry was still finding its roots, the wealthy families of Japan maintained their huge appetite for rare and exotic imported textiles, especially during the Edo years. But these shrewd intellectuals saw an opportunity to be more than just a passive importer of finished textiles.

Japan's sophisticated merchants were already actively trading routinely with China, Korea, and other Southeast Asian nations, but eventually they went a step further and came to own and operate their own cotton empires. Japanese businesses set up numerous expatriate cotton farms in China and Korea and brought this raw cotton back to Japan.

Japan also traded cotton goods with the West. In fact, the famed traders of the Dutch East India Company, which formed in 1602 and is believed to be among the first truly global establishments, were the most prominent Western traders in Japan, even throughout the Edo period when Japan is assumed to have been a closed country. The Portuguese, Spanish, and other European countries were in fact excluded, and large swaths of Japan's population lived in isolation, but trading was rampant during these years. The Dutch were allowed to remain, so long as they made their trades from Dejima, a small island off the coast of Nagasaki where they were confined.

TOP This map of Japan was first published in the Netherlands in 1655, during Japan's Edo period. *From the National Library of the Netherlands, courtesy Wiki Commons.*

BOTTOM The Dutch East India Company was a powerful global entity that retained trade relations with Japan during the Edo period when most other Western nations were excluded. Trade was conducted from a small, man-made island near Nagasaki. The three-masted, most sophisticated ships of their time depicted in this historical illustration, belonged to the VOC, or Dutch East India Company. *Courtesy Wiki Commons.*

Cultivating a Cottage Industry

By the mid-1700s, cotton became a common domestic crop, especially in the Kansai region (Osaka, Kyoto, Kobe, and Nara). This intriguing new commodity lured entire villages and powerful city merchants to pursue the enormous possibilities of cotton.

The years between 1760 and 1786 are considered the golden years, the epoch of Japan's cotton weaving days. It was common for nearly every household to have a loom, and in 1773, in the city of Hirano alone there were 2,000 households involved in cotton processing and trade. Peasants, and even professional weavers, dyers, and stitchers, were influenced by exotic foreign patterns and motifs and they incorporated these into their own traditional designs. In doing so, they created entirely new handicrafts, some of which are still celebrated today.

These years also gave birth to a new and modern industrialized textile industry, primarily in and around Osaka. The prevalence of fresh, soft water, easy access to sea ports, and the concentration of commercially-minded prominent families all converged to enable Osaka to be labeled the "Manchester of the East," the epicenter of Eastern textile trade.

A world away from all the flurry in Osaka, the vast majority of Japan's rural folk during these years primarily lived a quiet life in isolation from international influences.

Women were expected to learn expert weaving skills and these skills were considered an advantage in marriage. Cotton was a favored fiber for weaving. As these makers became more familiar with cotton, and cotton became more plentiful, an enduring domestic aesthetic took hold.

By the 1820s and '30s, sophisticated mechanized looms known as *takabata* were prevalent, and spinning and weaving became a profession. A couple decades later, the Meiji Restoration that began in 1868 unified the country and brought stabilization and growth to the textile industry. As a result, the industry expanded at an astounding pace. For example, in 1881, there were seven mechanized weaving mills in the country, and by 1889 that number had grown to 28 mills.

Osaka is a thriving metropolis filled with energy and night life. During the late 1700s, Osaka was the epicenter of Eastern textile trade and the city eventually came to be known as the "Manchester of the East." Today, many fabric companies, printers, distributors, and related companies are still located in and around Osaka.

LEFT This antique artwork is a paper-thin cotton *tenugui* depicting the face of the Great Buddha, Daibutsu. The Great Buddha is the subject of many of Japan's famous, enormous statues. *Courtesy of Ichiro Takizawa, Tokyo Wazarashi Co., Ltd.*

BOTTOM This everyday cotton jacket would have been worn by fishermen, merchants, or other workers and was made in the early 1900s. The kimono body is woven using a technique known as *sakiori*, a highly resourceful method to make use of every scrap of cotton cloth and also add durability and warmth to the garment. The weft material is made with scraps of torn cotton cloth and the warp is usually *asa* or cotton yarn.
Courtesy Yu-yu-tei, an Osaka antique dealer.

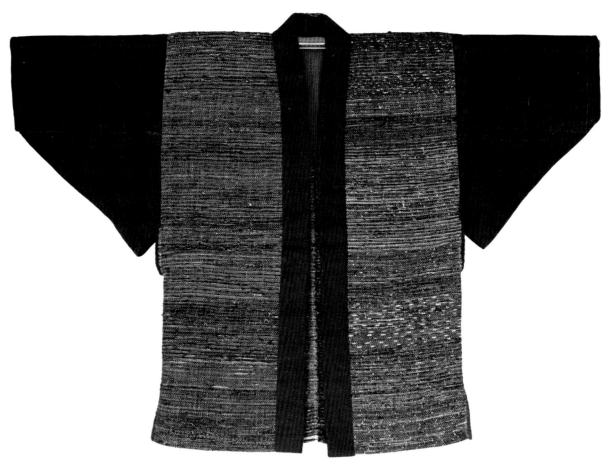

Twentieth century cotton grown in India, China, and Korea was gobbled up by the massive textile industry in Japan. American cotton entered the picture in 1896, when the Japan Cotton Trading Company became the first company to import American ginned cotton. Within the next three decades, American cotton remained extremely popular and the US and India competed neck and neck in the race to be the largest supplier to Japan. In 1935 specifically, half of all textiles made in Japan were made with US-grown cotton. In the 1940s, however, India took over as the largest supplier when US imports were interrupted due to trade disputes and other issues prior to World War II.

By 1912, half of Japan's economy was involved in the textile industry. By the time 1930 arrived, Japan became the world's largest exporter of clothing and finished textile goods (including silk, cotton, and synthetics). With regard to cotton specifically, Japan was such a dominant competitor that she exported more cotton goods than any other nation during this time period.

In the years leading up to World War II, the textile businesses gradually came under government control and the industry was eventually decimated. Much of the industrial equipment, including spindles and looms, were turned over to the military to be melted down to support the war effort. Some factories were taken over and converted to manufacture armaments. Many of the remaining textile mills were either heavily damaged or destroyed by Allied bombs.

After the war, in January of 1946, an official delegation of five representatives of the United States government, along with four observers from China, India, and the United Kingdom, traveled extensively throughout Japan in order to study and report on the status of her post-war cotton textile industry. Their report was submitted to General Douglas MacArthur, Supreme Commander of the Allied Forces, on March 31, 1946. The report, titled "The Textile Mission to Japan," outlined the decimated state of the industry and made recommendations for how to reinvigorate Japan's idle plants and restore her once renowned status as a leading exporter of cotton textiles.

Japanese industry experts and government officials, both of whom were eager to rebuild, gave their full cooperation. The whole world it seemed, and America in particular, were eager to enable the recovery of Japan's textile industry. To get the program back on track, the textile delegation, with General MacArthur's blessing, arranged for an expedited shipment of 200,000 bales of American cotton which arrived in Japan just two months later. This historic import was the first Japan had seen in a long time and those 200,000 bales of American cotton jump-started the entire textile restoration.

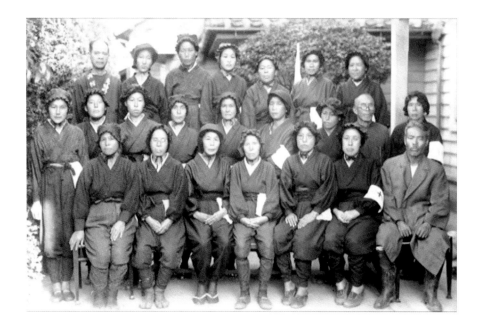

In 1944, during the war years, this women's volunteer organization is pictured during an air-raid drill outside a hospital near the Kitō region in Saga Prefecture. They are wearing traditional cotton clothing, including *monpe* pants (which are loose fitting with a drawstring at the waist and ankles). Their cotton bonnets are padded and quilted for protection. *Courtesy of the family of Yuriko Sakuraoka.*

Revitalizing the textile industry was a major tenant of the Allied Occupation economic plan, primarily because it was viewed as an acceptable and desirable alternative to any other heavy industry, such as anything related to armaments. But there were other benefits as well. Rebuilding this once vital industry not only provided a considerable market opportunity for American-grown cotton, but it also helped restore the worldwide shortage of cotton textile goods. These savvy and swift initiatives succeeded and finally, by 1951 Japan had once again regained her status as the world's largest exporter of cotton textiles, a position she held until 1967.

During the 1980s and 90s, the textile industry in Japan began evolving and many textile mills closed. Their world market share was taken up by other countries who could produce goods more cheaply, taking Japan's mills down the same path the textile mills in the United Kingdom and the United States suffered as well. While Japan remains a formidable competitor in textile printing, particularly for the quilting cotton industry, the vast majority of base textiles used in printing are now imported. However, some mills remain and a few Japanese fabric manufacturers, such as Yuwa Shoten and Kokka, still source a portion of their gray goods (unfinished textiles, also sometimes referred to as greige goods) from these domestic mills. In addition, there is a growing trend of boutique mills who are also producing specific textiles of superior quality, most of which are intended for the fashion industry. Producing cotton denim specifically is a growing trend in Japan and high-fashion blue jeans, jackets, and other denim items are being produced from domestic textiles.

Texas: America's King Cotton

Rodney Terry's farming roots run three generations deep. When he walks out the back door of his family's home, he is just a few feet away from the dusty, windy West Texas prairie where cotton is still King.

Rodney together with his parents and grandparents before him are a vital part of the network that makes Texas the largest cotton producing state in the United States. The vital connections between cotton and quilting are not lost on Rodney Terry. He realizes that the quilt community is a huge consumer of cotton and quilts are a natural part of his family's heritage. His wife makes quilts, and in his home are quilts made by his grandmother and great-grandmother.

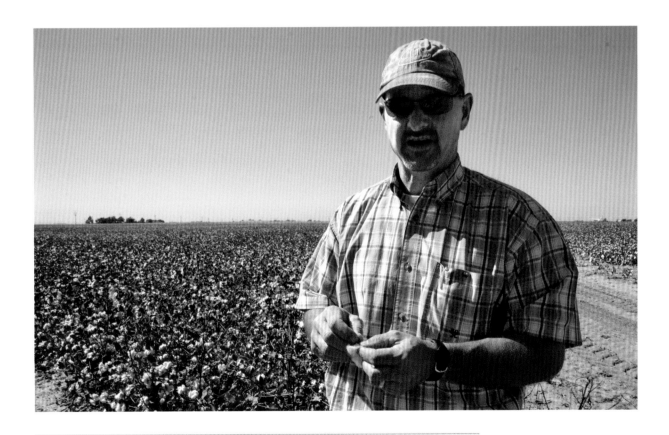

Rodney Terry is a cotton farmer in West Texas. He and his family have farmed cotton in this region for three generations. He is proud of the high-quality cotton grown on his farm and his neighbors' farms. Texas is a major contributor to the world's supply of raw cotton.

At one time, the quilts his great-grandmother made would have certainly been sewn with domestically grown cotton that was ginned and milled in the United States. Today, the scenario is vastly different and the majority of cotton growing on this farm and in other states as well, is destined for export. In fact, in 2015, 65 percent of American cotton was exported globally. Japan is among the top 10-15 export destinations for American-grown cotton. As for Japan's raw cotton imports, approximately 40 percent of all cotton imported to Japan comes from the US and is used to produce many high-quality textile products, such as high-fashion denim and blue jeans.

Growing all that cotton is a brutal business. The weather can wreak havoc. Drought, floods, freezing temperatures, crop supply and demand, and pure hard work all take their toll and over the centuries, farmers have learned to cope. However, it is cotton prices that tell a much more complicated and often brutal story, depending on where the farmer lives.

In the United States, the price the farmer is paid for a pound of raw cotton has remained roughly the same price for the past 40 years: about 60 to 70 cents per pound. There have been some wild swings in prices for short periods of time during this period, but on average, the price per pound for raw American-grown cotton from 1975 to 2015 is essentially unchanged.

Yet, consider this. During the 1970s, a farm tractor cost approximately $15,000. Today, a common, high-tech "GPS enabled" combine costs upwards of $200,000. And where one tractor might have sufficed years ago, today most farms require multiple pieces of similarly priced equipment to farm efficiently.

This very technology—along with a plethora of other necessities such as seeds, weed killer, fertilizers, complex irrigation—while certainly costly, are all some of the primary reasons why American-grown cotton is consistently considered some of the highest quality cotton grown in the world.

TOP Cotton fibers remain a wondrous thing. Cotton is used to make thousands of products and creates millions of jobs around the world. And it all starts when a farmer puts a seed in the ground and a squat, gangly plant begins to grow. Eventually, bolls of soft, strong fibers are formed, grown to maturity, harvested, ginned, then shipped around the world where they are milled, dyed, or printed, sewn, and then often shipped around the world yet again.

BOTTOM Long rows of freshly harvested cotton, grown on farms near Lubbock, Texas, are being transferred into transport trucks for the trip to nearby cotton gins.

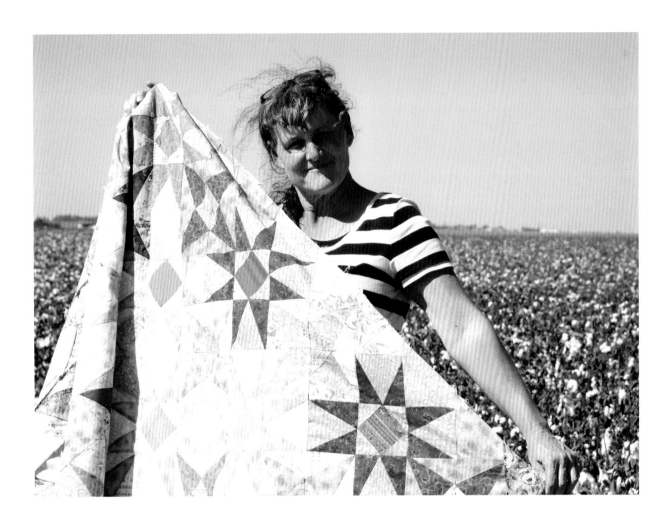

Quilting Where Cotton Is King

The tiny West Texas town where Trecia Terry Spencer grew up has a population of 532. This is cotton country, fondly called the land of King cotton. The prairie is vast and the houses are few and far between.

Trecia has always loved quilts, but her interest is more than a personal hobby. For many years she owned and operated a quilt retail store in Lubbock, Texas, and she considered her quilt shop as a way to help her family's primary business: cotton farming.

Trecia first encountered Japanese quilts in the early 2000s at the International Quilt Festival in Houston. She quickly fell in love with the taupe palette and the beautifully constructed quilts. She began selling Daiwabo (made in Japan) woven and printed fabrics in her retail shop and these new and unusual fabrics were very appealing to customers in the region. At the time she made the decision to carry these fabrics, she thought if they didn't sell, well then, she'd just use them herself to make quilts. But the fabrics did sell and Trecia went on to make three quilts of her own featuring Japanese fabrics. She is holding one of those quilt tops in this photo, which was taken on her family's cotton farm in Terry County, Texas.

> "I always dreamed that one day
> my daddy's cotton would go to Japan
> and come back to me with this
> beautiful color printed on it."
> —Trecia Terry Spencer

Trecia Terry Spencer.

Tad Takeada, who lives and works in Osaka, is the fourth generation to run his family business. His grandfather became part of Japan's cotton culture in 1907 when he founded a company, now known as Yamachu Mengyo, to collect leftover cotton material from industrial factories and repurpose it. The company went on to build and operate a sophisticated spinning company which is one of the premier industrial suppliers of cotton yarn to Japan's domestic textile companies. Yamachu is also a major cotton importer and their giant warehouse stores a conglomeration of massive cotton bales from all over the world, including cotton grown in the very same Texas soil that Rodney Terry farms.

Clearly, cotton has played a big role in Tad Takeada's life. Throughout his career, he's traipsed through cotton fields in every cotton growing region in search of good land, well-run operations, and honest farmers. He even spent several months during the 1970s studying cotton cultivation at a technical college in California. So when this seasoned expert prefers American-grown cotton for its cleanliness, color, and overall quality, his preference is based on both significant experience and awareness of the world's cotton supply. Simply put, he trusts American cotton.

That said, raw cotton from the US is not always his first choice. Cotton is a highly competitive commodity that's grown in some eighty countries, with India and China producing the largest crops worldwide. The United States is the third largest global producer. Pakistan is

This colorful padded girl's kimono was created for the daughter of a wealthy family to wear during special celebrations during the early 1900s. The kimono is made with cotton and is stuffed with silk floss for warmth. It is decorated on the outside with the family crest. *Courtesy Yu-yu-tei, an Osaka antique dealer.*

Traditional weavers often create a variety of new products with their cloth, such as these fans, in the hopes of finding new customers who appreciate their handiwork.

also a major cotton growing region. As for Japanese imports, on average approximately 40 percent of the country's raw cotton imports are from the United States. Other notable suppliers are Australia, Brazil, and Greece.

The country of origin for cotton in finished goods and mass-produced textiles is barely discernable in the modern world. In fact, it is extremely rare for textiles to be constructed today with cotton grown in just one region. Rather, huge bales of ginned cotton are often spread across the spinning room floor and giant machines blend fibers of different strengths and staple lengths, creating a veritable cornucopia of cotton fibers from every cotton growing region around the globe. In this way, textile manufacturers can get the best of many worlds by combining staple lengths, quality, and price to produce the most efficient cloth.

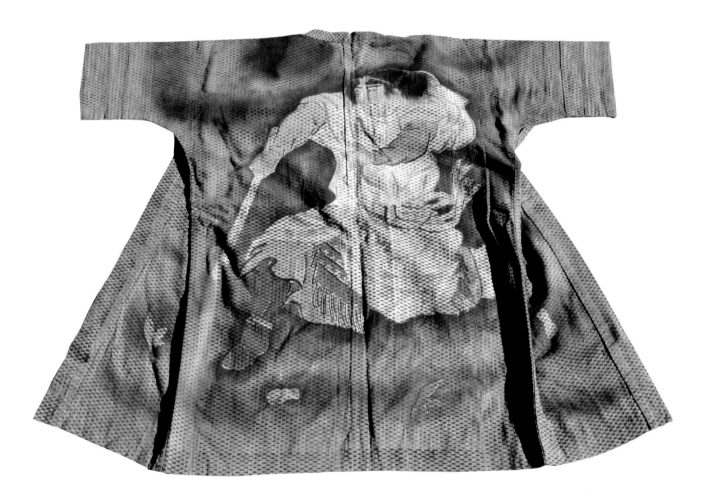

This small, cotton child's coat, known as a *happi* coat, was made during the first half of the twentieth century. The decorations are hand drawn and dyed using stencils. *Courtesy Yu-yu-tei, an Osaka antique dealer.*

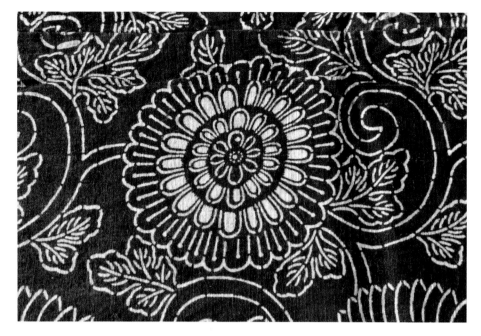

LEFT Antique *katazome* cotton. The decoration is made by using a combination of stencils and paste resist. A typical feature of *katazome* is its two-tone effect. In more elaborate designs, multiple colors can be used, or the whole cloth could be overdyed to create an even more intense hue.

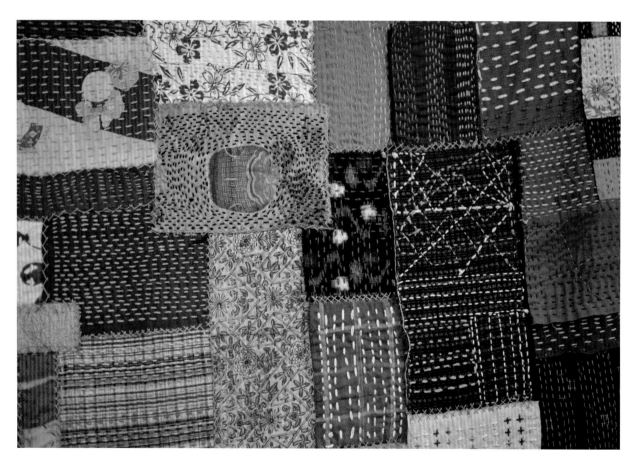

Remnants of antique and vintage cotton cloth are covered in an improvisational running stitch that is a derivative of sashiko. One of the modern characteristics of this type of stitching is the use of many different colors of cotton thread. By covering these old textiles in this contemporary method, the artist creates something entirely new with a vintage, modern aesthetic. *Photographed at the Niigata Ginka Gallery, Niigata Prefecture.*

BORO, KATAZOME, KASURI, SHIBORI, AND SARASA

Hundreds of years ago, the prized fibers of cotton cloth and *asa*, which means linen, ramie, or hemp, were treasured by those who so needed their protection, warmth, and durability. What little material they had was used over and over. Tattered rags were salvaged with needle and thread, with the hope that they'd be useful just a bit longer. Nothing was wasted. Japanese common folk used and reused nearly every useful thing in their daily life. Clothing would be patched and stitched and patched again to make it last as long as possible. Once a patched cloth was too ragged for clothing, the garment would be disassembled and the fabric was reused to make bed covers (*futon*), or cloth to carry things (*furoshiki*), even diapers for babies and dust cloths.

These patched textiles are among the most iconic and alluring Japanese textiles and are known as *boro*. The name is shortened from *boro-boro* and it is a catchall term generally intended to mean old rags or simply old cloth, tattered rags, or even a heavily patched textile. Most every used textile in the process of patchwork and recycling can be referred to as *boro*, and in Japan, antique *boro* is composed mostly of cotton, hemp, linen, or other natural fibers.

At one time, *boro* could be found in every corner of the country. But today, it is difficult to come by because so much of it has disappeared or been discarded. As older generations passed away, their families would often throw away many of these repaired textiles. Younger generations had no need for what they perceived as old, ugly rags, and keeping them served as a painful reminder of the difficulties and hardship of the past.

However, with the passing of time, these tattered fabrics are now coveted and respected for the service they once provided, and cherished for their simple beauty.

Needlework has been a vital part of Japan's heritage for centuries. This woman is pictured sewing, mending, and ironing items in her home around 1940. *Courtesy of the family of Yuriko Sakuraoka.*

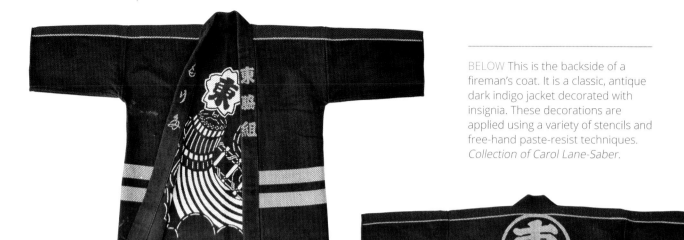

ABOVE Antique cotton fireman's coat. This coat is covered with a practical form of sashiko stitching using a thick cotton thread that traverses over and under each thread of the thickly woven fabric. As a result, the stitching seems integrated with the fabric itself and it adds considerable weight and durability to the garment. *Collection of Carol Lane-Saber.*

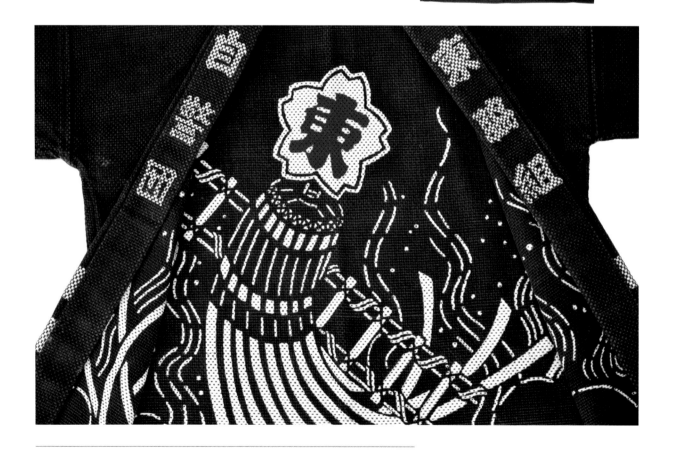

Many fireman's coats were designed to be reversible. It is believed that the fireman wore the highly decorated side of his coat on the inside while fighting fires, and once the fire was extinguished, the coat would be reversed to display the colorful insignia. *Collection of Carol Lane-Saber.*

LEFT This brightly painted, antique cotton canvas festival banner is fairly durable and was designed to hang outside. During certain holidays and celebrations, rows and rows of these very long banners would hang outside to mark a special occasion. *Collection of Carol Lane-Saber.*

BELOW A vintage advertising banner for a shoe shop is decorated with a modern, improvisational running stitch using white cotton thread. This stitching is an informal variation of classic sashiko and was made by Akiko Ike, Niigata Ginka Gallery, in 2015. Outdoor advertising banners like this one are still popular in Japan, but they are constructed mostly from synthetics today. Only the banners from the 1950s-60s era and earlier are 100 percent cotton. Their worn and faded surface make a classic canvas to feature *chiku-chiku* stitching, a needle art form taught by Akiko Ike.

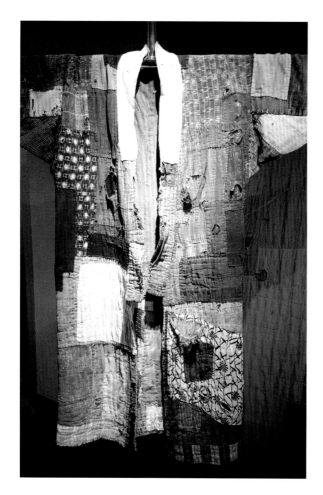

Chuzaburo Tanaka's Search for *Boro*

In northern Japan, particularly the Aomori Prefecture, where the climate is too cold to grow cotton, the Aomori people relied primarily on textiles woven from hemp and linen. What little bits of cotton cloth that were acquired during the Edo period came from local traders who sailed Japan's shores trading raw cotton, as well as new and used cotton textiles, in exchange for other goods. Because of their rarity, cotton textiles were extremely precious to the Aomori people.

Beginning in the 1960s, Chuzaburo Tanaka spent forty years walking door to door in the mountains and along the coast in Aomori Prefecture searching for *boro* and other folk art. Early in his quest, he was criticized for collecting rags and junk, yet he persevered. His search was made especially difficult by the fact that country people all over Japan would attempt to keep their tattered garments and scruffy household items out of sight when visitors came because their very presence was a shameful reminder of their poverty. As a result, the large collection eventually amassed by Chuzaburo Tanaka is all the more remarkable because it exists at all.

In 2009, the quirky Amuse Museum opened in Asakusa (Tokyo) and it has allotted considerable space to exhibit Chuzaburo Tanaka's collection of *boro*. Unlike many typical museums, Amuse allows museum goers to touch and photograph some of these very special *boro* textiles, thus providing an up close and personal experience.

These *boro* examples are evidence of how widely cotton was traded and reused because many items include an interesting variety of dyed and woven cotton patches. One family would not have had the wherewithal to hand-craft so many varieties of distinct patterns on their own. As a result, these treasures offer clues about cotton production throughout many regions in Japan.

The striking two-tone *katazome* prints are easy to identify amidst the woven and solid cotton indigo typically seen in many *boro* textiles.

RIGHT These patchwork pants would have been worn as work clothing, most likely by farmers. This style of work clothes is called *aizome* and is made of indigo dyed cloth, mostly cotton. *Photographed at Amuse Museum, Asakusa, Tokyo.*

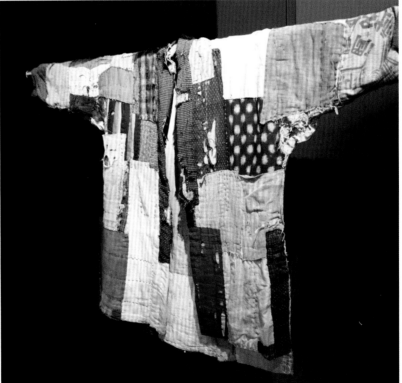

LEFT At one time, *boro* could be found all over Japan. Today, it is difficult to come by because so much of it has disappeared or been discarded. *Courtesy of Degai Antique Fabric and Kimono, Hachinohe City, Aomori Prefecture.*

RIGHT This colorful *boro* jacket, with its wide variety of dyed and woven cotton patches, shows how widely cotton was traded and reused. *Photographed at Amuse Museum, Asakusa, Tokyo.*

Creating *Katazome* and *Tsutsugaki*

Katazome is cloth that has been dyed and decorated with a wood block, or stencil. It happens to be one of the most attractive, and familiar, antique Japanese cotton prints. Gorgeously rendered flowers, including the iconic chrysanthemum, cherry blossom, or iris, exude an instant charm. Cranes, turtles, and koi are also popular patterns in *katazome*, but leaves, bamboo, vines, and geometric patterns are also used.

Katazome is most often a two-tone print featuring white on blue indigo, but it is also made in other variations. The repetitive pattern was originally created on large pieces of cloth and used to cover bedding or hang in doorways. In modern times, the soothing beauty of these hand-crafted textiles are particularly endearing to textiles lovers—especially if they are decorated with flowers.

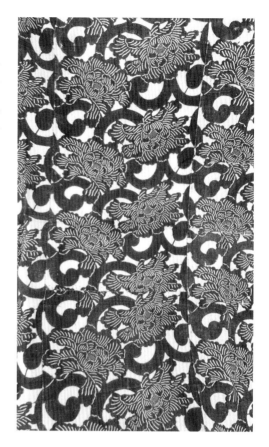

> "In joy or sadness, flowers are our constant friends. We eat, drink, sing, dance and flirt with them. We wed and christen with flowers. We dare not die without them . . . How could we live without them?"
> —Okakura Kakuzō, *The Book of Tea*, 1906

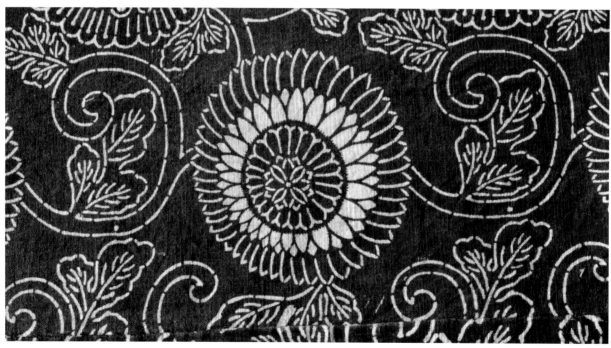

TOP This charming chrysanthemum, along with other floral patterns, is often seen in traditional *katazome* textiles. The chrysanthemum and the cherry blossom are the unofficial national flowers of Japan. *Courtesy Yu-yu-tei, an Osaka antique dealer.*

BOTTOM *Katazome* is most often a two-tone print, white on blue indigo, but it is also made in other variations. This over-all pattern was originally created on large pieces of cloth and used to cover bedding or hang in doorways.

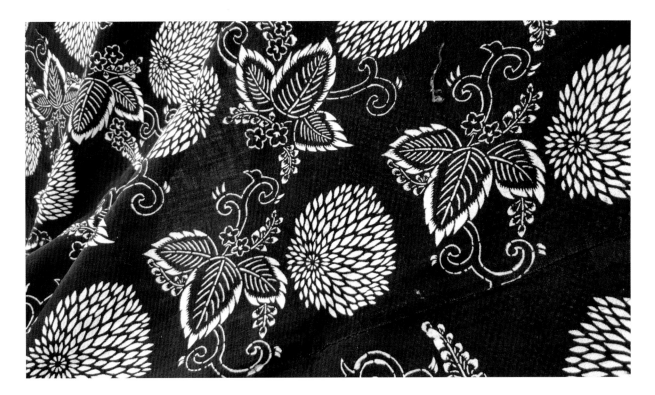

The process for making *katazome* hasn't changed much over the past several centuries. It is still made by using a combination of stencils, paste resist, and dyes. A patterned stencil is placed over the fabric and a paste-resist material is applied to the fabric through the stencil. The stencil is removed. The paste is allowed to dry and a sizing liquid is applied to the entire cloth. Once that dries, a colored dye is brushed over the whole surface. For indigo-dyed *katazome*, this same basic process is used, except both sides of the cloth would be covered in the paste resist and the cloth would be completely immersed in a vat of indigo. In either case, the dye may be applied multiple times in order to get the desired intensity.

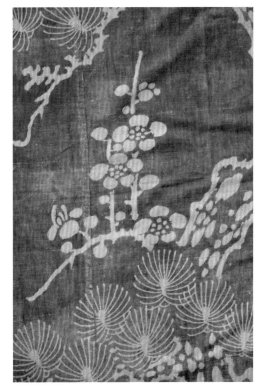

After the dye has dried, the paste resist is removed and the featured design is highlighted in the original color of the textile, usually white or natural, creating the two-tone effect. In more elaborate designs, multiple colors can be used, or the whole cloth could be overdyed to create an even more intense hue.

Tsutsugaki is crafted somewhat similar to *katazome*, with the primary difference being the design is rendered free-hand. No stencil is used. *Tsutsugaki* means drawing with a tube, which is a tool very similar to the one used in cake decorating. Originally it is believed that cloth decorated in *tsutsugaki* was used to make

TOP This classic, antique *katazome* features an indigo design printed on natural white cotton. It was made using a combination of stencils and paste resist. A stencil is placed over the fabric and a paste-resist material is applied to the fabric through the stencil, then the stencil is removed. The paste is allowed to dry and the cloth is dyed.

BOTTOM Antique indigo-dyed, cotton tsutsugaki (detail). *Collection of Carol Lane-Saber.*

costumes for the theater or clothing for the wealthy. Over time, this method, which is perhaps more free-form and less intensive than working with intricate stencils, became popular with artisans throughout Japan. By the end of the Edo period, nearly every village had at least one *tsutsugaki* dye workshop.

To make *tsutsugaki,* the garment or other item is sewn first into the desired shape and then stretched on a frame in order to create a smooth, wrinkle-free surface. The design is sketched onto the cloth or garment, and the artisan carefully squeezes the paste resist through a tube over the outline or pattern of the design. The tube, or cloth bag, has a metal or bamboo tip, and there are many different sizes of tips used to create different effects. Once dried, the process is repeated on the other side of the cloth.

After the resist materials have dried, the frame is removed and the entire cloth is dipped in the dye bath once, or multiple times. As with *katazome*, this process can be created with multiple colors.

Finally, it goes through an intricate washing to remove the paste resist and the final product is stretched again and allowed to air dry.

Hand crafting *katazome* and *tsutsugaki* requires immense patience and diligence. Each step must be carefully executed or the whole piece can be ruined. It can take up to several weeks, or longer in some cases, just to produce one finished piece of cloth.

Kasuri and Ikat:
Similar but Not the Same

The term *kasuri* means cloth woven with thread that has been dyed using some variation of resist so the thread is more than one color. The term covers a wide spectrum of woven cotton or silk cloth made with this type of thread. During the heyday of local cotton farming, many people were taken with the idea of creating *kasuri* textiles as a creative outlet. Over time, this distinctive cloth has become associated with community folk art and there are many regional and specialized variations of *kasuri* motifs and methods.

Kasuri is most commonly associated with cotton woven cloth made with warp thread, and occasionally weft thread, that has been tied, clamped, pasted, or

another technique is used in order for certain sections to resist the dye, thus creating a two-tone, or multi-tone thread. *Kasuri* can also mean double *ikat*, where both the warp and weft are patterned.

When these dyed threads are stretched and woven, the colored or non-colored sections fill pre-determined patterns in the finished cloth. It is technically difficult to finely tune this complex weaving with thread that has random or even soft edges. As a result, *kasuri* is recognizable as a woven pattern or design with a noticeable soft or hazy edge.

TOP Yarn-dyed, woven *kasuri* textiles are distinguishable by the soft edges of the images or graphics depicted, and most often, deep indigo background.

BOTTOM *Kasuri* is most commonly associated with cotton woven cloth made with a two-tone or multi-tone thread. This iconic crane and turtle is a very popular design often seen in *kasuri* textiles.

Shibori Traditions

Shibori is known and practiced all over the world, and there are many variations of traditional shibori practiced in Japan today, some of which are believed to be indigenous. Shibori is made when cloth is tied, bound, clamped, pleated, or folded, or otherwise manipulated, to keep certain areas from taking color (or resisting) when the cloth is dyed. When making shibori, the cloth can be wrung, squeezed, or pressed, and the dye can be applied by pouring or dipping. With all of these methods, the end result is cloth that looks crinkled, or has soft edges, or has softly blended colors.

The origins of *kasuri* date back to traditional woven cloth from Okinawa that made its way to Japan during the fourteenth through sixteenth centuries. Okinawa weavers were particularly innovative in the ways they manipulated the warp and weft thread to create their abstract and specific patterns. In fact, the Okinawans are believed to be the first culture to manipulate the weft thread in particular to create pattern.

In some instances, the term *ikat* is used in place of *kasuri*, and while there are similarities, these two terms are not exactly synonymous. *Ikat* is a word that comes from Malay-Indonesian vocabulary, and it refers specifically to textiles originating from Southeast Asia. There is no Western word equivalent. *Kasuri* refers specifically to textiles emanating from Japan.

Kasuri is often used to make cotton kimonos for men and women. The most easily recognizable form of *kasuri* is the indigo-dyed woven cotton depicting soft-edged images of carp, cranes, chrysanthemums, and other designs, or soft geometric patterns, checks, or stripes. The cloth can be dark with light images or patterns, or it can be white cloth with dark images or patterns. Most often the dark colors are indigo and the light colors are white, but brown, black, gold, tan, and other colors are used as well.

TOP This remnant is a *kasuri* textile that has been covered with heavy stitching using a dark indigo thread. This heavy stitching, a variation of sashiko, would have been used to reinforce the cotton and the textile was most likely once part of work clothing.

BOTTOM This photo shows an extreme close-up view of cloth that has been tied, in preparation for indigo dyeing. The spots that are held taut by string will resist the dye and maintain the original color of the cloth.

Shibori is quite different from paste-resist methods where clear lines can be delineated. Shibori intentionally has soft edges and in some cases the cloth is tied in such a way that the colors are intended to bleed over each other, especially in contemporary techniques.

Like many of Japan's distinct folk art textiles, there is no one English word that is equivalent to shibori. Shibori is often referred to as tie-dye, but this term is not entirely adequate because the technique can be infinitely more complex than the simple tie-dye methods most often associated with the counterculture movement in the US during the 1960s. The closest English phrase to describe shibori is shape-resist dyeing.

The most popular form of Japanese shibori is the method using ties to tightly bind very tiny sections of cloth so they will resist the dye. This task is an extremely laborious process. Shibori created in this manner is very popular for cotton kimonos. Most often these are dyed in indigo, red, or black, but there are many other variations as well. Another popular method is wax resist, which can be more conducive to creating large designs or imagery with a multitude of colors. Clamp resist is also used to create shibori.

The Mystique of *Sarasa*

Cotton Indian *sarasa* was first brought to Japan in the fifteenth century. It became so adored that as early as the mid-1700s, Japanese artisans began to produce their own versions of these exotic designs. Like its Indian counterpart, antique Japanese *sarasa* is most often produced in a subtle beige color, but can also be found in gray, red, brown, even indigo.

Sarasa is a richly-decorated, printed textile often depicting people in exotic settings and costumes, along with wild animals. These unusual figures are typically depicted among small patterns, vines, and florals, lending the entire textile an imaginative and eccentric mystique. *Sarasa* can also be decorated with repetitive geometric or floral patterns. Most often the illustrations are applied using a variety of wood block stamps, or paste-resist printing techniques, or both.

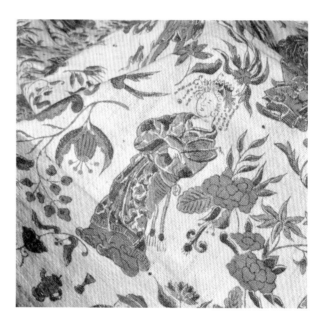

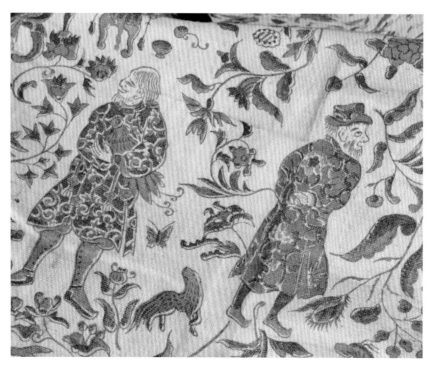

This beautifully-preserved Japanese *sarasa* cotton cloth (circa 18th–19th century) is decorated with a combination of *karahana* (a stylized floral pattern) and *karakusa* (a repetitive spiral, or arabesque, pattern that can often take the form of a vine). As is typical with the exotic aesthetic of *sarasa*, this example also features elegantly costumed men and women, unusual animals, and small objects. The designs were created using stencils, or wood blocks, and the cloth would have originally been used as a futon cover for a wealthy family. *Courtesy Yu-yu-tei, an Osaka antique dealer.*

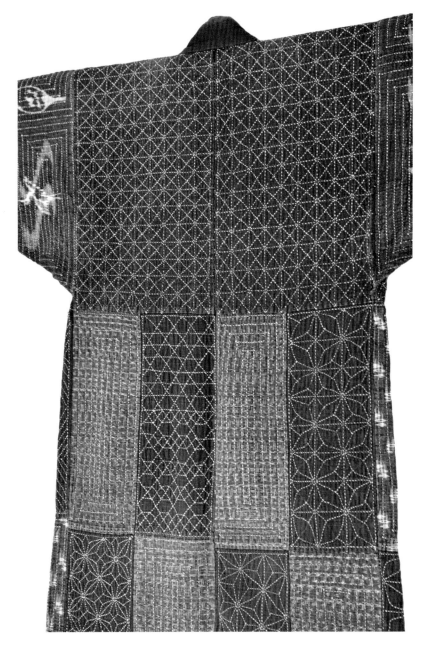

TOP LEFT Detailed view of patched *aizome*, or *boro* pants. *Courtesy of Degai Antique Fabric and Kimono, Hachinohe City, Aomori Prefecture.*

TOP RIGHT This antique fireman's hood and jacket is a typical, dark indigo design and features sashiko stitching with a thick cotton thread that traverses over and under each thread of the thickly woven fabric. In some cases, these coats and hoods would be doused with water as the firemen worked in the hopes it would add extra protection from the flames. This hood and jacket was once used in the Aomori region in Northern Japan. As is typical of rural areas, this coat does not have colorful designs or insignia and was most likely made by a domestic sewer, perhaps a wife or mother. *Courtesy of Degai Antique Fabric and Kimono, Hachinohe City, Aomori Prefecture.*

BOTTOM This is the backside of an exquisite fisherman's coat. Each patch features a traditional sashiko design. *Courtesy Yu-yu-tei, an Osaka antique dealer.*

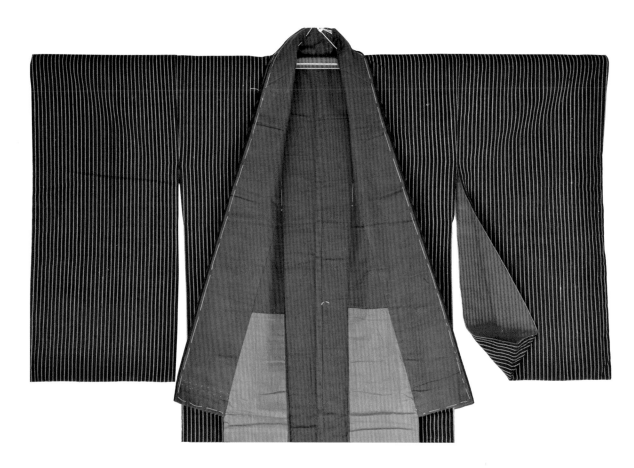

Just a touch of red. "Safflower red" dyed cotton textiles became very popular during the Edo period. Making red dye was extremely labor intensive and thus expensive. Red bespoke of money. During the eighteenth and nineteenth centuries, it became popular to show just a small spot of red in clothing—either through the lining of a kimono or red undergarments. *Courtesy Yu-yu-tei, an Osaka antique dealer.*

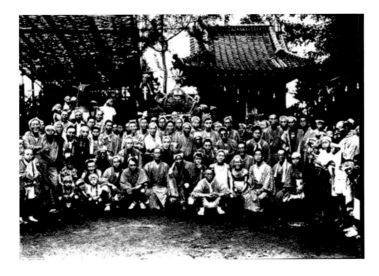

LEFT The individuals pictured in this 1951 photo are dressed in colorful cotton *yukata* (summer kimonos) and many are wearing cotton *tenugui* (hand towel, or handkerchief) on their head or around their necks. They are celebrating a *matsuri* (festival) which included a parade where they carried a figure representing the god *Mikoshi* in order to bring his spirit down to the people. Wearing cotton *yukata* and *tenugui* remains popular today for certain festivals. *Courtesy of Ichiro Takizawa, Tokyo Wazarashi Co., Ltd. The grandfather of Ichiro Takizawa is included in this photo.*

Michiko Okunishi, an antique dealer, with her husband. The couple is based in Osaka but they scour the entire country for rare and special textiles, especially cotton. Finding quality antique textiles takes immense patience, and a large network, because so many old pieces have been discarded. Michiko is especially supportive of researchers, and anyone who is interested in her country's textile history, and she hopes her efforts will help preserve the stories of how these precious fabrics were made and used.

6 / RESURRECTING JAPAN'S WOVEN COTTONS

Travel from the north to the south, east or west, within almost any culture and if you stay long enough, pretty soon you'll surely encounter regional differences in food, fashion, and even language. Experienced travelers, and even some longtime residents, recognize, seek, and appreciate the cultural distinctions of a particular region.

For textile aficionados, there are also recognizable, well-documented, regional specialties of textiles within certain cultures and these variations are also sought and appreciated. This is true of Japan, of course, and especially with her woven cotton where each region even has its own name, patterns, and aesthetic.

These are some of the historic regions where quality cotton was woven with dyed yarn or threads:

Tohoku, which produced *Aizu momen*. (See quilt by Keiko Goke on page 93)

Hokuriku, which produced *Kamo momen*.

Kanto, which produced *Yawara momen*, *Moka momen,* and *Mashiko momen*.

Chibu, which produced *Chita momen*.

Kinki, which produced *Yasu momen*, *Matsusaka momen*, and *Ise momen*.

Niigata, which produced *Kameda jima*. (See quilt by Yoko Saito on page 101.)

Note: *Momen* means cotton. Only some of these regions are still actively producing traditional hand-woven cotton.

Kimono Cotton from Ise: Only One Weaver Left Standing

For nine generations, the family of Naruo Usui has been weaving dyed cotton threads into traditional stripes and checkered patterns. At one time, there were hundreds of family-owned businesses in the area weaving these traditional patterns from locally-grown cotton. One by one they've vanished, leaving Usui Shokufu as the last company standing to create this iconic fabric known as *Ise momen*.

Ise momen is a traditional yarn-dyed cotton textile produced in the Ise region. Ise sits on the Ise Bay halfway between Osaka and Nagoya. The traditional *Ise momen* patterns date back to the middle of the Edo period and the family has no desire to create new patterns. Rather, they proudly feel they are preserving historic patterns and are re-introducing them over and over again for new generations to discover the softness and simple beauty of this hand-crafted cloth.

Ise is a warm weather climate and thus for many years, *Ise momen* was primarily used to make cotton kimonos for the hot, humid summer months. These days, there are still some kimono makers who seek this special textile for their traditional dress, but most often it is used to make shirts, dresses, bags, umbrellas, and many other charming, modern goods.

RIGHT These colorful stripe and plaid patterns are known as *Ise momen* . The designs are based on traditional designs that were originally created as summer kimono fabric.

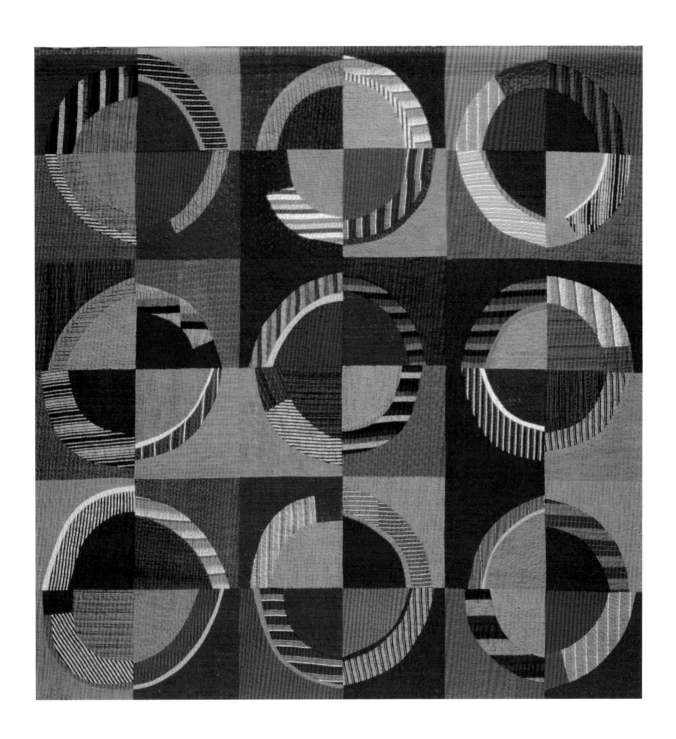

Keiko Goke. *Aizu Momen*. circa 2000. Cotton: 77" × 77" (195 × 915 cm). Pieced, machine quilted. This quilt is made predominantly with *Aizu momen*, which means cotton from the Aizu area, Fukushima Prefecture. Keiko Goke made several trips to visit the local weavers in Aizu in order to find these hand-woven textiles. Like Niigata Prefecture, weaving was once popular in this area and these traditional woven patterns and techniques have been passed down through the generations to the few who still pursue this craft.

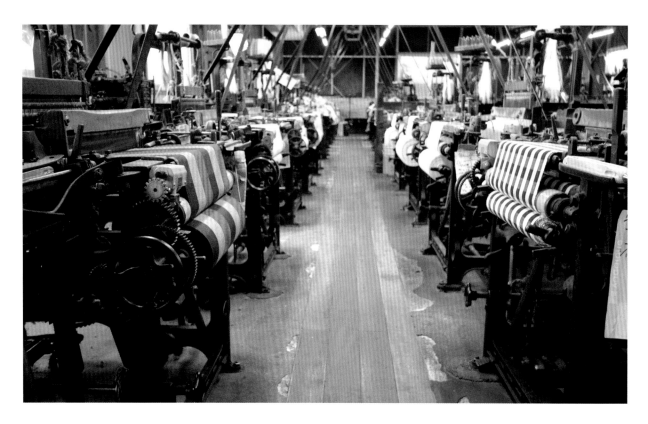

TOP *Ise momen* is a cotton textile produced in the Ise region. Traditional *Ise momen* patterns date back to the middle of the Edo period and this small, family-owned workshop is the last business in the area still making these traditional textiles.

BOTTOM American cotton bales stored in a warehouse in Osaka at Yamachu Mengyo Company, alongside cotton from many other countries. Some companies in Japan, such as Usui Shokufu, prefer the quality of American cotton over cotton grown in other countries.

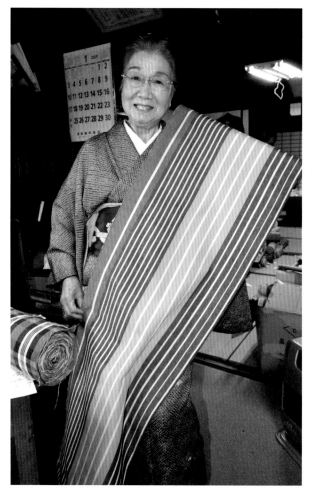

Naruo Usui lives and works in Shinshuji, a small town in Mie Prefecture with a well-known historic temple. Maintaining a family business that has been in existence for nine generations has not always been easy, and there were certainly days when he considered closing the business. But his company, Usui Shokufu, has something very special. Their textiles are woven on looms that are masterpieces from the Meiji era. Without the slow and gentle warp and weft mechanisms of these 100-year-old machines, producing this level of quality *Ise momen* would be impossible. Mass produced textiles could never reproduce the softness and special characteristics of the twisted and carefully woven yarns of this vibrant textile.

The looms owned by, and used daily at Usui Shokufu, were made by Sakichi Toyota, a man who is considered the father of the Japanese industrial revolution. He invented a number of looms and critical innovations for the weaving industry. He also happens to be the same person who founded the Toyota car company.

Each loom must be operated with a trained staff person to closely monitor the progress. Making cloth this way is time-consuming, of course. One loom can only produce a little over fourteen yards, or thirteen meters, in a single day. And out of necessity, the owner has learned how to keep these very old looms in working order.

Ise momen is woven with a single strand of thread, and single strands can break easily if they are pulled too hard or over stretched. Weaving with a single strand requires a yarn made from superior cotton. Usui Shokufu uses threads which are spun in Japan from 100 percent American-grown cotton.

The company produces over 100 different patterns, with labels such as Futon Stripe, Kasane Stripe, Kijiro Stripe, Benkei Check, and Half Stripe. Many of these designs feature bright, happy colors such as combinations of yellow, red, orange, purple, and white, or variations of pale pinks, aqua, and cranberry. Others are more subtle with gray, brown, or indigo.

LEFT & ABOVE These seamstresses have traveled to Usui Shokufu, a cotton textile company in Mie Prefecture, specifically to find this charming, traditionally woven cotton. These women appreciate the fine quality of these fabrics and the historic patterns they pay tribute to. They purchase *Ise momen* in long, uncut rolls and use it to sew their own cotton kimonos.

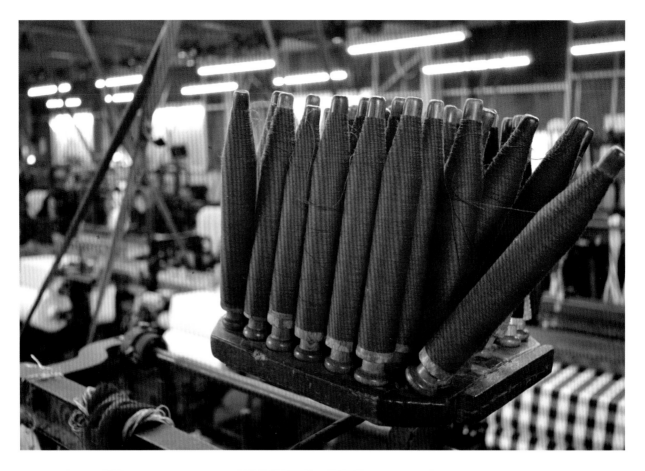

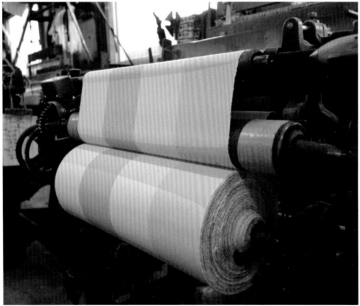

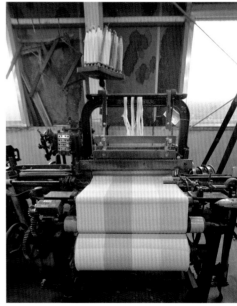

TOP *Ise momen* is woven with a single strand of dyed thread. Weaving with a single strand requires a yarn made from superior cotton and Usui Shokufu uses threads spun and dyed in Japan, which are made from 100 percent American-grown cotton.

BOTTOM The slow and gentle warp and weft mechanisms of these 100-year-old looms create a cloth of incredible texture and quality.

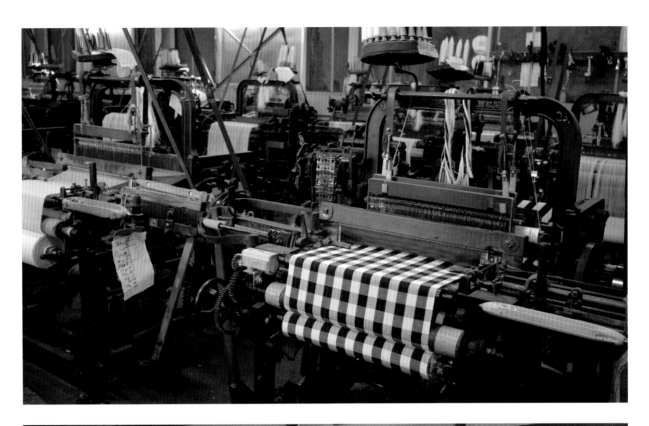

TOP The looms used at Usui Shokufu to make *Ise momen* are about 100 years old and are considered masterpieces of the Meiji era. They were made by Sakichi Toyota, who is considered the father of the Japanese Industrial Revolution. Sakichi Toyota invented a number of important looms and innovations for the weaving industry. He also happens to be the same person who founded the Toyota car company.

BOTTOM Naruo Usui lives and works in Shinshuji, a small town in Mie Prefecture with a well-known historic temple. He is the ninth generation to run the family business, Usui Shokufu.

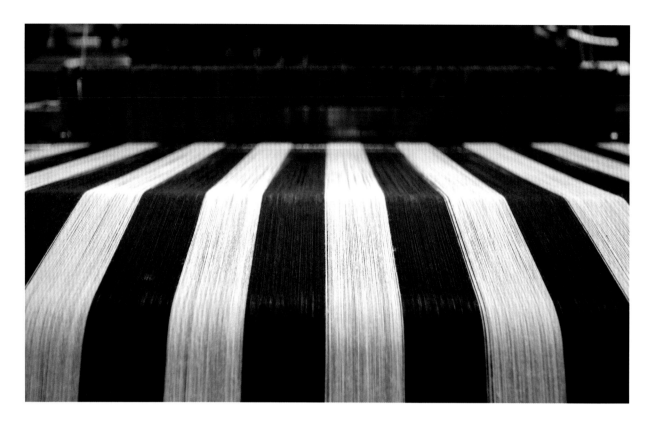

Woven Work Wear from the North

Hiroshi Tachikawa was lulled to sleep as a baby by the gentle sounds of modern, clanging cotton weaving looms. He was born in 1953, during a time when locally woven cotton cloth was popular in Japan, and his family ferried him back and forth every day to their textile factory. By the time the 1990s arrived, however, customers had slowly dropped off one by one until there were none left. Hiroshi was forced to close the family business.

His passion for woven cotton textiles never faded, though, and soon he came upon an idea.

Hiroshi discovered one copy of a priceless, handmade book made more than a century ago. The book was housed at a local museum and it featured samples of historic woven cotton fabrics, with the actual cloth pasted onto each page. These fabrics had been created right in his own neighborhood. The book, which was dated circa 1902, featured *Kameda jima* cotton. Kameda refers to the area in and around Niigata Prefecture, in Northern Japan, and *jima* is thick cotton woven in a specific traditional checkered or stripe pattern.

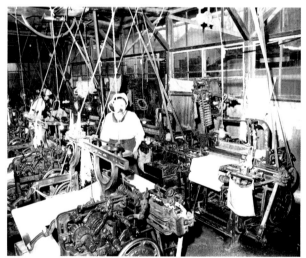

ABOVE This early 1900s photo shows a *Kameda jima* weaving factory in Niigata (Northern Japan). By the latter half of the nineteenth century, there were approximately 1,500 weaving machines in use in the region, and weaving was a way of life for the vast majority of families.

TOP This striking black and gray stripe is a popular *Kameda jima* pattern. The dyed threads are pictured here as they enter the weaving loom. The thread is spun and dyed in Japan from cotton grown primarily in India.

Niigata is a cold and snowy climate and is about as far north as cotton can grow in Japan. Sometime around the 1600s, cotton cultivation was merely a side business in Niigata. The main crop was hydroponically farmed in man-made lakes and as such, farmers were forced to stand in frigid, waist-deep water to work. They needed clothing that would help protect them. As the old saying goes, necessity is the mother of invention. The local weavers proved this adage to be true and invented a durable, thick, locally woven cloth. Driven by necessity, a new handicraft tradition was born.

As the years went by, word spread about this new textile, so it became popular in other parts of Japan as well. Weaving *Kameda jima* became a viable business opportunity, so much so that the farmers eventually gave up the difficult life of hydroponic farming and turned their attention to weaving. By the latter half of the nineteenth century, there were approximately 1,500 weaving machines in use in Kameda. Weaving became a way of life for the vast majority of families.

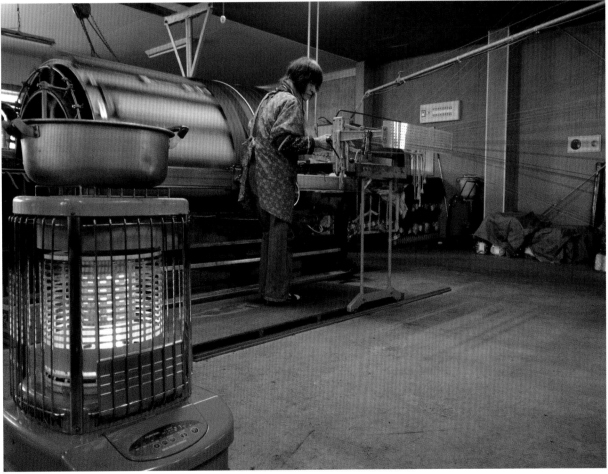

TOP Close-up of threads at a weaving loom making *Kameda jima*, a specialized regional yarn-dyed cotton.

BOTTOM Weaving traditional *Kameda jima* cotton textiles during a cold winter day, Niigata Prefecture, 2016.

When Hiroshi re-discovered this old sample book from days gone by, he devised an ambitious plan to recreate these beautiful fabrics. In 2005, the Kameda Cooperative Textile Society was born. Local family-owned textile manufacturers signed on and together they set about replicating these original *Kameda jima* designs.

He traveled the country sharing his story of how the community was resurrecting these historic designs. He was willing to meet with basically anyone who would listen. In 2009, his persistence paid off as he caught the attention of renowned quilter, business owner, and fabric designer Yoko Saito.

TOP Centuries ago, many farmers in Northern Japan worked at hydroponic farming in man-made lakes. In order to withstand this cold water for long periods of time, they needed tough, durable clothing. Out of necessity, a new handicraft tradition was born.

BOTTOM This cloth is known as *Kameda jima*. *Kameda* refers to the area in and around Niigata Prefecture, in Northern Japan; and *Jima* is cotton woven in a specific traditional checkered or stripe pattern.

Yoko Saito and the Resurrection of *Kameda Jima*

The weavers in Niigata credit the quilt master and teacher Yoko Saito with single-handedly helping shine an international spotlight on their locally woven cotton cloth. When she first heard this remarkable story, Yoko was deeply moved and wanted to be involved in helping to preserve a part of history.

Her collection of *Kameda jima* fabrics, produced with Lecien (one of Japan's major fabric manufacturers), debuted in 2010. These fabrics feature first and foremost the taupe palette with which she is so closely identified. It also includes similar colors that Japanese so closely associate with *iki* such as natural hues of brown, tan, cream, or pearl, mauve and rust, and many shades of gray and soft blacks.

Besides the colors, perhaps the most interesting distinguishing characteristic of these textiles is their imperfect, or slubbed, surface. Some patterns of *Kameda jima* are woven with thick threads and occasionally these threads will create raised surfaces on the cloth. Rather than be considered as a flaw, this uneven surface delights the quilter or garment designer who finds this distinct texture special.

Hiroshi Tachikawa, pictured at right, founded the Kameda Cooperative Textile Society in 2005. He is credited with rejuvenating the cottage weaving industry in this part of Northern Japan. Local farmers are experimenting with growing their own cotton in the hopes that Japanese grown cotton can once again supply the community's weavers. The raw cotton sitting on the table in this photo was grown by the farmer pictured on the left.

Yoko Saito. *Victoria and Albert Museum Quilt.* 2010. *Kameda jima* woven fabrics and other cotton: 60" × 73" (153 × 185 cm). Pieced, hand appliquéd, hand quilted. This truly original quilt features pieces of *Kameda jima* woven fabric, a locally woven cloth from the Niigata Prefecture which Yoko Saito helped resurrect and showcase to an international audience. *Photo by Toshikatsu Watanabe.*

Some patterns are produced with a single strand of very fine thread interspersed in the cloth in order to bring a speck of pink into a dark brown background, or fine black thread intersecting checks of gray. These well executed subtleties enable the production of a very special cloth that is clearly woven by skilled craftsmen and women who weave with incredible attention to detail. These unusual threads are made in Japan from cotton most often grown in India. The yarns are dyed in workshops in Hiroshima, as well as the Niigata region.

Frankly, the *Kameda jima* weavers credit this special collaboration with Yoko Saito and Lecien with helping to keep them in business. There are only a handful of companies left who make this cloth, and customers are scarce. Most of these multi-generation family businesses once encouraged their sons and daughters to seek work elsewhere. Yet now, with the revival of the Yoko Saito fabrics and interest among the international quilt community, there is a new opportunity and even hope that the next generation of Niigata weavers will be able to make a living and continue these important traditions.

Some of Yoko Saito's students live in the Niigata region and they come directly to the Kameda Co-op's retail shops to select from a wide assortment of *Kameda jima* fabric. Local garment sewers also fashion these textiles into clothing and bags and these are marketed all over Japan. Slowly, people are beginning to recognize the historic value of this soft and beautiful cotton and its significance is growing.

ABOVE This book of woven cotton samples, created around 1902, includes historic fabrics woven in Niigata Prefecture. When Hiroshi Tachikawa discovered this book, he devised an ambitious plan to recreate these beautiful fabrics. In 2005, the Kameda Cooperative Textile Society was born. In 2010, Yoko Saito and Lecien, a Japanese fabric manufacturer, collaborated with the weavers to make a line of fabrics for quilters worldwide, a move which has rejuvenated traditional *Kameda jima*.

LEFT These natural hues of brown, tan, cream, or pearl, mauve, and rust, many shades of gray, and soft blacks are typical of *Kameda jima* cotton textiles. They exude a serene sense of *iki*, and this soft and luxurious texture cannot be duplicated by many commercially woven cottons.

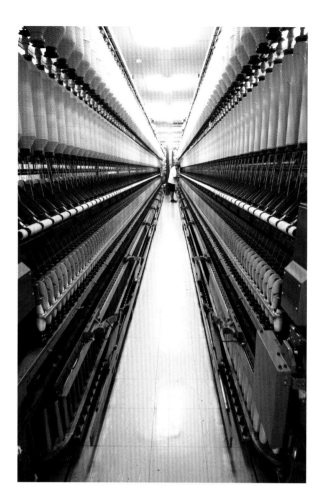

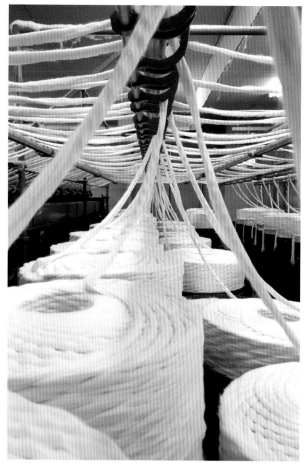

TOP LEFT A seemingly endless supply of spindles at a modern spinning factory in Osaka operated by Yamachu Mengyo Company. All of the yarn produced here is intended for the domestic market.

TOP RIGHT & BOTTOM Ginned cotton from around the world is being spun into fine threads destined for Japan's domestic weaving and textile industry.

One quilt in particular has helped spread the awareness of these stunning fabrics: *Victoria and Albert Museum Quilt* (2010) by Yoko Saito. This breathtaking, tour-de-force features a plethora of the *Kameda jima* fabrics that Yoko and Lecien first introduced in 2010. The quilt features an overall design that combines folk art birds, people, and houses made using intricate hand appliqué techniques with a variety of blocks made from traditional pieced patterns. The charming and sophisticated blocks are visually held together by the subtle and showy taupe palette, and the exquisitely woven *Kameda jima* textiles. And perhaps the most charming aspect of this large quilt is the triumphant conglomeration of Western and Eastern folk art.

The collaboration between Lecien, Yoko Saito, and the Kameda Co-op continues to showcase the importance of these reproduction textiles to the world. In 2017, a second collection was under consideration. These subtle, yet striking checked and striped fabrics cross many genres and have been incorporated in quilt tops, bags, purses, even clothing. Their appeal is so strong that many sewists and quilters adore these fabrics simply for their color and rich texture. They possess little or no knowledge that these are reproductions of woven cloth once intended to keep farmers warm during long, difficult wet winters.

TOP A lone umbrella, made with traditional yarn-dyed cotton, sits outside the historic building where *Ise momen* is produced in Mie Prefecture.

BOTTOM Purses, tote bags, and clothing are some of the modern products made with *Ise momen*.

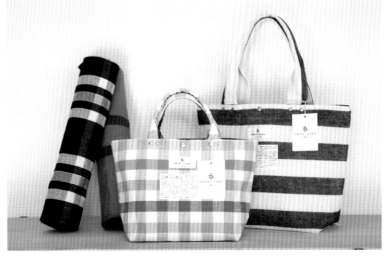

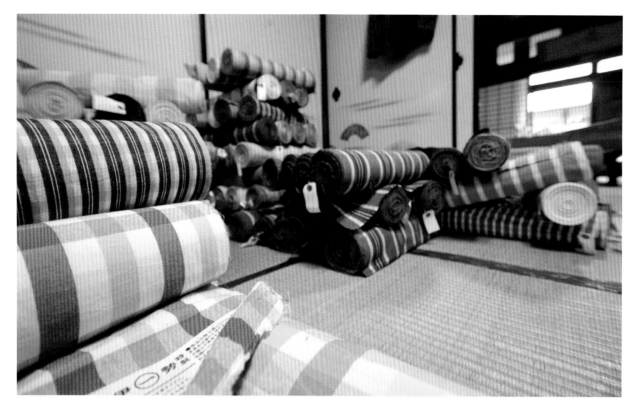

TOP Finished rolls of colorful *Ise momen* on display.

BOTTOM LEFT *Kameda jima* is woven with thick threads. Occasionally these threads will be thicker at some points and as they are woven, this creates raised surfaces on the cloth. This slightly uneven surface delights the quilter or seamstress who finds this distinct texture charming.

BOTTOM RIGHT This remnant of antique cotton shows the thick, heavy sashiko stitching used to make the cloth stronger and more durable. Unlike decorative sashiko, these stitches are applied in a mostly straight up and down motion to essentially weave the dark indigo cotton thread over and under the strands of cloth.

7 / CHUSEN

EXTRAORDINARY COTTON YUKATA AND TENUGUI

Chusen is a highly specialized, artistic form of dyeing cotton cloth using a time intensive and centuries old method that combines two Japanese favorites—paste resist and the beloved carved stencil—with another unusual technique, steaming hot, hand-poured dyes.

Whether this iconic decoration shows up on the common hand towel, the chef's bandana, or an incredible work of art, there are distinctive characteristics unique to *chusen* that are easily identifiable. For example, *chusen* allows a layering of colors without blending them, and one color does not drown out the other. *Chusen* is also notable for the lack of fine lines. Most *chusen* patterns feature chunky images with charming gaps between parts of the image. The front and back sides of the textile are mirror images and unbeknownst to many, the artisan can dye about 20 pieces of cloth simultaneously. Most importantly, the specialized *chusen* process of making textile art is reserved almost exclusively for the decoration of *yukata* and *tenugui*.

Yukata Culture: From Bath House to Fireworks

Originally, a *yukata* and a kimono were two very different things. For outsiders though, distinguishing the unique characteristics of the various types of kimono can cause quite a conundrum. Even the semantics are confusing; a *yukata* is referred to as a summer kimono. But technically, there are subtle differences between a cotton *yukata* and a summer kimono.

This action photograph shows steaming hot, red dye the moment it is being carefully poured over a stack of cloth about twenty layers deep. Once the dye covers the desired areas, the dyer quickly activates a vacuum pump which sucks the color down through each layer of cloth. In this way, the dye is pulled through the cloth and the image, or pattern, will be printed on both sides. *Photographed at Murai Senko Jo.*

The *yukata* was first intended primarily as a type of robe to wear back and forth to the public bath house, or as a type of pajama worn at home. It was designed as the ultimate casual wear, especially during warm weather. The construction of the *yukata* is a simple variation of the traditional kimono. It's almost always made of cotton, always unlined, quite easy to wear and historically, it was not expensive.

Traditional kimonos, however, are most often made from silk, brocade, or cotton. Kimonos come in many different styles. They can be unlined for summer, or lined for autumn and spring, or thickly padded for winter. The kimono is typically worn with another layer underneath. At least two collars are added, sometimes more depending on the occasion. The standardization of the 14-inch kimono panels from which kimonos are constructed makes it simple to assemble and disassemble, but the standards by which kimonos are worn are very strict. As each year passes, fewer and fewer people are familiar with how to properly wear a kimono.

There are several popular holidays and celebrations where men and women still wear traditional kimonos. For example, on the second Monday in January, the "Coming of Age" day marks the time to congratulate men and women who have reached the age of 20. There are ceremonies held by civil servants in communities all over Japan and many young women take the opportunity to wear beautiful *furisode* (long sleeve) kimonos and *zōri* sandals. Since the vast majority of these young women, and their mothers for that matter,

LEFT This 1905 postcard represents another era entirely, a time when Japan's steamy public bath houses, natural hot springs, and small private baths were part of a daily ritual that cleansed the body, as well as the soul. The woman pictured is wearing a *yukata,* which is an unlined robe, or kimono, made of cotton. During the nineteenth and twentieth centuries, it was common to wear a *yukata* back and forth to a public bath house, or as a robe or pajama while at home. *Courtesy Yu-yu-tei, an Osaka antique dealer.*

RIGHT The *yukata,* a type of summer kimono, is popular dress for certain holidays and festivities, especially during *Gion Matsuri* (or Gion Festival), which is celebrated in Kyoto during the month of July with parades and fireworks. Many Japanese take advantage of special celebrations to wear gorgeous, colorful cotton *yukata.* In addition, the *yukata* has become a fashion icon on its own and is sometimes worn by men and women for daily wear.

do not know how to dress in a formal kimono, they often make appointments at a beauty salon to dress them. Furthermore, these very special formal kimonos can be quite expensive to purchase, so many people rent them.

The *yukata* has evolved considerably and it is no longer clothing just for the bed or bath. It too is also worn at certain holidays and festivities, especially during the popular *Gion Matsuri* (or Gion Festival), which is celebrated in Kyoto during the month of July with parades and fireworks. Many Japanese take advantage of this celebration and many other events to wear gorgeous, colorful cotton *yukata*. In addition, the *yukata* has become a fashion icon on its own and is sometimes worn by men and women for daily wear.

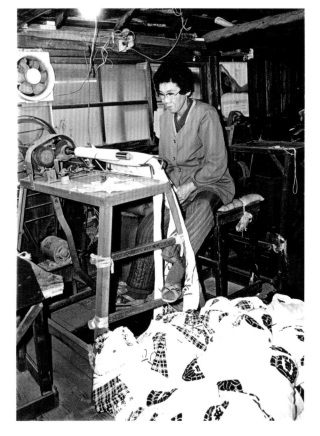

TOP The Kitano Temple, in Kyoto, hosts a large open-air market on the 25th day of every month. Vendors sell food, crafts, pottery, dishes, clothing, and many other items, including a wide variety of old textiles.

BOTTOM LEFT Open-air markets are held at temples and shrines on certain days and these events are a popular attraction for tourists, as well as locals. Textile enthusiasts especially seek out these events in order to shop at the best stalls featuring antique fabric and unusual textiles.

BOTTOM RIGHT This photo from the late 1940s shows how long, uncut panels of cotton *tenugui* are rolled with the help of this simple machine. *Courtesy of Murai Senko Jo studio.*

From the Runway to the Studio of Quilters

There is an awakening in Japan among a community of hip fashion designers who are making highly creative renditions of traditional cotton kimonos and *yukata*. These new brands have accumulated dedicated followers who crave the traditional ideas, but with a modern wearability and cutting-edge aesthetic. This new genre of *yukata* and casual kimono clothing mixes fashion statements such as lace t-shirts and leather boots with classic Eastern motifs and patterns, and funky new graphics. The cloth itself can be a work of art and can be hand-dyed, hand-painted, or even digitally printed. More and more these fashionable works of art are moving past the runway and are making their way into the daily lives of the fashion conscious.

Some of these new-generation fashion designers are renowned for referencing vintage *yukata* patterns and colors for their collections, especially from the pre- World War II years, as well as the fresh colorful fashions from the 1960s, '70s, and '80s. And it is the latter category, the vintage *yukata* cloth from the 1960s forward, that has also captivated an entirely new audience: quilters.

A small cadre of individuals and quilt retailers in the US are introducing rolls of exceedingly unique vintage *yukata* cloth to the quilt community. Quilters are constantly searching for fresh ideas and fabric, particularly those quilters who make quilts with fabric featuring vivid prints. These gorgeous color-infused and hand-dyed cotton textiles offer a design aesthetic unlike anything Western quilters are accustomed to. They appreciate that these textiles are hand-dyed, and as such, their quality is vastly different than commercially printed cottons.

Vintage *yukata* from this era is either the typical blue and white indigo with iconic emblems, geometric shapes, or modern designs, or it is very colorful with vivid imagery of flowers, dragonflies, butterflies, Japanese characters, or repetitive patterns. In some cases, these have incredibly striking color combinations.

Yukata textiles are consistently made in long rolls of cloth that are typically fourteen inches wide (35 cm). These same fourteen-inch widths have endured for centuries because these are the standardized widths for kimono making. Each section of a traditional kimono is made from one fourteen-inch panel. Two panels are used for the front, two panels for the back, and one panel each for the front and the back of the sleeve, for a total of eight panels of uniform width. Some modern kimono fabric is now available in wider widths.

LEFT Vintage *chusen* dyed cotton *yukata* fabric is sometimes exported to the US and other countries where it finds new audiences who appreciate the Japanese aesthetic and unique hand-dyed patterns. *Photo courtesy of Okan Arts, a Seattle retailer and online shop that markets Japanese yukata to quilters and seamstresses.*

RIGHT Two Japanese women are pictured in 1940 wearing *yukata* and cotton summer kimonos. They are sightseeing in the mountains in Taiwan and are very casually dressed. The woman on the left is wearing a *yukata* decorated in a *yagasuri* pattern, which is a repeating, geometric pattern featuring arrowhead-shapes. It is associated with good luck and weddings. The woman on the right is wearing a traditional cotton kimono. *Courtesy of the family of Yuriko Sakuraoka.*

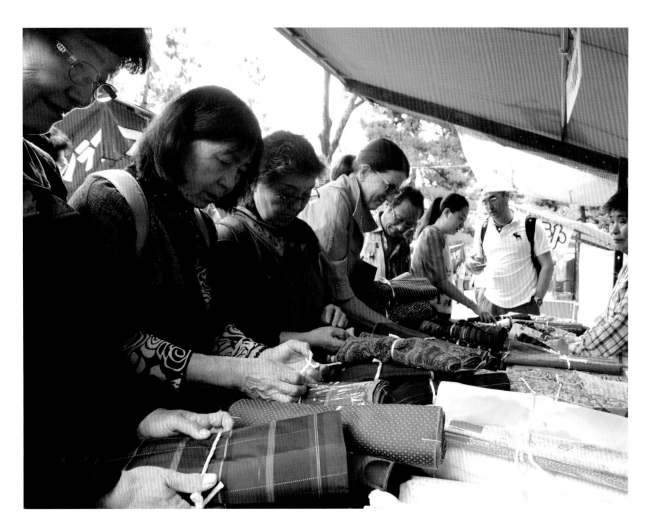

TOP Shoppers arrive at outdoor markets in Japan's major cities early to find the best selection. Some die-hard shoppers will arrive at 2:00 or 3:00 a.m. in order to meet the vendors as they arrive and be the first to preview their goods. Most markets like this one open for business around 5:00 a.m., and frequent shoppers will explain that the highest quality goods are sold by mid-morning. The shoppers in this photo are intently studying vintage *yukata*, cotton kimono cloth, and other folk textiles.

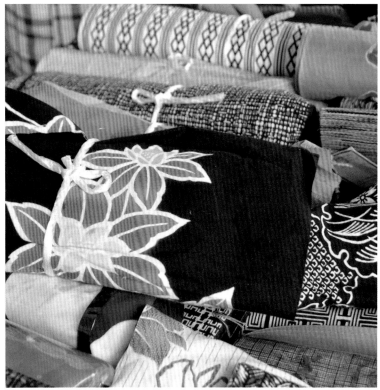

BOTTOM Rolls of hand-dyed vintage *yukata* made using the *chusen* method, such as some of those pictured here, are deemed attractive and exotic textiles by quilters and sewists around the world. Not all *yukata* cloth on the market today is made using traditional methods. Many are mass produced using modern printing techniques.

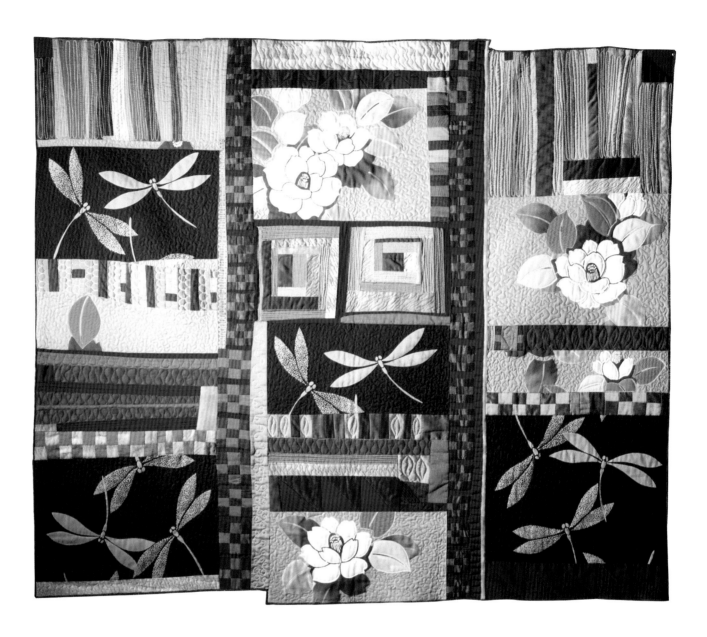

This quilt is an example of vintage, hand-dyed *yukata* cotton that has been cut up and incorporated into an improvisational, pieced studio quilt, along with commercial cotton fabrics and wool. The striking taupe flowers and the beautiful indigo dragonflies lend the quilt an exotic aesthetic. This quilt was made by the author in 2015. It is machine quilted.

Tenugui: Simultaneously Ubiquitous and Exclusive

Tenugui (the literal translation is a hand wiping towel) is something akin to a slightly longer version of a Western handkerchief. The width of *tenugui* can be approximately ten inches, but is most often produced in the same fourteen inch (35 cm) width as *yukata* and kimono fabrics. Finished *yukata* textiles are sold in long rolls, but *tenugui* is cut in lengths about of about ninety centimeters, or roughly one yard/meter. Like its sister cloth the *yukata*, *tenugui* are also hand-crafted using the *chusen* method.

Tenugui is always made of a thin cotton and the cut edges are traditionally left unhemmed. The thinness of the cotton and the fact that there are no bulky seams or stitching means the *tenugui* is fast drying, which was an important benefit when *tenugui* were carried as towels to the bath house or elsewhere.

TOP This vibrant and artistic octopus is an example of handmade *tenugui* (hand towel, or handkerchief). *Tenugui* has evolved far beyond its original intention of a mere towel and many are considered rare and special works of art. Ichiro Takizawa has more than 10,000 *tenugui* in his personal collection, some of which are his own designs or produced in his studio called Tokyo Wazarashi. *Courtesy of Ichiro Takizawa, Tokyo Wazarashi Co., Ltd.*

RIGHT This clever illustration, which has been created as a *tenugui*, accurately depicts each step in the *chusen* process as it was done centuries ago: creating stencils, preparing cloth for dyeing, making paste, using the squeegee, pouring dyes, old fashioned vacuum techniques, hanging on poles to dry, and finally, the river wash. Interestingly, not too much has changed, other than electrical vacuums and more environmentally-friendly washing options.

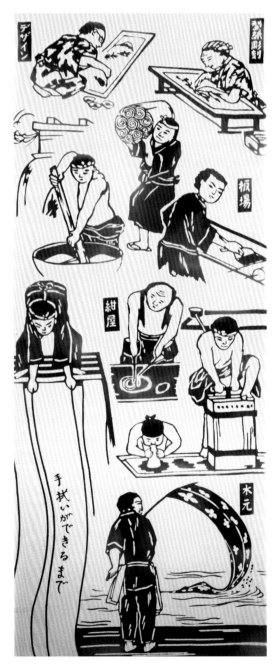

Tenugui is a bit like wine. The everyday variety is popular with the masses and can be as ordinary as a towel. It also has many other innovative applications. It's particularly popular with chefs who use *tenugui* as colorful head scarves. It can double as a *furoshiki* (cloth wrapping paper) to transport gifts or groceries. In addition, it is common to use *tenugui* as a collar that is tucked under a traditional kimono. Custom-printed *tenugui* are also popular at parades, festivals, weddings, and other events. There is also an avid group of contemporary graphic designers collaborating in Japan today who seek to make the artsy *tenugui* as ubiquitous, and as well loved, as a graphic t-shirt.

But there are also certain varieties of *tenugui* that are in an exclusive category, just like an aged, rare, estate wine. These *tenugui* are sought and collected by art aficionados in Japan and abroad who recognize and grasp the unique traits of this art form. Some of the most sought after *tenugui* were made during the Edo period, or just after, by well-known artists whose names evoke awe, and also by unknown artisans who toiled away without credit or name recognition. Because of their small size and exquisite and truly unusual aesthetic, it's not unheard of for some collectors today to acquire tens of thousands of *tenugui* for their personal collections.

Chusen: Crafting *Yukata* and *Tenugui* Today

There are many variations and regional specialties of *chusen*, yet the future state of this ambitious handicraft is a huge unknown. Like so many traditional folk arts, there are only a few artisans and workshops left who still practice this method today. To fully endorse the traditional *chusen* methods is to commit to a fairly lengthy process that takes years to master skillfully. Ichiro Takizawa owns a *chusen* workshop called Tokyo Wazarashi Co. Ltd, and he hosts many cultural classes to inspire people to learn the craft with the help of

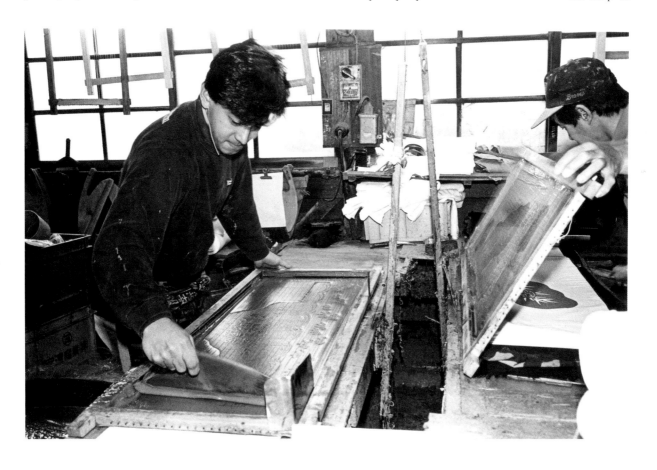

Mitsutoshi Murai (left) is working in his family's *chusen* studio in 1980. The traditions of *chusen* dyeing have remained essentially the same for centuries. Mitsutoshi is applying a paste-resist mixture to one layer of cotton cloth to prepare if for dyeing. The areas where the paste is applied will resist the dye. Eventually, the artisan will fold many layers of cloth, one on top of another, and each layer will be treated with the paste resist, and later dyed. *Courtesy of Murai Senko Jo.*

Megumi Yahagi, an experienced instructor at his workshop. Serious students often seek out classical training through an instruction system known as *Shokunin-juku* (a type of artisan cram school). However, only a tiny fraction of people who visit his studio are truly interested in mastering these techniques. He estimates that it requires two to three years to master dyeing techniques and at least five years to truly grasp the craft of making stencils. Another prominent studio where *chusen* masters go to work is Murai Senko Jo, located in Edogawa. This studio is run by a father and son team and they have been making stunning works of art continuously since 1936 when the father, Yonesuke Murai, first opened his shop. The studio is also well known for its custom-dyed *tenugui*. Many Japanese seek out these traditional hand-crafted textiles and request special messages to be printed so they can be presented as gifts for special events, weddings, business parties, and other occasions.

The important stencil is used to transfer the pattern and it is still made by hand in many workshops, although some stencils are now cut using laser technology. The handmade stencils are built with several layers of mulberry paper and the craftsman must first transfer the design and carefully cut away the image, leaving tiny sections connected so the whole thing won't fall apart. A thin layer of lacquered silk gauze is placed over the stencil to secure it, and additional layers of *washi* are added for support; then those remaining connectors, called *tsuri*, are removed. Once the stencil is ready, it is softened, stretched, and nailed onto a wooden frame.

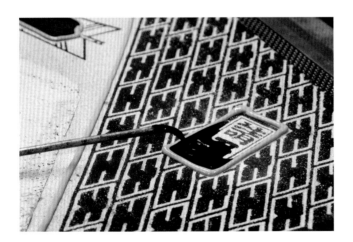

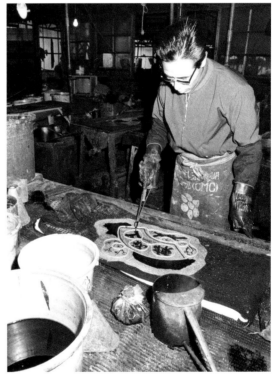

TOP RIGHT After each layer has been treated with paste resist, the whole stack of cloth is placed on the floor and dusted with sand or sawdust, which helps prevent the layers of cloth from sticking together.

BOTTOM LEFT Deep indigo dye as it is being poured into a special part of the design. Certain areas, like this one pictured here, are "walled-off" (or lined) to keep the color from spreading. The paste to make these walls, or lines, is applied using a bag with a special tip, much like a cake decorating tool.

BOTTOM RIGHT *Chusen* has been hand-dyed using basically the same process for hundreds of years. This vintage photo shows the hot dyes being poured onto the cotton cloth. *Courtesy of Murai Senko Jo studio.*

The cotton textiles, which have been washed, prepared for dyeing, and rolled are placed on one end of the table. A special resist paste is spread onto the fabric with a squeegee. Then the fabric is pulled from the roll and folded over, and a second layer is placed on top of the cloth that has just been marked with the paste. In this step, the placement of this next fabric layer, as well as the placement for the stencil is critical. The screen is placed on the second layer. Anything other than perfect registration will spoil the design. The paste is applied through the stencil one layer of fabric at a time. The purpose of the paste is to protect (or resist) the areas of cloth which are not meant to be colored. This is repeated as many as 20 times for each layer of cloth.

Chusen dyes are heated prior to being poured. The finished product can be dyed a single color, which would most often be indigo, or it can be multiple colors, even variegated colors. Multiple dyes can be poured on the fabric simultaneously, sometimes by more than one person, and when done properly, these movements are highly choreographed and carried out by only the most skilled craftsmen and women. Once the dyes are poured, the dyer steps on a pedal to active a vacuum which quickly sucks the liquid down to the bottom layer of cloth, ensuring a mirror image of pattern and color on each side of the cloth, yet another trait unique to *chusen*.

After dyeing, the cloth is washed in a series of tanks to remove the paste and excess dye. Then it is spun to remove excess water. Finally, the very long rolls of cloth are taken outside to air dry on tall drying poles. Once these poles are filled with drying *yukata* and *tenugui*, the poles themselves become a decorative work of art, their unique colors and iconic images fluttering in the wind to remind all who pass by of an important part of Japan's cultural traditions. Collectors and passionate textile enthusiasts around the world treasure these handmade cotton textiles.

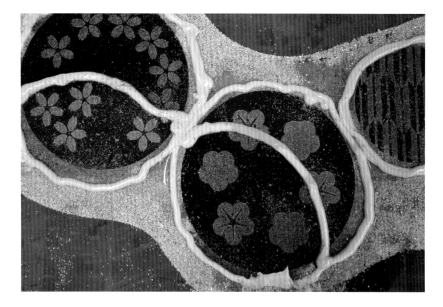

LEFT One of the unique advantages of *chusen* dyeing is the ability to apply two or more colors at the same time, using the same pattern. This is known as *sashiwake-zome*. In this example, a thick, paste-resist line (or wall) is added by hand in order to keep the blue and green dye from bleeding outside the image area. With highly skilled artists, two or more people will pour the dyes at the same time using carefully choreographed motions so that no dye is spilled and the colors appear in the desired areas. *Photographed at the Tokyo Wazarashi Company, an artist co-op located in Tateishi, Tokyo.*

BOTTOM These children are pictured in a 1981 photograph wearing colorful cotton *yukata*, celebrating *Tanabata*, or Star Festival, which is held the seventh day of the seventh lunar month. *Courtesy Yu-yu-tei, an Osaka antique dealer.*

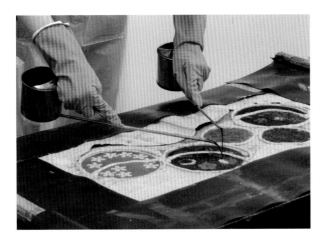

TOP LEFT Ichiro Takizawa's *chusen* workshop, Tokyo Wazarashi Co., Ltd., is a place for artists and students to gather and practice. A visitor is pictured here learning *sashiwake-zome,* the technique of dyeing two or more colors at the same time. Newcomers and students are welcome to visit and learn the art of pour dyeing. Keiko Takizawa works with her father in the family business in an effort to keep the art form alive for future generations.

TOP RIGHT *Yukata* and *tenugui* are deeply rooted in Japanese traditions and the *chusen* method to decorate these textiles have been used for centuries. These stainless steel dyeing cans resemble old-fashioned watering cans and their long spout is ideally suited to pouring hot dyes with precision.

BOTTOM A special mixture of paste is spread onto the fabric with a squeegee through the stencil. This paste is applied to one layer of fabric at a time.

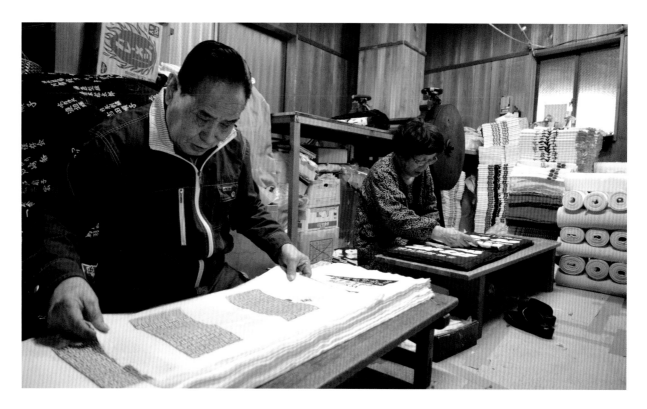

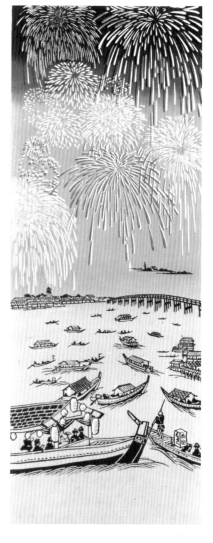

TOP Stacks of customized *chusen*-dyed *tenugui* are being folded by the parents of Mitsutoshi Murai for their family business. Mistutoshi's father, Yonesuke Murai, founded the company and is a *chusen* master. *Photographed at the Murai Senko Jo studio in Edogawa, Tokyo.*

BOTTOM LEFT Another popular use for *tenugui* is a clever folding technique to convert it into a type of wallet, or small pocket.

RIGHT A hand-crafted *tenugui* depicting a popular summer fireworks celebration. *Courtesy of Ichiro Takizawa, Tokyo Wazarashi Co., Ltd.*

LEFT The second Monday in January is the "Coming of Age" day, which marks the time to congratulate men and women who have reached the age of twenty. There are ceremonies held by civil servants in communities all over Japan and many young women take the opportunity to wear a beautiful *furisode* (long sleeve, formal) kimono and *zōri* sandals, worlds away from the subdued dress seen in most of modern Japan.

This 1956 photo was taken outside the Murai Senko Jo studio, a *chusen* workshop located in Edogawa, Tokyo. This studio first opened in 1936. The men are pictured wearing *hanten,* a traditional short coat, and hanging above their heads are long rolls of cotton that have been dyed using the *chusen* process. Yonesuke Murai, who is pictured in the center with his young nephew sitting on his lap, is considered a *chusen* master, and as of 2016 he is one of the few still actively pursuing this craft. He began studying this particular art form at the tender age of twelve. *Photo courtesy of Murai Senko Jo studio in Edogawa, Tokyo.*

ABOVE & OPPOSITE After the *chusen* dyeing is complete, the long rolls of continuous cloth are hung outside to dry. *Photos taken at Murai Senko Jo studio in Edogawa, Tokyo, in the late 1950s and in 2016.*

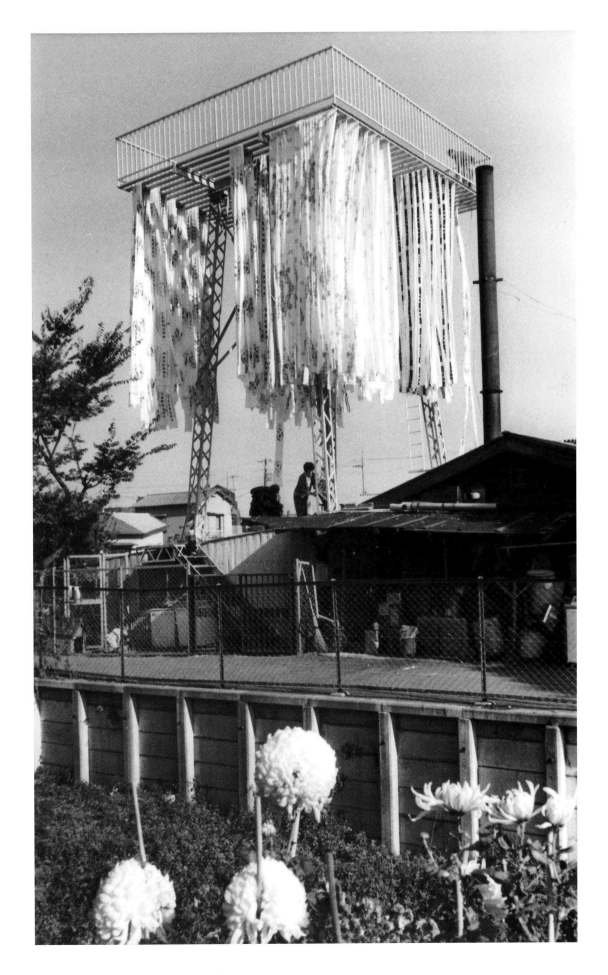

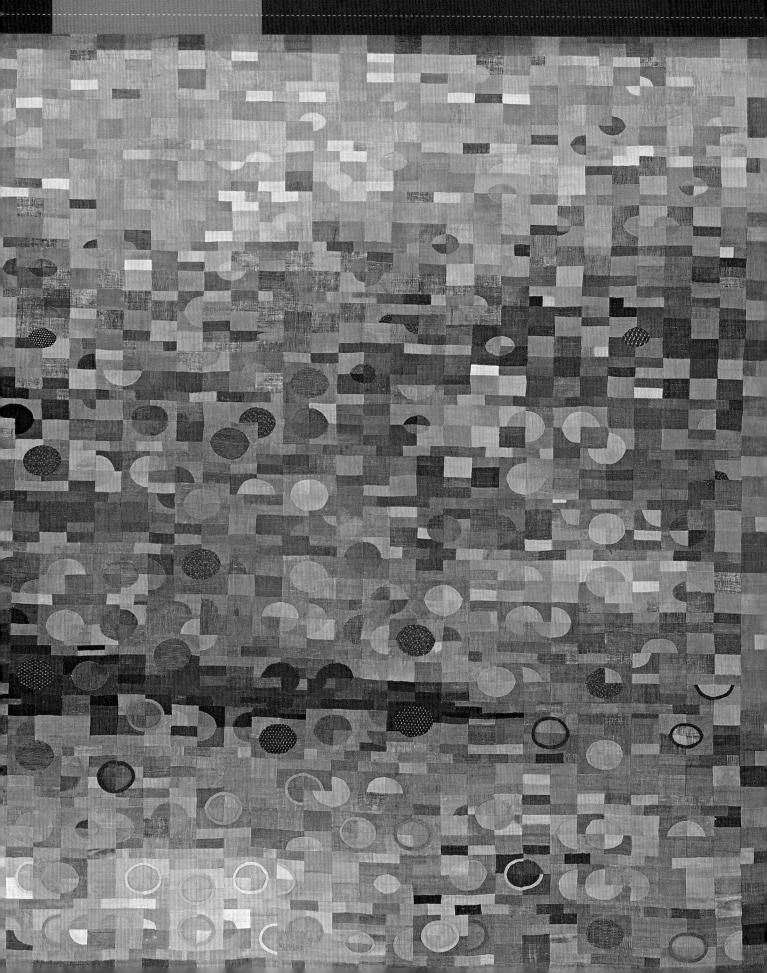

JAPAN BLUE

The color blue is both familiar and distant. It is strikingly rare in the natural world of plants, animals, or minerals, but seemingly ubiquitous in the vast sky and sea. To the island nation of Japan, blue is symbolic of water and rebirth. Blue is magical. Indigo from Japan is so adored it even has its own name: Japan Blue.

Japan Blue is a centuries-old, endearing term identified with indigo of course, but it is so much more. It is an aesthetic, a sensation, and a revered art form all rolled into one. In the minds of many in the modern world, Japan Blue means cotton, and more specifically denim.

In recent years a small clique of devoted "denim chasers" (also known as "denim heads") have emerged, and these fashion aficionados travel the world seeking the best of the best in blue jeans. Japan Blue is a powerful draw for the denim heads. Their quest for quality cotton and astounding blue color can be found in Japan's specialized boutiques in the big cities, but also in places like Kurashiki, a vital part of Japan's denim heritage. For those willing to pay the hefty prices, today's Japan Blue seekers can find exquisite, high-fashion denim of every kind made exclusively in Japan. In addition, large retailers, such as the Japanese company Uniqlo, are

OPPOSITE Etsuko Misaka. *Calm*. 2014. Indigo cotton: 80" × 69" (203 × 176 cm). Pieced, hand quilted. This superbly crafted quilt, with its very appropriate title, was awarded the Grand Prix prize at the 2015 Tokyo International Great Quilt Festival. It is an impressive study of the subtle variations of indigo.

ABOVE Indigo is a magical, mysterious, mighty color. For centuries, indigo dyers closely guarded the secrets of their craft. But one could always distinguish the indigo dyers by their permanently-dyed, blue hands. Toru Shimomura has those permanently dyed blue hands, just like the indigo heroes of his past. As most dyers have moved to synthetic and chemical dyes, they have adopted gloves as well. But this dyer is a missionary for natural dyes and as such, he—and his blue hands—are a constant icon for authenticity.

having mass-market success bringing low-cost Japanese denim blue jeans, as well as many other products, to consumers worldwide.

Chasing Japan Blue is actually not all that new. During the Victorian era when the Japan craze moved through England and France, blue was a powerful draw for those seeking and making art. Japan Blue was sought by the wealthy who imported decorative items and textiles for their homes, especially indigo. England's William Morris, the Western father of the arts and crafts movement, was certainly inspired by Japanese patterns and motifs and he dedicated years to studying natural dyes. He was so taken with indigo that at one point, his indigo experiments and stained blue hands were an endless source of amusement to his friends and colleagues. Many other artists, such as the French master Edgar Degas and the American expatriate Mary Cassatt, both studied the Japanese aesthetic extensively. Many other artists and art enthusiasts in the late nineteenth century were inspired by Japan Blue, and by the art of Katsushika Hokusai and his contemporaries.

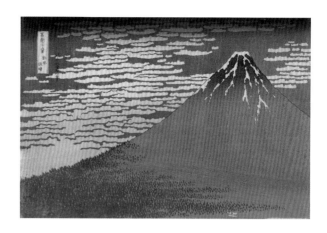

Katsushika Hokusai (1760–1849). *Fine Wind, Clear Weather*. (Also known as *Red Fuji*, part of the series "Thirty-six Views of Mount Fuji"). 1830–31. Woodblock print, ink and color on paper: 9⅝" × 15" (24.4 × 38.1 cm). *Collection of Museum of Fine Arts, Boston. Image courtesy of Wiki Commons.*

LEFT These two variations of beautiful, shibori-dyed cotton indigo are original designs by Ken-ichi Utsuki made at his indigo studio, Aizenkobo, in Kyoto. Modern consumers use handmade textiles like this for scarves and other clothing, as well as wall hangings, table decoration, or to make quilts.

RIGHT A traditional indigo wall hanging created using a hand-drawn, paste-resist technique. Dyed with natural indigo dye by the studio Kobo ai no Yakata ("House of Indigo").

The Great Hokusai: A Patriarch of Blue

Hokusai's *ukiyo-e* style woodblock prints are considered masterpieces in the world of printmaking. In the 1830s, he created his now famed series of prints known as "36 Views of Mt. Fuji," and ten of those celebrated prints were issued in blue, or *aizuri*. These particular *aizuri* prints were either blue on white, or *semi-aizuri* which were primarily blue along with subtle shades of pink, green, black, and other colors. Hokusai's blue graced all the obvious places, sky and water, even Mt. Fuji itself. But he also brought the color to common items, such as clothing.

As the Japan craze swept the Western world during the 1880s and '90s, interest in all things Japanese skyrocketed. Japan Blue—this one strong, magical color—began to dominate Japanese art and handicrafts as they migrated around the world of art. Artist, critic, and famed collector John La Farge, who was a fierce competitor to Louis Tiffany in the creation of stained glass, was a prolific importer of Japanese prints to America, as well as textiles and other crafts. La Farge traveled to Japan in 1886 with Henry Adams, grandson of US President John Quincy Adams. In the West, La Farge was a sought after lecturer on Japanese art and decoration and he truly prized *ukiyo-e* prints. Okakura Kakuzō, author of the classic *Book of Tea* (1906), dedicated his book to his close friend, John La Farge.

Hayashi Tadamasa, a Japanese expatriate art dealer living in Paris in 1899, sold approximately 160,000 *ukiyo-e* prints to Western clients over a decade. He is credited with the duality of legitimizing the art form of *ukiyo-e* and simultaneously draining Japan of their native art prints. In fact, it is widely believed that Hayashi Tadamasa, John La Farge, and other art dealers like them, helped build a greater appreciation for this art form among the Japanese themselves.

The famed American architect Frank Lloyd Wright also adored *ukiyo-e* prints. He was particularly drawn to their spectacular simplicity and drama, and *ukiyo-e* was the only muse he would willingly acknowledge.

Today, Hokusai's prints are beloved, and his blue is particularly brilliant. His superb renderings of the everyday worker wearing *aizome*, which is indigo-dyed cotton work clothes, solidified the image of this practical cotton cloth as simply Japan's national dress of the day.

In an ironic and fascinating twist of fate, Westerners perceived the source of the deep rich blue ink of Hokusai's original works on paper as mysteriously Japanese. Most assuredly it was assumed to be indigo. But the pigment used to create Hokusai's hue on paper was actually a synthetic pigment imported from a German chemical manufacturer. Its name? Berlin blue.

Utagawa Hiroshige (1797–1858). *The Rendezvous Pine near the Asakusa River*. (Part of the series "One Hundred Famous Views of Edo.") 1856. Woodblock print, ink and color on paper. This *ukiyo-e* print of historic Edo (Tokyo) captures a deep intensity of magical blues in the sky and water. *Image courtesy of Wiki Commons.*

"I have never confided to you the extent to which the Japanese print per se has inspired me. I never got over my first experience with it, and I shall never, probably, recover. I hope I shan't."

—Frank Lloyd Wright

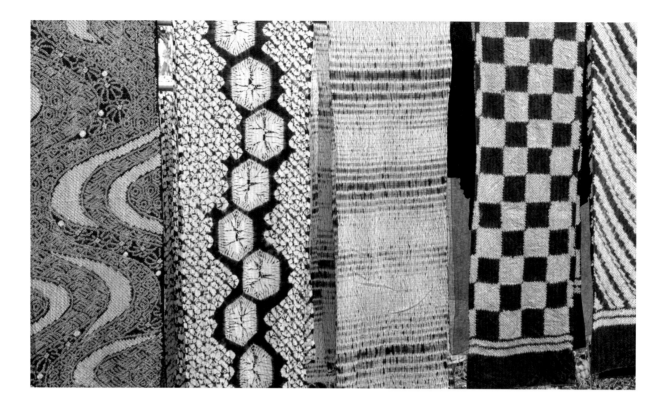

Crops of Indigo

In Japan, the perfect blue dye grows in their own home-grown soil in the leaves of *Ai,* the almighty indigo plant. It is perhaps strange and fitting that the word for beloved indigo is *Ai,* which means both indigo and love. Indigo even has its own god: *Aizen Shin.* Japan's indigo dyers trust in *Aizen Shin* and they often pray to her for good luck before starting their work.

It's also intriguing to consider that the enormous influence of the epic indigo plant is so closely connected and dependent on another epic plant: cotton. The fibers of cotton are extraordinarily well suited to becoming one with indigo dye, a reality that has been fully exploited by Japan's folk and textile dyers, artists, weavers, and stitchers.

Strange as it may seem, there are thousands of natural varieties of indigo plants grown around the world, yet all of them produce essentially the same blue color. Japan's indigo, technically known as *polygonum tinctorium,* was first introduced in the fifth century.

TOP Newly dyed indigo cloth drying in the fresh air and sun.

BOTTOM Extreme close-up of a beautifully pieced quilt made by Shizuko Kuroha using antique indigo cotton. Shizuko is a master of antique cotton textiles and she has a strong affinity for indigo. Her brilliant quilts exude her love for indigo and have inspired quilters around the globe.

To make dye from the indigo plant is a long and complicated, even dirty, process. At one time, growing indigo was big business in Japan. In 1903, there were an estimated 40,000 acres of indigo cultivated in Japan. But indigo farming is so difficult that the number of farmers in Japan willing to take on this work has plummeted. As of 2016, there are only a half-dozen small farms left that are cultivating about 100 acres. Most of these farms are located on Shikoku Island and Okinawa.

Indigo dye is made from the leaves. Japan's indigo stalks produce green leaves that turn dark-blue when dried. The leaves quickly regenerate, so they can be harvested twice each growing season. The flowers, which range from white to pink, are not used in dye making. The flowers generate seeds for the next season's crop.

TOP Improvisational running stitch with white cotton thread covering a vintage indigo and white textile.

LEFT Antique *katazome* print featuring a stunning variation of indigo and the natural cotton color.

RIGHT Each time the textile is dipped in an indigo dye bath, the textile must be rinsed afterwards to fully oxidize the material and bring out the indigo color.

Once the leaves are harvested, they must be separated from the stems, dried, and spread in a *nedoko* (covered shed) where they are treated and turned into *sukumo,* fermented indigo. Making *sukumo* is a tough business. The leaves are kept in huge clay beds. The giant piles of harvested indigo leaves are kept covered and they are constantly sprayed and steamed with hot water. Every five days the beds must be turned, which is an arduous task because the beds can be several feet high and depending on the size of these wet beds, each bed can weigh a ton or more. Turning a bed of the smelly, wet concoction can take several hours.

The fermentation process requires at least three months. If all goes well, the leaves will solidify and darken, an indication that enzymes and oxygen have properly fermented. Afterward the leaves are dried again, and at this stage they can be shipped and safely stored. When the dyer is ready, the dried, fermented—yet, all natural—leaves are added directly to the vats.

Indigo Dyes Alone

Part of the magic and mystery that surrounds indigo in so many cultures revolve around the fact that indigo, and shellfish purple, are the only natural dyes that work without mordant. Mordant is an organic chemical, like salt, that must be added to all other natural dyes to make them adhere to textile fibers. But natural indigo has its own inherent chemical reactions that allow it to dye all alone, as if by magic. No mordant required.

Synthetic, Chemical, and Natural

Chemical indigo dye was first discovered in the nineteenth century and it became widely available and adopted at the beginning of the twentieth century. It is difficult for the untrained eye to distinguish between cloth dyed with synthetic, chemical, or natural indigo dyes. There are many technical differences between these methods. For example, the use of chemical dyes can make the dye treatment in the final product longer lasting. Chemical dyes are used in modern textile production factories, such as those for blue jeans and other items. For artisan dyers, the use of chemical dyes can speed up the entire process, especially for the dark colors.

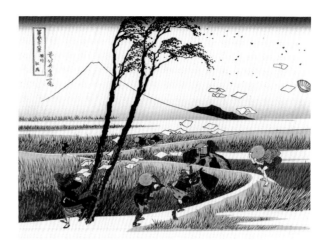

With natural indigo dyes extracted from plants, the primary difference in color, (which at the same time can be considered the primary benefit) is that with natural indigo, there are so-called "impurities" that are a natural part of the dye. These impurities can be tiny bits of indigo red or other miniscule elements of color that are inherent in a natural product and dyers using this method believe these elements give organic indigo a richer, more interesting, hue.

In the quest for true Japan Blue, the natural dyer must be patient. The cloth must be dipped in the vat, removed and oxidized, rinsed, dried, and then the process is repeated all over again until the true color reveals itself. Indigo, perhaps because of these repeated dye baths, is so colorfast that it can last for many, many years. The deepest blue may fade, but the indigo tinge will remain.

Many indigo dyers in Japan use a traditional vat of natural Japanese-grown, fermented indigo leaves, but they will enhance their dye with synthetic indigo, such as grains, paste, or pre-reduced indigo solutions. On the flip side, some dyers will use all synthetic or chemical dyes as their primary base, and add small bits of naturally grown fermented indigo as a way of seeking some of the impurities of color associated with natural indigo.

ABOVE Ken-ichi Utsuki is an artisan indigo dyer. His son and wife work alongside him, and the whole family hopes to keep the art form alive for future generations. *Photographed at Aizenkobo studio in Kyoto.*

TOP RIGHT Katsushika Hokusai (1760–1849). *Yejiri Station, Province of Suruga.* (Part of the series "Thirty-six Views of Mount Fuji"). Circa 1832. Woodblock color print: 9.6" × 14.3" (24.3 × 36.3 cm). Hokusai's superb renderings of the everyday worker wearing *aizome* (indigo-dyed cotton work clothes) solidified the image among Westerners that this practical cotton cloth was Japan's national dress of the commoner. *Collection of Brooklyn Museum of Art. Image courtesy of Wiki Commons.*

OPPOSITE Indigo dye has lifelike characteristics that change, so nurturing the vat of organic indigo can be a persnickety process. The dye needs constant attention and must be stirred at least four times a day, every day to keep it oxidized. From his studio in the mountains of Ohara, Toru Shimomura can feel, see, and smell the condition of each vat of his natural indigo dye.

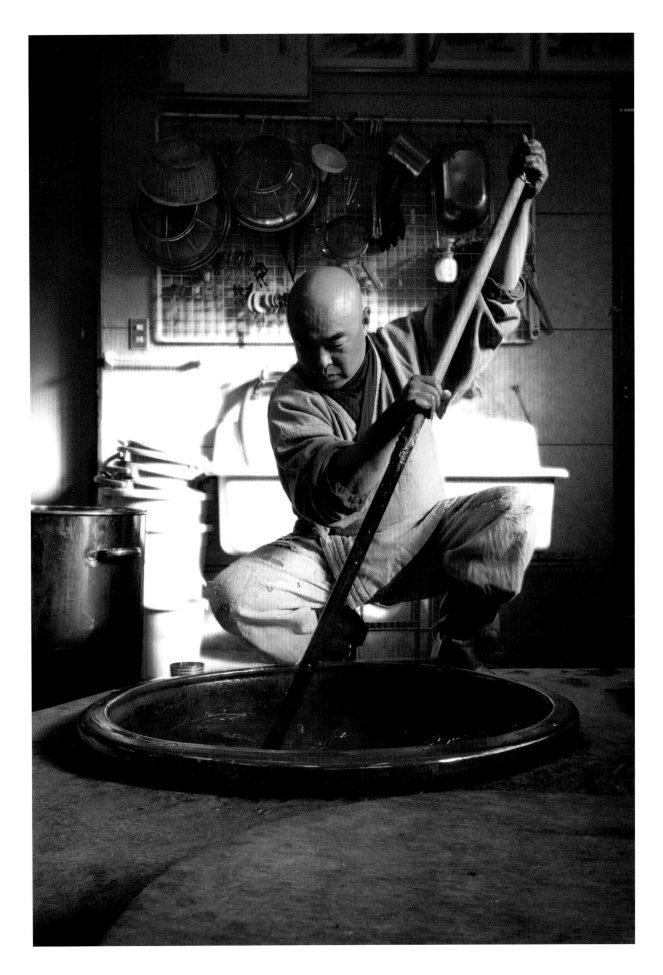

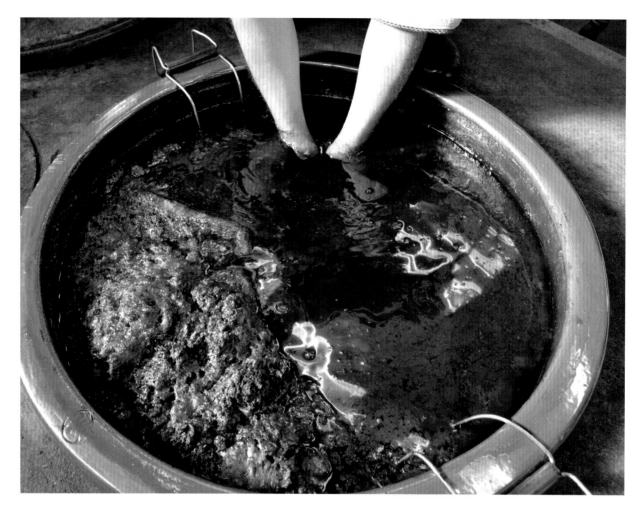

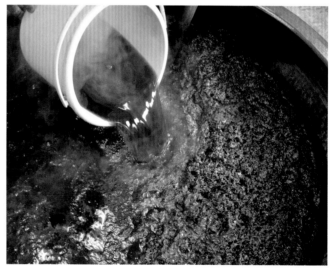

TOP There are no shortcuts in indigo dyeing. To achieve deep rich colors, each piece of cloth must be dipped and rinsed multiple times.

BOTTOM LEFT Close-up view of the thick, gooey indigo mixture.

BOTTOM RIGHT Steam rises as hot liquids are added to the indigo mixtures. Temperature is an important variable for keeping indigo dye at its peak. The vats must be heated at all times.

LEFT The blue hands of Toru Shimomura holding fermented indigo leaves, called sukumo. The fermenting process is typically done by the farmer. At one time, there were thousands of indigo farms in Japan. Today, there are less than a dozen farmers still growing native indigo and fermenting it the traditional ways.

BELOW One of the greatest mysteries for indigo dyers is knowing the intensity of the dyed cloth because when the cloth is first taken out of the dye bath, initially it looks green or yellow. Oxygen turns it blue.

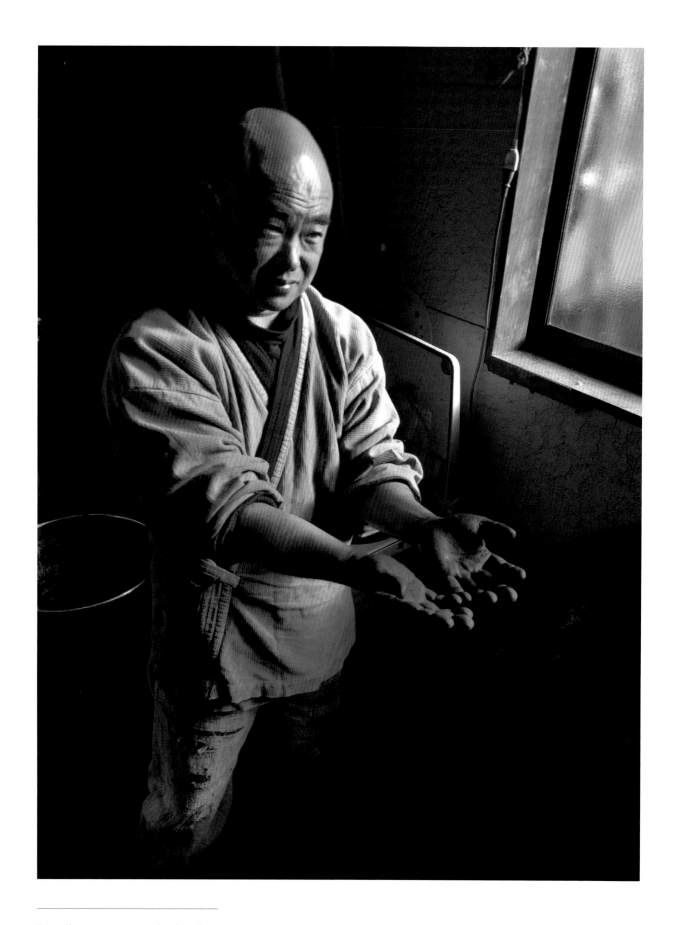

Toru Shimomura, natural indigo dyer.
Kobo Ai no Yakata, Ohara.

TOP A traditional wall hanging made with a paste-resist process and dyed with natural indigo. From the studio of Kobo Ai no Yakata.

CENTER & RIGHT Handcrafted goods like these, made from hand-dyed textiles, are special. They also typically cost more than mass produced goods. Fortunately, there is a growing awareness in many communities of the value of handmade, and consumers are beginning to place a higher value on their own folk traditions and the artists who are maintaining them.

TOP LEFT Etsuko Misaka. *Calm* (detail). 2014. A beautiful hand-stitched quilt featuring the many shades of indigo.

TOP RIGHT A strikingly rich cotton indigo created in part with shibori. This is one of many original textile designs from Aizenkobo studio.

BOTTOM Detailed image of a pieced quilt made by Shizuko Kuroha using antique indigo cotton.

WHITE ON INDIGO

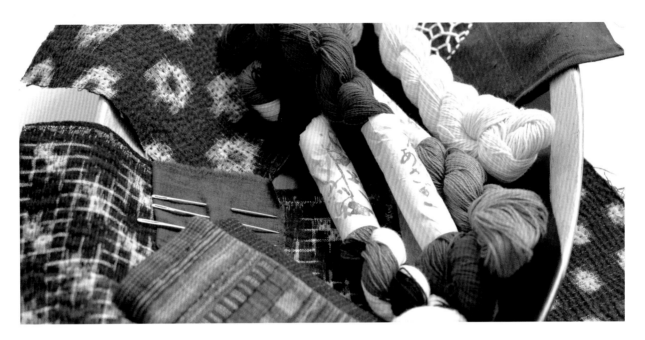

Origins of Sashiko

Sashiko is a style of stitching typically associated with white cotton thread on indigo-dyed cotton. Historically, sashiko grew out of the need to mend cloth, particularly when layers of cloth were added to patch holes or add extra protection from the cold. So what began as utilitarian straight stitches eventually, over time, evolved to become a substantial art form.

Sashiko is a specialized type of short, running stitch executed with equal spaces between where the thread is pulled in and out of the cloth. Most sashiko stitching uses a double thread, but it can also be made with a single thread. Typical patterns require evenly spaced stitches that create vertical, horizontal, diagonal, or curved lines on the fabric. Many patterns require straight lines that intersect at right angles, and in order to achieve this effect properly, the number of stitches and their length must be consistent. Often, each stitch is counted and carefully placed. Some sashiko designs are exceedingly complex and can take years to master.

Sashiko is prevalent all over Japan and has been practiced for centuries. The highly-specialized needle craft has spread to nearly every corner of the world and there are many sashiko masters throughout the East and West.

Sashiko has been practiced in Japan for centuries. Over the years, this highly-specialized stitching form has spread to nearly every corner of the world and there are many sashiko masters throughout the East and West. The finest sashiko is created using 100 percent white cotton thread, and most often, cotton textiles.

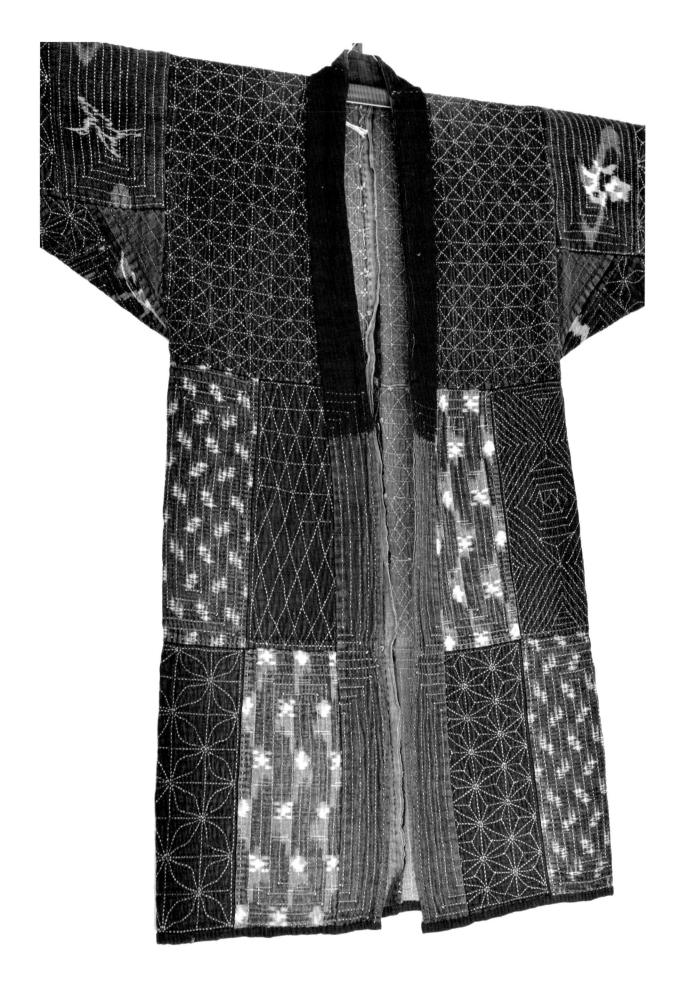

Catching Fish, Fighting Fires

The most stunning examples of antique sashiko can be seen in Japan's fisherman's coats. These coats are most often made with indigo-dyed cotton and typically covered with stitched geometric sashiko patterns in white thread. Originally these long coats were worn by fishermen at sea and the extra layers would protect the men from the bitter wind and cold. Most often they were made by wives, grandmothers, sisters, or professional seamstresses and the makers took great pride in creating beautiful garments worthy of the men who wore them. These highly-decorated coats came to be recognized as a type of uniform unique to fishermen and the style of coat and decoration would immediately identify the wearer as a fisherman. In some cases, these beautiful garments were too precious to wear as work clothes and instead would be worn only on special occasions or formal events.

Another equally treasured antique garment is the fireman's jacket. Again, these coats originally were created to protect men from the heat and flames and the layers of cotton would be stitched together with thick cotton thread. Often, firemen would douse the coats with water in the hopes that this would add even more protection.

Firefighting was tremendously difficult work. During the Edo period, the vast majority of structures were wooden and fires were rampant. It is believed that some of the finest examples of fireman's coats would have been specifically made by seamstresses for use by professional firemen in the urban areas. In many cases, the style of sashiko stitching on these coats is less decorative and more practical. It is created with thick cotton thread that traverses over and under each thread of the thickly woven fabric using an up and down stabbing motion. As a result, the stitching seems integrated with the fabric itself. This intense, extra layer of thread added considerable weight and protection beyond what the textile alone could offer.

Many of these antique fireman's coats in existence today are dark indigo and are highly decorated with insignia, characters, or colorful illustrations that were applied using a variety of stencil and free-hand paste-resist techniques. In many cases, these coats are reversible and it is also possible that, like the decorated fisherman's coats, these jackets would have been worn only during parades, celebrations, special events, or even when paying respects to a deceased fireman's family. In some cases it is believed that the firemen wore the highly decorated side of his coat on the inside while fighting fires, and once the fire was extinguished, the coat would be reversed to show the public the colorful insignia and convey the pride of a job well done.

OPPOSITE This antique fisherman's coat is made with indigo-dyed cotton and covered in geometric sashiko patterns in white thread. Originally these long coats were worn by fishermen at sea and the extra layers would protect the men from the bitter wind and cold. Over time they were worn on special occasions. *Courtesy Yu-yu-tei, an Osaka antique dealer.*

RIGHT Sashiko stitched with white cotton thread over indigo-dyed cotton patchwork. The crane is part of a woven textile known as *kasuri*.

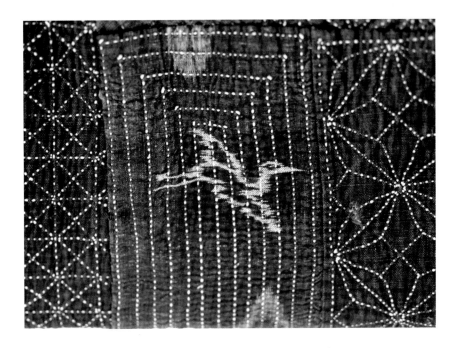

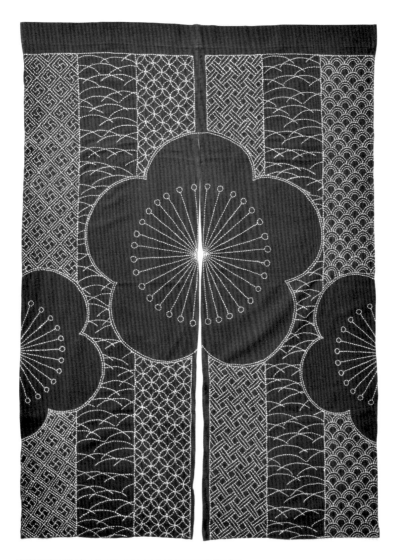

A traditional *noren* cloth decorated in traditional geometric sashiko. *Noren* is used as a type of curtain to cover open doorways. *Collection of Carol Lane-Saber.*

Specialized Sashiko: *Kogin*

Kogin, sashi kogin or *koginzashi* is an intricate variation of sashiko where each stitch is counted and planned in order to form patterns based on an elongated diamond or geometric shape. *Kogin*, which originated in Tsugaru in the Aomori Prefecture, uses a running stitch to essentially fill in the pattern and cover large areas of the cloth. These precise stitches are placed very close together and the final effect is an intricate design that appears as if it might have been woven into the cloth itself, rather than applied one stitch at a time.

TOP LEFT & RIGHT *Kogin, sashi kogin*, or *koginzashi* is an intricate variation of sashiko where each stitch is counted and planned in order to form patterns based on an elongated diamond or geometric shape. This example of *Tsugaru koginzashi* originated in Aomori Prefecture. *Photographed at Amuse Museum, Asakusa, Japan.*

BOTTOM This small purse is constructed using a remnant of an antique *kogin* textile.

Kiyoko Endo: Sashiko from the North

In 1976, a chance encounter with a customer forever changed the path Kiyoko Endo would follow for the next forty years.

At the time, she and her husband owned a small textile business and one of their customers requested that she hand stitch a pattern over one of their products. Those first few stitches sparked a career where her masterful sashiko designs have been shown in museums and galleries all over Japan, as well as Italy, Belgium, China, and the US. She's been honored with many cultural awards, featured on television, and was even introduced to Japan's royal family.

Like most great art, the incredible precision and exquisite beauty of sashiko made by Kiyoko Endo seems genuinely effortless. In fact, it can be difficult to conceive how this extraordinary texture can be achieved with just one woman, a needle, and some thread.

Kiyoko is a quiet, thoughtful, and very practical individual. She lives in a 140-year-old home in Yonezawa in Northern Japan, and living here puts her firmly in the center of a region that is recognized for its textile production and stitching, particularly the art of sashiko which has been practiced here for the past 250 years.

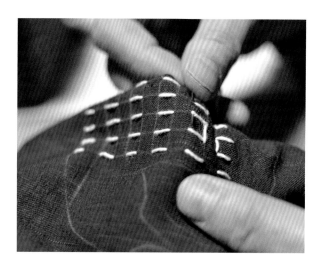

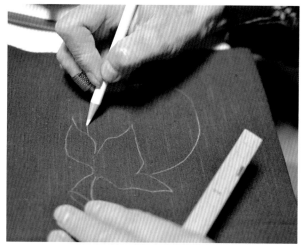

TOP Kiyoko Endo is a sashiko master who began stitching in the late 1970s and hasn't stopped since. She teaches and exhibits her work around the world.

BOTTOM LEFT Traditional and highly skilled Japanese sashiko stitchers like Kiyoko Endo work their needle in a horizontal motion, from side to side, as illustrated in this photo. This is quite different from Western style embroidery where the needle is held perpendicular and the stitch is primarily worked in an up and down motion.

BOTTOM RIGHT Kiyoko Endo enjoys designing original sashiko patterns. She marks the lines of her patterns first, then the hand stitching begins.

The process of creating and marking the specific designs is the part that Kiyoko enjoys most. She marks the lines of her traditional geometric patterns first, then the stitching begins. Her work has expanded beyond the repetitive patterns most often associated with sashiko and includes beautiful free-hand, creative designs used to decorate kimonos, table runners, bags, and many other items.

Her large, log-cabin style home has been converted to include a spacious workshop to teach classes during the summer months, a shop to sell supplies and finished pieces, as well as a sashiko gallery to showcase her work and her students' work. Another section of the house serves as living quarters.

She gets inspiration everywhere—from her students (some of which have studied with her for twenty years or more), from the changing seasons, from music. But perhaps her greatest inspiration comes from the history of Yonezawa itself.

Yonezawa is hot and humid in the summer and glacial cold in the winter. These extremes make the region ideal for growing Fuji apples and raising beef, both of which Yonezawa is famous for. But it also provides an ideal setting during the long winter months, when the snow banks reach the roof-tops and normal activities slow to a halt, to sit under a *kotatsu* and concentrate on stitching. A *kotatsu* is a traditional heating system whereby a heater is placed under a coffee table and covered with blankets. Usually, the *kotatsu* is large enough to accommodate a whole family.

Kiyoko spent two years in a formal program studying sashiko. The training was very strict and built a strong foundation of technical knowledge and expertise that she relies on to this day. In 1982, she began teaching others. Her original sashiko designs are inspired by the traditions of Northern Japan, particularly the *Harakata* sashiko, which originated in Yonezawa. Her first sashiko instruction book was published in 1987. She has published numerous books since.

Yonezawa is home to one of the most treasured sixteenth century garments in all of Japan. It is a patchwork *dōbuku,* which is a man's cloak or outer coat. This coat has been designated as an important cultural property. *Dōbuku* often featured strong, vivid designs to show off the warrior's masculinity.

This particular *dōbuku* was made especially for Kenshin Uesugi, a Samurai warrior whose family ruled the region in the 1500s. Kenshin Uesugi died in 1578 and the people in Yonezawa are proud of their association with this historic family. To honor him and his place in Yonezawa's history, Kiyoko has recreated a tapestry version of this famous patchwork coat and outlined it with her beautiful sashiko stitches.

These examples of cloth covered entirely with sashiko by Kiyoko Endo appear almost effortless. Given the incredible precision and exquisite beauty of Kiyoko's sashiko, it can be difficult to conceive how this extraordinary texture and decoration can be achieved with just one woman, a needle, and some cotton thread.

Crazy Sashiko: *Chiku-Chiku* and the Art of Akiko Ike

At the opposite end of the formal, precise, geometric sashiko designs is a free-form stitching that resembles sashiko but is known as crazy sashiko. In this case, the stitches are typically running stitches, but the stitch length and the space in between stitches are random, or crazy, and can go in any direction. Crazy sashiko has a definitive folk art appeal.

Akiko Ike is at the forefront of this type of stitching and in fact, she is the champion of a type of stitching known as *chiku-chiku*. This term is an ancient phrase generally meant to reference sewing or needlework. It is an onomatopoeic word that originated from the delicate sound of the needle as it whips, quickly, in and out of fabric. Akiko has adopted this term to describe her art because it so perfectly represents her straight running stitches, modern yet old.

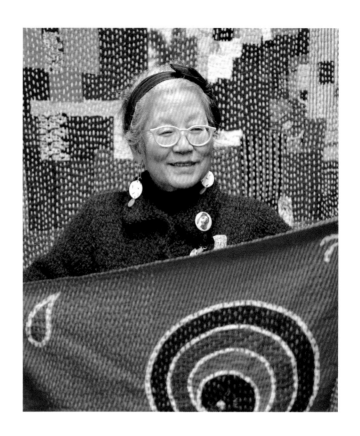

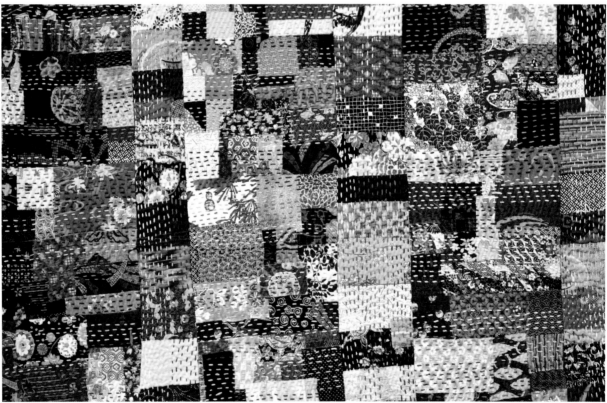

TOP The art of Akiko Ike is both attractive and unusual. She owns a gallery, retail shop, and coffee shop in Niigata and often travels to teach her unique style to quilters, embroiders, and other stitchers around the world.

BOTTOM These vintage and antique textiles are covered in a stitch known as *chiku-chiku*. The piece was made by a student of Akiko Ike and displayed at Niigata Ginka Gallery.

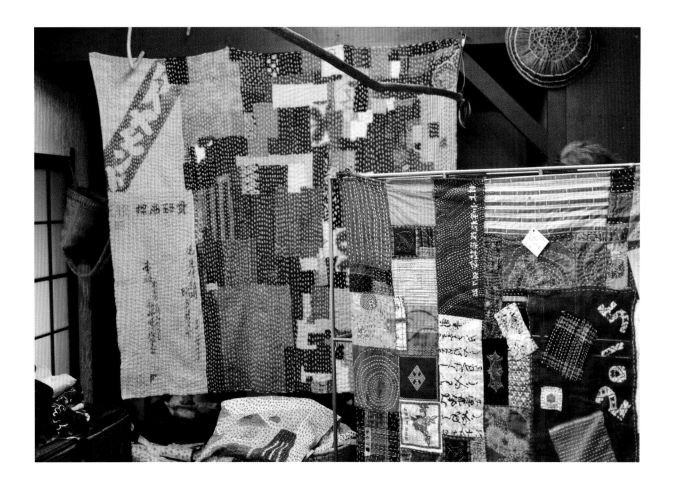

While traditional sashiko is most closely associated with whole cloth indigo, Akiko creates her work on *boro,* or other folk art textiles. When working with these old fabrics, she can sense the many hands that have touched these textiles and by working with them, she feels as if she is having a dialogue with the fabric.

To construct her patchwork, she lays pieces of antique cotton together, with their raw edges showing, in random layers, and stitches through them with her imperfect running stitch. The blocks may or may not be pieced or sewn together as a traditional quilt would be constructed. Typically, there is no batting or other textile layer between the top and bottom fabrics. In some cases there may only be one layer of patchwork, and in other cases she might incorporate a backing, or second textile layer, as a foundation.

TOP The large piece hanging in the back was created by Akiko Ike, a gallery and shop owner and a champion of *chiku-chiku.* The stitched piece in front, right, was created by a group of stitchers who attend classes with Akiko at Niigata Ginka Gallery. It is titled *Minna no Chiku-Chiku* and was assembled from several smaller parts.

BOTTOM The *chiku-chiku* style of stitching taught by Akiko Ike is typically created on *boro,* patchwork, or other folk art textiles.

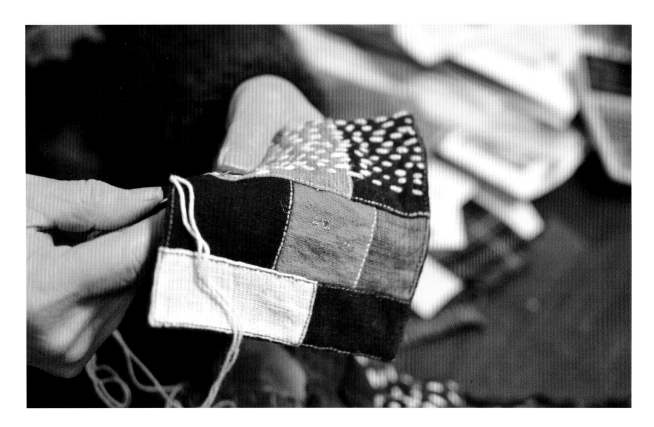

In addition to *boro*, Akiko will stitch over vintage decorated banners or painted fabric, as well as modern garments, bags, pillows, pin cushions, etc. Virtually any type of cloth will work. To add to the freshness of this art form, *chiku-chiku* and crazy sashiko are often created with a variety of thread colors, versus the clean white thread seen most often in formal sashiko.

When finished, Akiko Ike's art is both gorgeous and unusual. Her most dramatic works are the ones with the stitches running side by side, all in the same direction, typically top to bottom, or occasionally right to left. So what started as merely random pieces of *boro*, or a worn out festival banner, in the end is completely transformed by an effect that can best be described as having the look of a fine, gentle rain flowing down from above.

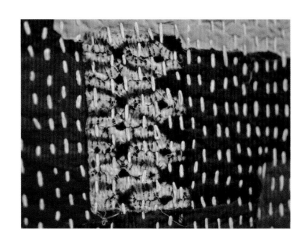

TOP With crazy sashiko, the needle is often worked from side to side, in a horizontal motion as illustrated here, similar to traditional sashiko. The needle movement in Western style embroidery is most often a vertical, or up and down motion.

CENTER Small squares, covered with *chiku-chiku,* are connected together and can be hung to make a string of small flag shapes.

BOTTOM Detail view of the crazy sashiko, or random running stitch.

The resemblance to rain is fitting because Akiko lives and works in Niigata, on the northwest coast. Niigata is often called the "city of water" because this port city faces the Sea of Japan and has a strong river running through it. Her gallery, bright and colorful craft store, and cozy coffee shop are all housed here within one beautiful, old building. She regularly teaches classes at her gallery and shop. She also travels to teach workshops in France and Australia. Students also travel to visit her as well, including groups from the US.

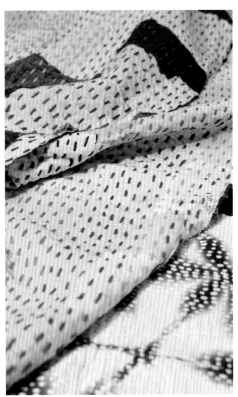

TOP LEFT & ABOVE Textile traditions are clearly dependent on the all-important needle. Japan has been producing sharp, incredibly honed needles for centuries and in fact, it is one place where some manufacturers still make needles by hand. The fine craftsmanship of both handmade and machine made needles from Japan are appreciated and sought by stitchers everywhere. *Photographed at Misuya-Bari, a needle shop in Kyoto that has been in operation for 350 years.*

TOP RIGHT These beautiful, softly colored stitches transform an old cotton cloth into something entirely unexpected.

THE AMBASSADOR
OF COTTON AND INDIGO

If there was ever an ambassador for antique Japanese cotton and indigo, it would be Shizuko Kuroha. She has dedicated most of her adult life to the pursuit of old textiles, specifically those of indigo and Japanese *sarasa*, and has used these treasures to make quilts that celebrate Japan's incredible history with textiles, especially cotton production.

Shizuko takes these old solid indigo cottons, as well as antique *katazome*, *kasuri*, *sarasa*, and other folk textiles, and in her own way, she's helped reacquaint her own modern culture with this important part of her native cultural history. Like a true ambassador, in doing so, she believes she has helped spark a greater appreciation for the beauty of old cotton, and also an appreciation for exactly how hard Japan's older generations of textile producers worked to create these precious fabrics.

Her quilts are traditional, with sometimes uncomplicated patterns. By design, they are the antithesis of most colorful contemporary quilts because the artist carefully restrains her palette and limits her fabric decisions to the precious, sometimes faded, beauty of indigo and the gentle palette of *sarasa*.

The *Poem of Indigo II* (1988) includes a carefully curated selection of folk textiles, such as *katazome* and *kasuri*, surrounded by solid indigo. Each block is carefully pieced so the eye is drawn to the center, which prominently showcases the antique textiles.

Spring Breeze (2002) is a masterpiece of tiny traditional pieced blocks. Each block is the exact same size and flawlessly pieced together and then hand quilted. What makes this old-fashioned quilt pattern so incredibly fresh is the gentle whisper of color. It is the essence of *iki*. Light indigo blues are interspersed with beautifully

subtle *sarasa* prints. An almost hidden inner border, along with an outer border, feature only indigo in carefully placed hues of near-white and light blues.

For *Cosmos II* (1992), Shizuko has adopted another timeless quilt block pattern, known as the tumbling block, and incorporated its subtle variations of brown, indigo, and off white. She has masterfully manipulated the size and scale of some of the tumbling blocks, and by stretching or shrinking each piece and carefully controlling the color, she has created planets floating in a sea of uninterrupted indigo.

Shizuko Kuroha celebrates Japan's traditional folk arts through her use of antique cotton *katazome*, *kasuri*, *sarasa*, indigo, and other fabrics in her striking quilts. As a traditionalist, she often wears her gorgeous kimonos, and sometimes handmade obis, when attending public events.

Shizuko Kuroha. *The Poem of Indigo II*. 1988. Cotton, antique kimono: 92" × 80" (234 × 202 cm). Pieced, hand quilted. *Collection of International Quilt Study Center and Museum, Lincoln, Nebraska.*

Detailed views of *The Poem of Indigo II*, made by Shizuko Kuroha in 1988. This quilt is part of the permanent collection of the International Quilt Study Center and Museum in Lincoln, Nebraska. The author was granted access during research visits.

She often tells her students, and the large crowds who gather to hear her speak, that when working with these old textiles, quilters should endorse the flaws found in these antiques. She explains that if a textile is tattered or has a hole, don't cut it off, instead showcase the hole or tear as a special feature. And if the material is discolored from age or stained, endorse that spot as an additional color in the finished quilt.

The many variations of color in antique indigo and vintage cotton are especially appealing to Shizuko because these colors remind her of the deep blue sea, the sky, and the wide open spaces that surround us. Over the years, she has become an expert in using these cottons, both old and new, whether dyed or woven. In some cases, she will use new cotton in her quilts, and specific indigo dyers who are intimately familiar with her quilts will dye cotton cloth to her exact specifications.

While Shizuko Kuroha adores using antique Japanese cotton that has been passed down through many hands in her quiltmaking, she recognizes that this fabric is rare and can be expensive. This concern has prompted her to design her own collections of commercially printed cotton that mimic antique textiles. She sees these careful reproductions as an affordable option for quilters who want to create in this palette, but who might not be able to afford the high cost of antique cotton, or simply do not have access to these old textiles. In fact, she recognizes that the day will come when textiles from the Meiji and Edo periods will no longer be available in the market. What's more, large quilts require a great deal of fabric on the front and back, so Shizuko uses her own commercially printed fabric as backings for her quilts. In this way, she preserves the most precious cotton for the quilt's top layer.

Shizuko Kuroha. *Cosmos II*. 1992. Antique cotton: 75" × 87" (192 × 222 cm). Pieced, hand quilted. Photo taken by the author when this quilt was part of an exhibition at the 2014 Tokyo International Great Quilt Festival. The quilt is hanging from the ceiling alongside several decorated spheres covered in flowers and mounds of grass and flowers on the ground.

Shizuko Kuroha. *Fireflies*. 1995. Antique cotton:
40" × 40" (102 × 102 cm). Pieced, hand quilted.

When working with indigos, either new or old, the first thing Shizuko will do is set these fabrics out in the sun. She explains that this is the only way to know exactly what you are dealing with because cotton dyed with natural indigo, and even some chemical dyes, might fade in the sunlight. Sometimes the indigo or *sarasa* has already faded and she appreciates its altered state. However, the most important factor is not the age or condition of the fabric, but how well these textiles blend in the final design. She is constantly studying and considering her design, never trying to force a particular fabric in one spot. Rather she gives the process time and seeks a balance of color, line, and pattern.

TOP A variety of very old remnants of cotton indigo, *katazome*, and *sarasa* are combined in this quilt by Shizuko Kuroha. The soft, faded surfaces of these antique textiles add to the coolness, the *iki*, of this beautifully constructed quilt.

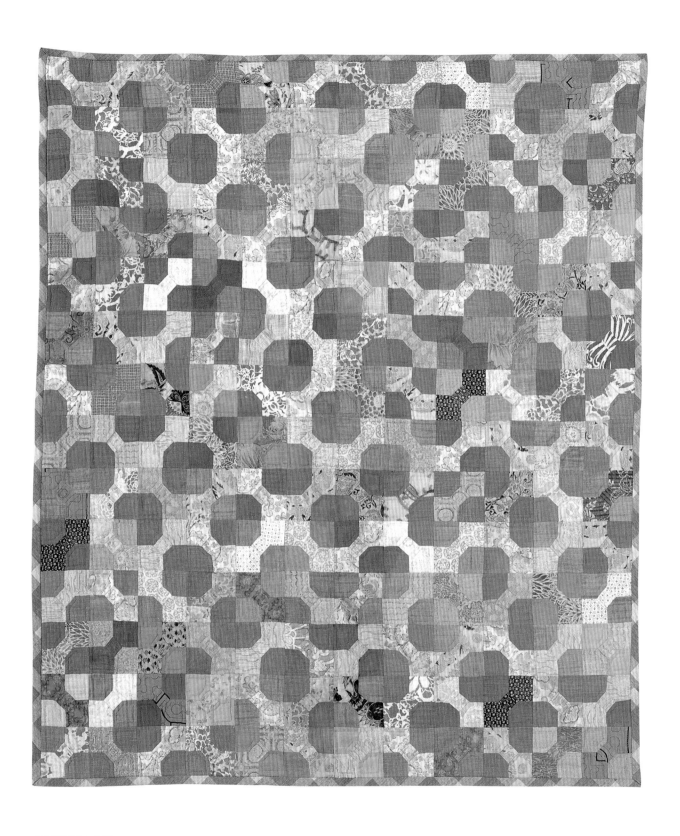

Shizuko Kuroha. *Knots*. 1993. Antique cotton: 55" × 47"
(140 × 120 cm). Pieced, hand quilted.

The quilted line is a very important consideration of her designs. Like most Japanese quilters, her quilts are always hand quilted and she especially loves the dimples made with needle and thread in these beautiful fabrics, an effect she believes cannot be duplicated with a machine.

Shizuko Kuroha is well-respected and well-known among the international quilt community. When she goes out to speak in public, such as the giant Tokyo International Great Quilt Festival, or the International Quilt Study Center in Lincoln, Nebraska, she will always be dressed in traditional kimonos. She feels a strong connection to Japan's past and wants to reflect these traditions in her dress, and also in her work.

Shizuko has taught many people to quilt and she thoroughly enjoys sharing her techniques. She has published many books and patterns in Japanese, and several of her books are available in French and English. Shizuko believes her books allow her to share her methods with a much wider audience than she could possibly teach in person, and she takes great pride in the fact that she has many "students" out there who are learning from her books.

As of 2016, she personally teaches, or mentors, approximately 100 or so students. The quilters gather in her Tokyo studio once a month, and in six cities throughout Japan. Some of her students first began studying with her in the early 1980s and have remained her students ever since. Many of them are highly accomplished master quilters themselves; some of them have been awarded Grand Prix awards or have exhibited in museums, department stores, and galleries.

While her teaching style is loosely based on traditional Japanese instruction, it is more flexible than the well-known *iemoto* system. *Iemoto* is a highly structured style of learning that is very common in Japan. Under the *iemoto* system, students are expected to closely follow the master's technique and to emulate their style.

Shizuko prefers a teaching style known as *terakoya*, which is a more relaxed method of learning. *Terakoya* can best be described as an open system of learning whereby students learn from a master and are instructed in best practices, but are encouraged to follow their own styles when making their quilts. *Terakoya* ensures technical quality and craftsmanship, but allows room for innovation and experimentation in art. During the Edo period, *terakoya* was a vital part of the educational system—a way of learning through a particular school, such as a specialized private school available today. Japan's public education system has replaced these classical systems of learning, of course, but some teachers like Shizuko have taken the ideas of this learning style and loosely re-applied them in a modern setting to teach quilting.

While Shizuko Kuroha adores using antique Japanese cotton that has passed down through many hands in her quiltmaking, she recognizes that this fabric can be expensive and also hard to find, and at some point in the future it may not be available at all. This is partly what inspired her to produce her own collection of reproduction printed cotton that mimics the color and aesthetic of antique Japanese cotton. She often uses these printed cotton fabrics as the backing for her own quilts, thus saving the most precious cotton for the front.

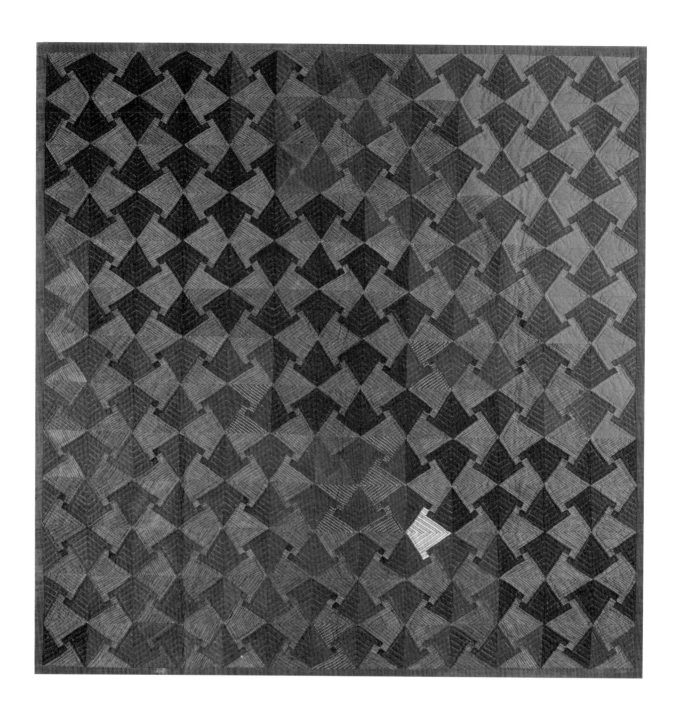

ABOVE Shizuko Kuroha. *Sea of Japan in Winter.* 1983.
Cotton, antique *kasuri:* 79" × 78" (201 × 198 cm). Pieced,
hand quilted. *Collection of International Quilt Study Center
and Museum, Lincoln, Nebraska.*

OPPOSITE *Sea of Japan in Winter* (detail).

For artists in Japan, the teacher-student relationship is vastly different than relationships in the Western world. For starters, when most students sign up to take classes from an accredited master artist teacher, they commit to a multi-year arrangement, most often a minimum of five years. In reality, most students in these programs spend twenty years or more studying with the same master. Over time, the so-called student may also become a master artist themselves. He or she may have been awarded major prizes, or their work may be widely exhibited, etc., yet they continue to "study" with their same master teacher. The instruction for these widely-accomplished students becomes more akin to mentoring or intellectual support, yet the student-teacher designation remains, primarily due to the cultural expectations associated with these relationships.

In the case of Shizuko Kuroha, the author focused her research on three of Shizuko's very talkented master students: Kyoko Yoshida, Tamiko Mawatari, and Etsuko Misaka.

Kyoko Yoshida and Tamiko Mawatari have studied with Shizuko since 1977. Both of them share their mentor's love of antique Japanese *sarasa* and indigo-dyed cotton. Because they are learning through Shizuko's *terakoya* style of teaching, each of their quilts exude their own style and personality.

In 2005, Kyoko Yoshida was awarded the Grand Prix at the Tokyo International Great Quilt Festival.

Winning the top honor at this highly competitive event is a fitting tribute for this talented quilter. The Tokyo International Great Quilt Festival is held each January. It is the largest quilting event in the world when judged by attendance, approximately 230,000 people attend the seven-day event.

In 2015, another talented master student of Shizuko Kuroha won the Grand Prix at the Tokyo International Great Quilt Festival. This time the award was given to Etsuko Misaka for her quilt entitled *Calm*. The title is an apt description of this gorgeous and expertly pieced quilt made from ever so slight variations of antique indigo cotton.

Creating with antique and vintage cotton requires a certain amount of fortitude, primarily because these fabrics are hard to find. Over the years, these quilters have grown adept at scouring Japan's open-air temple markets and other sources, such as antique dealers, to find the very best cotton. They are quick to explain that you can buy new fabric at any time, but it has no character. Rather, they treasure the fact that the cotton fabrics they use have been passed through many hands and they hope that the quilts they are making will honor this past and create even more hands to touch this fabric in the future.

This is a detailed image of a quilt by Tamiko Mawatari, an accomplished student of Shizuko Kuroha. She has combined a wide variety of antique cotton, including indigo, woven textiles, *kasuri, katazome, sarasa,* and other cotton fabrics. They are expertly pieced to form an unusual and striking quilted mosaic.

American Society of International Law. "Japan and the United States: Textile Agreement." American Society of International Law: *International Legal Materials* Vol. 2, No. 6 (1963): 1047–1054.

Arehart-Treichel, Joan. *Protecting King Cotton* (Society for Science & the Public: *Science News* Vol. 115, No. 16 (1979), 266–268).

Balfour-Paul, Jenny. *Indigo: Egyptian Mummies to Blue Jeans* (London: Firefly Books, 2012; 1st edition 1998).

Beckert, Sven. *Empire of Cotton: A Global History* (New York: Vintage Books, 2014).

Brown, D. Clayton. *King Cotton in Modern America* (Jackson, Mississippi: University Press of Mississippi, 2011).

Conlon, Michael. *The History of U.S. Cotton in Japan* (USDA Foreign Agricultural Service: *Global Agricultural Information Network (GAIN) Report* No. JA0503, 2010).

Fletcher, W. Miles. *The Japan Spinners Association: Creating Industrial Policy in Meiji Japan* (Society for Japanese Studies: *The Journal of Japanese Studies* Vol. 2, No. 1 (1996), 49–75).

Grange, Kenneth. *Grist to the Mill or Grist to the Miller? Twenty-one Years of Design in Japan* (Royal Society for the Encouragement of Arts, Manufactures and Commerce: *RSA Journal* Vol 141, No. 5436 (1993), 101–113).

Hargrave, Harriet. *From Fiber to Fabric: The Essential Guild to Quiltmaking Textiles* (Lafayette, CA: C&T Publishing, 1997).

Hauser, William B. *The Diffusion of Cotton Processing and Trade in the Kinai Region in Tokugawa Japan* (Cambridge University Press: *The Journal of Asian Studies* Vol. 33, No. 4 (1974), 633-649).

International Cotton Research Center. Texas Tech University: College of Agricultural Sciences & Natural Resources. http://www.depts.ttu .edu/agriculturalsciences/cotton/.

Jinzenji, Yoshiko. *Quilt Artistry: Inspired Designs from the East* (Tokyo: Kodansha International Ltd., 2002).

Kakuzo, Okakura. *The Book of Tea* (New York, Dover, 1964. Reprint of original published by Fox, Duffield and Company, 1906).

Koide, Yukiko, Kyoichi Tsuzuki (editors). *Boro: Rags and Tatters from the Far North of Japan* (Japan: Aspect Corporation, 2008).

Kuki, Shuzo *Reflections on Japanese Taste: The Structure of Iki* (Sydney: Power Institute, 1997. Translation of the original published in Tokyo: Iwanami Shoten, 1930).

Kuroha, Shizuko. *Indigo & Sarasa* (Saint-Etienne-de-Montluc, France: QuiltMania, 2011). French and English translation of a book originally published by Nihon Vogue Co. Ltd. in 2005.

Metropolitan Museum of Art, New York. *The Printed Image in the West: Woodcut.* http:// www.metmuseum.org/toah/hd/wdct/hd_wdct .htm.

Metropolitan Museum of Art, New York. *Art of the Pleasure Quarters and the Ukiyo-e Style.* http://www.metmuseum.org/toah/hd/plea/hd _plea.htm.

McCarty, Cara, Matilda McQuaid. *Structure and Surface: Contemporary Japanese Textiles* (Henry Abrams: The Museum of Modern Art, New York).

New York Fashion Center. "Not All Fabrics Are Created Equal." http://www.nyfashioncenter fabrics.com/pages/cotton-fabric-information.

Okazaki, Manami. *Kimono Now* (Munich: Prestel Verlag, 2015).

Pastoureau, Michel. *The Devil's Cloth: A History of Stripes* (New York: Washington Square Press, 1991).

Peck, Amelia (editor). *Interwoven Globe: The Worldwide Textile Trade, 1500–1800* (New York: Metropolitan Museum of Art, 2013).

Rathbun, William, J. (editor). *Beyond the Tanabata Bridge: Traditional Japanese Textiles* (Seattle, WA: Seattle Art Museum, 1993).

Rosen, George. *Japanese Industry Since the War* (Oxford University Press: *The Quarterly Journal of Economics* Vol. 67, No. 3 (1953), 445–463).

Sigur, Hannah. *The Influence of Japanese Art on Design* (Layton, Utah: Gibbs Smith, 2008).

Smith, Henry II. *Hokusai and the Blue Revolution in Edo Prints* (Columbia University, 2005).

Takeda, Sharon Sadako, and Luke Roberts. *Japanese Fishermen's Coats from Awaji Island* (Los Angeles: The Fowler Museum of Cultural History, UCLA, 2001).

Taylor, Fred (Chairman, Textile Mission to Japan). *The Textile Mission to Japan: A Report to the War Department and to the Department of State January-March 1946* (United States Government Printing Office, Washington, DC, 1946).

Triplett, Kay, and Lori Lee Triplett. *Indigo Quilts* (Lafayette, CA: C & T Publishing, 2015).

Wada, Yoshiko Iwamoto. *Memory on Cloth: Shibori Now* (New York: Kodansha USA, 2002).

Welch, J. Mark, Conrad P. Lyford, and Kenneth Harling. *The Value of Plains Cotton Cooperative Association* (Oxford Journals: *Review of Agricultural Economics* Vol. 29, No. 1 (2007), 170–185).

Wiki Spaces. *History of Textile and Screen Printing.* https://wftprintpm.wikispaces.com /Textile+%26+Screen+Printing.

Wong, Teresa Duryea. *Japanese Contemporary Quilts and Quilters: The Story of an American Import* (Atglen, PA: Schiffer Publishing, 2015).

Yafa, Stephen. *Cotton: The Biography of a Revolutionary Fiber* (New York: Penguin Books, 2005).

A field of cotton—
as if the moon had flowered.

—Matsuo Basho (1644–1694)
Translated by Robert Hass